D1540262

My Adobe® Photoshop
Lightroom® 4

Ted LoCascio

QUE®

800 East 96th Street,
Indianapolis, Indiana 46240 USA

My Adobe® Photoshop Lightroom® 4

Copyright © 2013 by Que Publishing

ISBN-13: 978-0-7897-4997-0
ISBN-10: 0-7897-4997-1

Library of Congress Cataloging-in-Publication Data

LoCascio, Ted.
 My Adobe Photoshop lightroom 4 / Ted LoCascio.
 pages cm
 Includes bibliographical references and index.
 ISBN 978-0-7897-4997-0 (alk. paper) -- ISBN 0-7897-4997-1 (alk. paper) 1. Adobe Photoshop lightroom. 2. Image processing--Digital techniques. 3. Photography--Digital techniques. I. Title.
 TR267.5.A355L64 2013
 771--dc23

Printed in the United States of America

First Printing: September 2012

Trademarks

Warning and Disclaimer

Bulk Sales

Que Publishing offers excellent discounts on this book when ordered in quantity for bulk purchases or special sales. For more information, please contact

U.S. Corporate and Government Sales
1-800-382-3419
corpsales@pearsontechgroup.com

For sales outside of the U.S., please contact

International Sales
international@pearsoned.com

Editor-in-Chief
Greg Wiegand

Acquisitions Editor
Laura Norman

Development Editor
Charlotte Kughen

Managing Editor
Kristy Hart

Project Editor
Anne Goebel

Indexer
Erika Millen

Proofreader
Sarah Kearns

Technical Editor
Christine Ricks

Book Designer
Anne Jones

Composition
Nonie Ratcliff

Contents at a Glance

Table of Contents

About the Author

Ted LoCascio is a professional graphic designer, author, and educator. He served as senior designer at the National Association of Photoshop Professionals (NAPP) for several years and has created layouts, graphics, and designs for many successful software training books, videos, websites, and magazines.

Ted is the author of numerous software training books and videos and has contributed articles to *Photoshop User* magazine, Creativepro.com, the Quark Xtra newsletter, PlanetQuark.com, indesignsecrets.com, and *InDesign Magazine*.

He has also taught at the Adobe CS Conference, the InDesign Conference, the Pixel Conference, the Vector Conference, and PhotoshopWorld.

A graphic designer for more than 15 years, Ted's designs and illustrations have been featured in several national newsstand and trade magazines, books, and various advertising and marketing materials. For more about Ted LoCascio, please visit tedlocascio.com.

Dedication

To my wonderful wife, Jill, and our two sons Enzo and Rocco, for their never-ending love and support.

Acknowledgments

First and foremost, I must thank God for giving me such a wonderful life, a loving family, supportive friends, and the wonderful ability to use my talents as an educator.

I must also thank everyone at Que Publishing and Pearson Education for making this book possible. Thanks to associate publisher Greg Wiegand and to acquisitions editor Laura Norman for sharing my vision on this project and for being as genuinely enthusiastic about Adobe Photoshop Lightroom as I am. Thanks also to Christine Ricks for acting as my technical editor and making sure every step, shortcut, and tip is correct. I must also thank my project editor, Anne Goebel, for working with me on the book's schedule and keeping everything on track.

Loving thanks to my wife, Jill, and to my sons, Enzo and Rocco, for being so patient while I was busy writing this book. Thanks also to Mom, Dad, Val, Bob and Evelyn Innocenti, and the rest of my extended family for being so supportive.

And of course, thanks to the Adobe Lightroom development team for making such great software to write about.

We Want to Hear from You!

As the reader of this book, *you* are our most important critic and commentator. We value your opinion and want to know what we're doing right, what we could do better, what areas you'd like to see us publish in, and any other words of wisdom you're willing to pass our way.

We welcome your comments. You can email or write to let us know what you did or didn't like about this book—as well as what we can do to make our books better.

Please note that we cannot help you with technical problems related to the topic of this book.

When you write, please be sure to include this book's title and author as well as your name and email address. We will carefully review your comments and share them with the author and editors who worked on the book.

Email: feedback@quepublishing.com

Mail: Que Publishing
ATTN: Reader Feedback
800 East 96th Street
Indianapolis, IN 46240 USA

Reader Services

Visit our website and register this book at www.quepublishing.com/register for convenient access to any updates, downloads, or errata that might be available for this book.

Learn to create
a customized
identity plate.

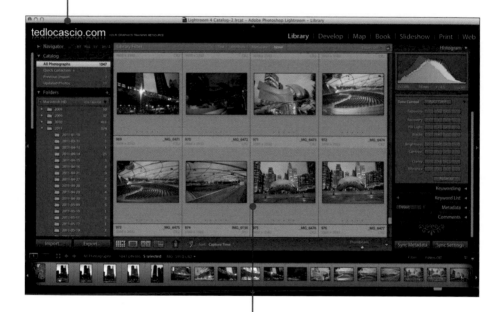

Learn to import
photos into a
Lightroom catalog.

In this chapter, you learn the essential skills to get you up and running with Lightroom 4.

→ Launching Lightroom 4
→ Customizing the Identity Plate
→ Creating a New Catalog
→ Opening an Existing Catalog
→ Choosing Settings
→ Importing Photos
→ Creating Import Presets
→ Using Auto Import
→ Exporting Photos from a Catalog
→ Renaming Photos
→ Converting Photos to DNG

Getting Started with Lightroom 4

Adobe Photoshop Lightroom is both a powerful image catalog management application and a high-quality image processor. The various modules available in Lightroom enable you to to organize, edit, and output your digital photos in the easiest way possible.

With this first chapter, you learn how to launch Lightroom, choose some important preview, import, and backup preference settings, and then begin importing images into a catalog. You also learn how to work with multiple catalogs, and how to use Lightroom's Auto Import feature, which can be especially helpful when conducting a tethered photoshoot.

Launching Lightroom 4

When you first launch the application, Lightroom displays the Library module with the Module Picker (top), Filmstrip (bottom), and left and right Module Panels visible. Unless you choose to update an existing Lightroom or Adobe Photoshop Elements catalog that is already on your system disk, the Content area of the Library module should appear empty.

Start Lightroom 4 in Windows XP/Vista/7

1. Click the Start button on the taskbar.

2. Point to All Programs.

3. Click Adobe Lightroom 4.

4. If you haven't done so already, choose the option to enter your serial number and click Next.

5. Enter your serial number in the fields provided and click Next.

Update Existing Catalogs

If you have Adobe Photoshop Elements or a previous version of Lightroom installed on your system, the Create New Lightroom Catalog dialog box appears the first time you launch Lightroom 4. You can use the controls in this dialog box to update an existing Elements or Lightroom catalog or create a new catalog.

After you install the application using the install wizard, the Lightroom interface appears with the Library module displayed.

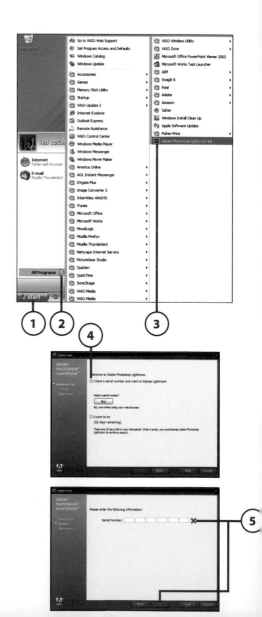

Start Lightroom 4 in Mac OS X

1. Choose Go, Applications.

Keyboard Shortcuts
Press Shift+Cmd+A to apply the Go to Applications command quickly.

2. In the Finder window, select the Adobe Lightroom 4 icon and double-click.

3. If you haven't done so already, choose the option to enter your serial number and click Next.

4. Enter your serial number in the fields provided and click Next.

Update Existing Catalogs
If you have a previous version of Lightroom installed on your system, the Create New Lightroom Catalog dialog box appears the first time you launch Lightroom. You can use the controls in this dialog box to update an existing Lightroom catalog or create a new catalog.

After you install the application using the install wizard, the Lightroom interface appears with the Library module displayed.

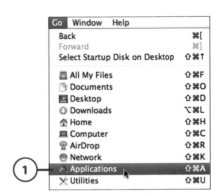

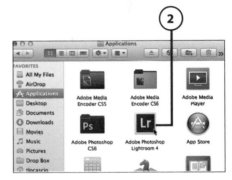

>Go Further

LAUNCHING LIGHTROOM FROM THE MAC OS X DOCK

To launch Lightroom 4 from the Mac OS X Dock, you must first save the Lightroom 4 application icon inside of it. With Lightroom 4 already launched, click the LR icon in the Dock and choose Keep in Dock. If Lightroom 4 is not launched, you can drag the LR icon from the Applications folder into the Dock. After you save it in the Dock, you can click the LR icon at any time to launch the application.

Customizing the Identity Plate

The Identity Plate is displayed in the upper-left corner of the Lightroom interface and is positioned in a retractable top panel called the Module Picker. By default, the standard Lightroom logo is displayed in the Identity Plate; however, you can replace it with custom text or an image logo of your own. The Identity Plate Editor also enables you to choose different fonts, styles, point sizes, and colors for the module buttons displayed in the upper-right corner of the interface.

Create a Styled Text Identity Plate

1. Under the Lightroom menu (Mac) or the Edit menu (Win), choose Identity Plate Setup.

2. In the Identity Plate Editor dialog box, check the Enable Identity Plate option. Doing so displays the new Identity Plate in the interface.

3. Enable the Use a Styled Text Identity Plate option and enter some text in the field below.

4. Highlight the preview text with the cursor. From the drop-down lists positioned below the text preview, choose a font, style, and point size.

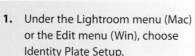

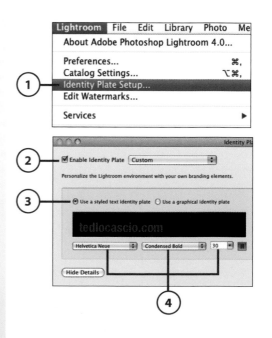

5. Click the color swatch icon to launch the system Color Picker and choose a different color for the Identity Plate text.

6. From the drop-down lists positioned below the module picker buttons preview, choose a complementary font, style, and point size for the button text.

7. Click the color swatch icons to launch the system Color Picker and choose different colors for the selected and nonselected states of the buttons.

8. Click OK to apply the Identity Plate.

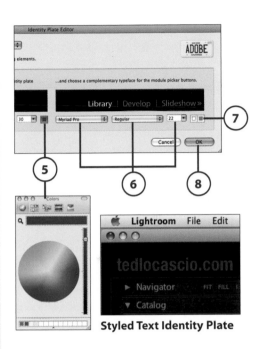

Styled Text Identity Plate

Place a Graphical Identity Plate

1. Under the Lightroom menu (Mac) or the Edit menu (Win), choose Identity Plate Setup.

2. In the Identity Plate Editor dialog box, check the Enable Identity Plate option. Doing so displays the new Identity Plate in the interface.

3. Enable the Use a Graphical Identity Plate option.

4. Click the Locate File button located under the preview area.

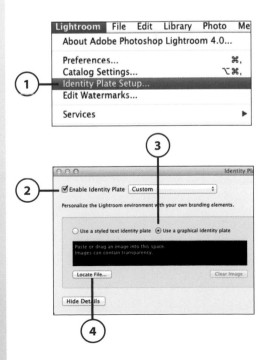

5. In the Locate File dialog box, browse to the file on your system and click Choose. You can also drag and drop, or copy and paste the image into the preview area.

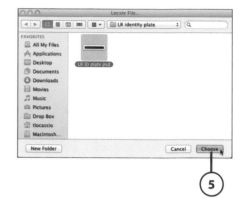

Image Size and Formats

The graphical Identity Plate image can contain transparency but should be no more than 57 pixels in height. You can place a JPEG, GIF, PNG, or TIFF. If you use the Mac OS X version of Lightroom, you can also place a PSD.

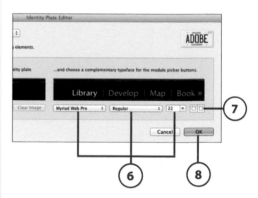

6. From the drop-down lists positioned below the modular picker buttons preview, choose a complementary font, style, and point size for the button text.

7. Click the color swatch icons to launch the system Color Picker and choose different colors for the selected and nonselected states of the buttons.

8. Click OK to apply the Identity Plate.

Graphical Identity Plate

Creating a New Catalog

When you install Lightroom 4, a new catalog is automatically created for you. Although it is much easier to manage all your photos from within a single catalog, there are situations where you might want to create more than one. For example, you might want to create separate catalogs for personal photos and professional work, or create separate catalogs for different Lightroom users who share the same computer.

Choose the New Catalog Command

1. Choose File, New Catalog.

2. In the Create Folder with New Catalog dialog box, enter a name for the catalog in the Save As field.

3. Choose a save location for the new catalog folder on your system. The default save location is *username*/Pictures (Mac OS X) or *username*\My Documents\My Pictures (Windows).

4. Click Create.

Lightroom automatically closes the current catalog and relaunches to open the new empty catalog.

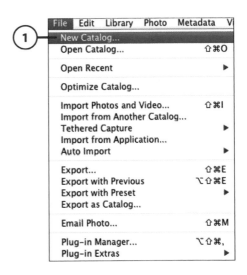

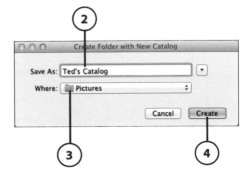

Opening an Existing Catalog

The current catalog always remains displayed in Lightroom, even after you close and relaunch the application. However, Lightroom can display only one catalog at a time. Therefore, anytime you open a different catalog, Lightroom must relaunch itself. To remind you of this, Lightroom displays a relaunch warning dialog box every time you open a new catalog.

Choose the Open Catalog Command

1. Choose File, Open Catalog.

Keyboard Shortcuts

Press Shift+Cmd+O (Mac) or Shift+Ctrl+O (Win) to apply the Open Catalog command quickly.

2. Lightroom displays the Open dialog box (Mac) or the Open Catalog dialog box (Win). Navigate to the catalog (.lrcat) file on your system and click Open.

3. Lightroom displays the Open Catalog warning dialog box. Click Relaunch to close the current catalog and relaunch Lightroom with the new catalog displayed.

Don't Show Again!

Click the Don't Show Again option in the Open Catalog dialog box to bypass the relaunch warning every time you open a catalog.

Lightroom closes the current catalog and relaunches to open the new empty catalog.

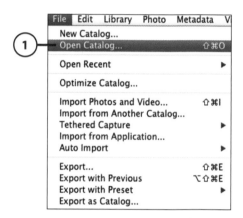

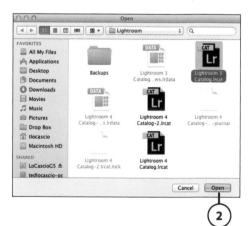

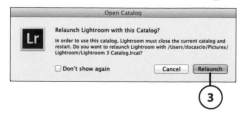

>>>Go Further

DOUBLE-CLICK TO OPEN A LIGHTROOM CATALOG FILE

When opening an existing Lightroom catalog, you're not limited to just using the File, Open command. In fact, an alternative way to open an existing Lightroom catalog is to locate and double-click the .lrcat file from the OS X Finder, Windows Explorer, or Adobe Bridge.

When you do, Lightroom closes the catalog you currently have open and relaunches to open the catalog whose .lrcat file you double-clicked.

Choosing Settings

There are a number of settings in Lightroom that you should choose before you start working with your images. The Backup settings enable you to schedule regular backups to ensure that you never lose your catalog data. Preview settings enable you to choose image preview cache settings, which can affect your overall system performance when working in Lightroom.

Choose Backup Settings

The General panel of the Catalog Settings dialog box contains a back-up preference, which enables you to choose how often you would like to perform a scheduled backup.

1. Under the Lightroom menu (Mac) or the Edit menu (Win), choose Catalog Settings.

Keyboard Shortcuts

Press Cmd+Option+comma (Mac) or Ctrl+Alt+comma (Win) to display the Catalog Settings dialog box quickly.

①

| Lightroom | File | Edit | Library | Photo | Me |

About Adobe Photoshop Lightroom 4.0...

Preferences... ⌘,
Catalog Settings... ⌥⌘,
Identity Plate Setup...
Edit Watermarks...

Services ▶

Hide Lightroom ⌘H
Hide Others ⌥⌘H
Show All

Quit Lightroom ⌘Q

2. In the Catalog Settings dialog box that appears, click the General tab.

3. Choose a backup catalog option from the Back Up Catalog drop-down list.

4. Close the Catalog Settings dialog box.

5. The next time a backup is scheduled, the Back Up Catalog dialog box appears. You can choose a backup directory by clicking the Choose button. Navigate to it in the Choose Folder dialog box and click Choose. You should only have to choose the backup directory once.

6. Enable the Test Integrity Before Backing Up option to test for any corruptions in the database.

7. Enable the Optimize Catalog After Backing Up option to reduce wait time while working in Lightroom.

8. Click Back Up.

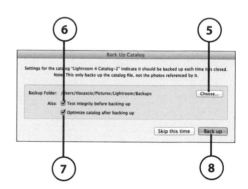

Choose Preview Settings

Before you start working with photos in Lightroom, you should choose the proper preview cache settings.

1. Under the Lightroom menu (Mac) or the Edit menu (Win), choose Catalog Settings.

2. In the Catalog Settings dialog box that appears, click the File Handling tab.

3. From the Standard Preview Size drop-down list, choose a preview size that is suitable for your display monitor.

Size Matters

If you use Lightroom with a large 30-inch monitor, then you should choose the highest pixel setting (2,048 pixels) as the Standard Preview Size. If you use Lightroom on a laptop, then the 1,024 pixels setting should keep the preview cache size manageable.

4. Choose a preview quality setting suitable for your hard drive from the Preview Quality list.

Preview Quality Guidelines

If hard drive space is limited, choose Low or Medium preview quality. If it is not a concern, then choose High, which applies the least amount of compression and results in the best preview. The High setting also uses the ProPhoto RGB space, which ensues better color consistency between Library and Develop modules.

5. As they are generated, 1:1 Previews can take up a lot of room on your hard disk. To manage this, you can choose when to discard 1:1 Previews by selecting an option from the Automatically Discard 1:1 Previews drop-down list.

6. Close the dialog box.

Importing Photos

Unlike Adobe Bridge, Lightroom is much more than just a browser application. Lightroom is both a catalog manager and a raw image processor. To work with images in Lightroom, you must first import them into a catalog.

Importing Photos from a Camera or Card Reader

The most common way to import photos is to do so directly from a camera or card reader.

1. Plug your camera or card reader into your computer. Make sure the memory card is inserted and the device is turned on. Then, under the File menu, choose Import Photos and Video or click the Import button in the bottom-left corner of the Library module.

Keyboard Shortcuts

Press Cmd+Shift+I (Mac) or Ctrl+Shift+I (Win) to display the Import dialog box quickly.

2. In the Import dialog box, select the image source from the Source drop-down list located in the upper-left corner, or from the Source panel.

 Lightroom displays the image thumbnails in the center panel of the dialog box.

3. Click one of the following buttons at the top of the dialog box:

 Copy as DNG—Choose this option to copy the photos to a preferred folder and convert them to Digital Negative format as you import them.

 Copy—Choose this option to copy the photos to a preferred folder as you import them.

4. By default, the selected photos are copied into *username*/Pictures (Mac) or *username*\My Documents\My Pictures (Win). If you'd like to copy the photos into a different location, select one from the Destination drop-down list or choose one from the Destination panel. Choose Other Destination from the Destination drop-down list to specify a destination folder on your disk. In the Choose Destination Folder dialog box that appears, browse to a different folder on your disk and click Choose.

5. From the File Handling panel, choose the quality of preview to generate by selecting an option from the Render Previews drop-down list. Choose Minimal for a quicker import. Choose 1:1 for high-quality previews.

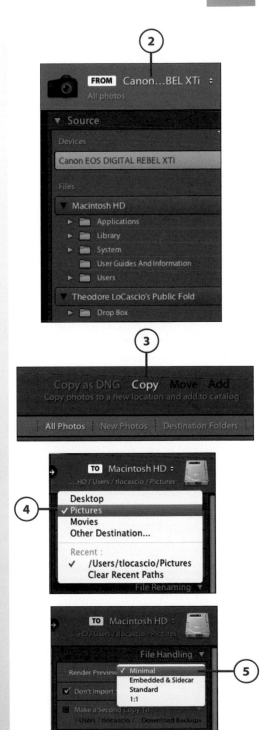

6. From the File Handling panel, enable the Make a Second Copy To option to save backup copies of the photos to a separate folder. Click the current location displayed in the panel to specify a backup location.

7. In the Choose Folder dialog box, browse to the preferred folder and click Choose.

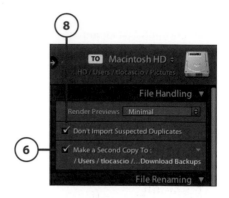

Always Save a Backup

You should always save a backup as you import. After you erase your photos from your media card, they are gone forever. Therefore, it's always a good idea to save a backup of all unedited master images as you import them.

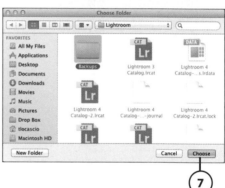

8. To avoid importing duplicates into the catalog, be sure to enable the Don't Import Suspected Duplicates option in the File Handling panel.

9. To rename the files as you import them, enable the Rename Files option in the File Renaming panel.

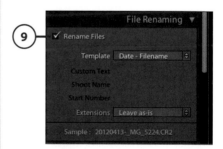

10. Choose a file-naming preset from the Template drop-down list. To create a custom preset, choose Edit and enter your preferred settings in the Filename Template Editor dialog box.

11. In the Apply During Import panel, choose from the following options:

Develop Settings—You can apply adjustments to the images as they are imported by choosing any one of the available develop presets.

Metadata—You can add metadata to the images as you import them by choosing a preexisting meta-data preset from the drop-down list. You can create a metadata preset by choosing New, enter-ing the info in the New Metadata Preset dialog box that appears, and clicking Create.

Keywords—You can add key-words to the images as they are imported by entering them in the field provided here. Separate each keyword with a comma.

12. Click the Import button in the lower-right corner of the dialog box.

As the photos import, their respec-tive thumbnails begin to appear in the library Content area. The status indicator in the upper left of the module displays the import progress.

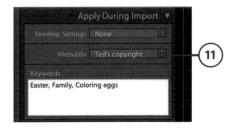

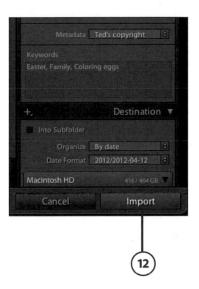

The status indicator displays the import progress.

Importing Photos from a Folder

You may also have photos stored in folders on your system that you'd like to import, as well as photos stored on external media such as a CD, a DVD, or an external drive.

1. Choose File, Import Photos and Video or click the Import button in the Library module.

2. In the Import dialog box, select the image source from the Source drop-down list or from the Source panel.

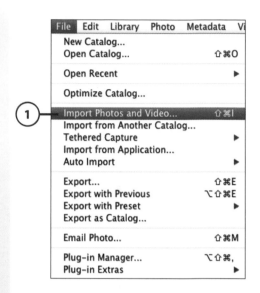

Acceptable File Formats

Lightroom accepts 16- or 8-bit TIFFs, JPEGs, and PSDs saved in RGB or CMYK mode. Layered PSD files must be saved with Maximum Compatibility turned on in Photoshop's File Handling preferences. Lightroom also accepts various raw file formats, including DNG, CR2, and NEF.

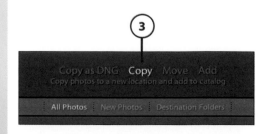

3. Click one of the import buttons at the top of the dialog box. Copy as DNG copies raw photos to a preferred folder and converts them to Digital Negative format as you import them. The Copy option copies the photos to a preferred folder. The Move option moves the photos to a preferred folder as you import them. Add keeps the photos in their current location as you import.

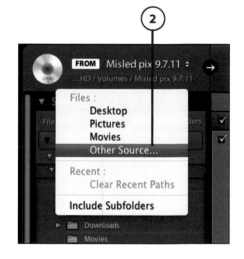

4. By default, the selected photos are placed into *username*/Pictures (Mac) or *username*\My Documents\My Pictures (Win). If you'd like to place the photos into a different location, select one from the Destination drop-down list or choose one from the Destination panel. Choose Other Destination from the Destination drop-down list to specify a destination folder on your disk. In the Choose Destination Folder dialog box that appears, browse to a different folder on your disk and click Choose.

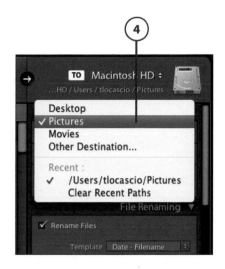

Where's the Destination List and Panel?

When you choose to add photos to the catalog without moving them, the Destination drop-down list and panel do not appear in the dialog box.

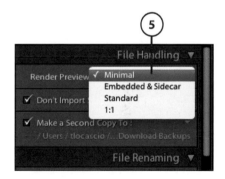

5. From the File Handling panel, choose the quality of preview to generate by selecting an option from the Render Previews drop-down list. Choose Minimal for a quicker import. Choose 1:1 for high-quality previews.

6. From the File Handling panel, enable the Make a Second Copy To option to save backup copies of the photos to a separate folder. Click the current location displayed in the panel to specify a backup location. In the Choose Folder dialog box that appears, browse to the preferred folder and click Choose.

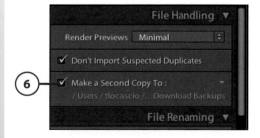

7. To avoid importing duplicates into the catalog, be sure to enable the Don't Import Suspected Duplicates option in the File Handling panel.

8. To rename the files as you import them, enable the Rename Files option in the File Renaming panel.

9. Choose a file-naming preset from the Template drop-down list. To create a custom preset, choose Edit and enter your preferred settings in the Filename Template Editor dialog box.

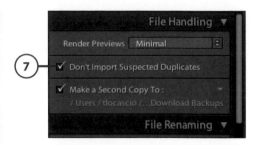

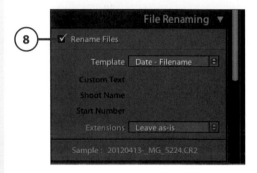

Where's the File Renaming Panel?

If you choose to add photos to the catalog without moving them, then the File Renaming panel does not appear in the dialog box.

10. Choose an option from the Apply During Import panel.

Develop Settings applies adjustments to the images as they are imported by choosing any one of the available develop presets.

Metadata adds the metadata via a preexisting metadata preset, which you can choose from the drop-down list provided. You can create a metadata preset by choosing New, entering the info in the New Metadata Preset dialog box that appears, and clicking Create.

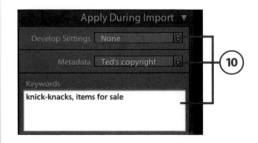

Keywords enables you to add keywords to the images by entering them in the field provided. Separate each keyword with a comma.

11. Click the Import button.

As the photos import, their respective thumbnails begin to appear in the library Content area. The status indicator in the upper left of the module displays the import progress.

Importing Photos via Drag-and-Drop

Another quick-and-easy way to import photos into a Lightroom catalog is to drag-and-drop the selected images, or folder(s) of images, into the Library module.

1. Select the images from Finder (Mac) or Explorer (Win).

2. Drag-and-drop the selected photos into the Content area of the Library module.

3. In the Import dialog box, select the image thumbnails from the center Preview area.

4. Click one of the import buttons at the top of the dialog box. Copy as DNG copies raw photos to a preferred folder and converts them to Digital Negative format as you import. The Copy option copies the photos to a preferred folder. The Move option moves the photos to a preferred folder. Add keeps the photos in their current location.

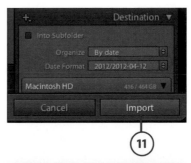

The status indicator displays the import progress.

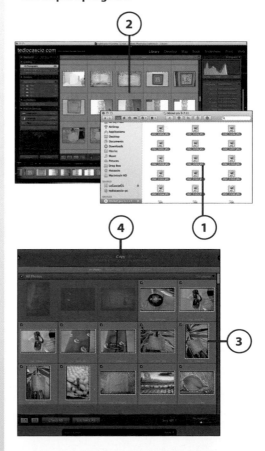

5. By default, the selected photos are placed into *username/*Pictures (Mac) or *username*\My Documents\My Pictures (Win). To place the photos into a different location, select one from the Destination drop-down list or choose one from the Destination panel. Choose Other Destination from the Destination drop-down list to specify a destination folder on your disk. In the Choose Destination Folder dialog box that appears, browse to a different folder on your disk and click Choose.

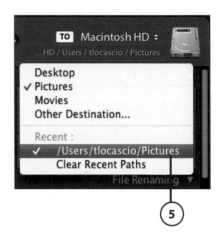

Where's the Destination List and Panel?

If you choose to add photos to the catalog without moving them, then the Destination drop-down list and panel do not appear in the dialog box.

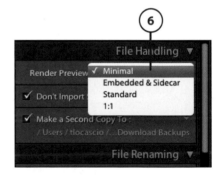

6. From the File Handling panel, choose the quality of preview to generate by selecting an option from the Render Previews drop-down list. Choose Minimal for a quicker import. Choose 1:1 for high-quality previews.

7. From the File Handling panel, enable the Make a Second Copy To option to save backup copies of the photos to a separate folder. Click the current location displayed in the panel to specify a backup location. In the Choose Folder dialog box that appears, browse to the preferred folder and click Choose.

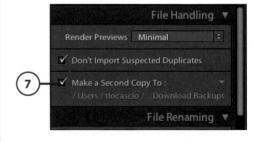

8. To avoid importing duplicates, be sure to enable the Don't Import Suspected Duplicates option in the File Handling panel.

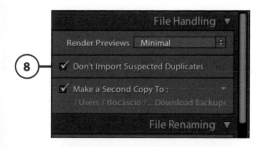

9. To rename the files as you import them, enable the Rename Files option in the File Renaming panel.

10. Choose a file-naming preset from the Template drop-down list. To create a custom preset, choose Edit and enter your preferred settings in the Filename Template Editor dialog box

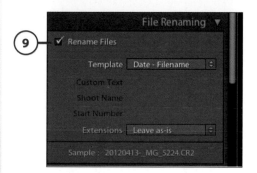

Where's the File Renaming Panel?

If you choose to add photos to the catalog without moving them, then the File Renaming panel does not appear in the dialog box.

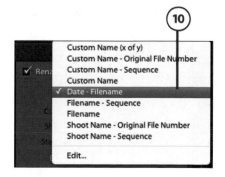

11. Choose an option from the Apply During Import panel. Develop Settings applies adjustments based on which develop preset you choose from the drop-down list.

Metadata adds the metadata via a preexisting metadata preset, which you can choose from the drop-down list provided. You can create a metadata preset by choosing New, entering the info in the New Metadata Preset dialog box, and clicking Create.

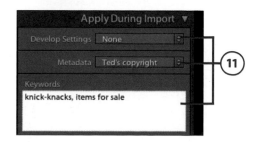

Keywords enables you to add keywords to the images by entering them in the field provided. Separate each keyword with a comma.

12. Click the Import button.

As the photos import, their respec-
tive thumbnails begin to appear in
the library Content area. The status
indicator in the upper left of the
module displays the import progress.

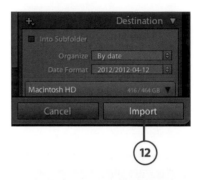

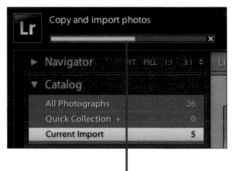

**The status indicator displays the
import progress.**

SAVING IMPORT SETTINGS AS A PRESET

>>>Go Further

You can save your favorite import settings as a preset. To do so, choose
your preferred Import dialog box settings; then from the Import Preset
pop-up list located at the bottom of the Import dialog box, choose Save
Current Settings as New Preset. In the New Preset dialog box that appears,
enter a name for your preset and click Create.

After you create it, the new preset appears in the Import Preset pop-up
list. Whenever you choose this Import preset, Lightroom recalls the saved
import settings.

Importing Photos from Another Catalog

If you use Lightroom on two computers, then your workflow will most likely involve importing images that were saved in a separate catalog. It may also involve importing image data that was edited remotely in an exported catalog.

1. Choose File, Import from Another Catalog.

2. Lightroom displays the Import from Lightroom Catalog dialog box. Navigate to the catalog (.lrcat) file on your system and click Choose.

3. In the Import from Catalog dialog box, enable the Show Preview option. You can then select the thumbnails for any new photos you would like to import into the current catalog from the Preview area on the right.

4. For any new photos, choose one of the options from the File Handling drop-down list.

 Add New Photos to Catalog Without Moving keeps the photos in their current location as you import.

 Copy New Photos to a New Location and Import copies the photos to a preferred folder as you import. This option is only available when the catalog you are importing from includes negative master files.

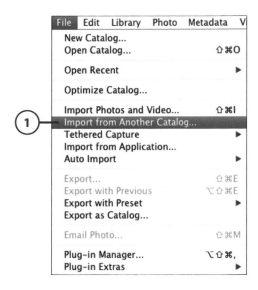

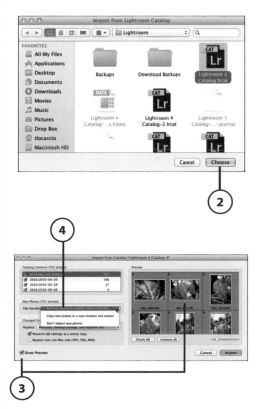

Don't Import New Photos ignores any new photos and only imports existing ones.

5. For any existing photos, choose an option from the Replace drop-down list.

 Nothing ignores any existing photos and only import new ones.

 Metadata and Develop Settings Only replaces the metadata and develop settings for any existing photos that you import.

 Metadata, Develop Settings, and Negative Files replaces the metadata, develop settings, and negative files for any existing photos that you import. This option is only available when the catalog you are importing from includes negative master files.

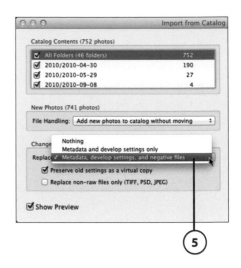

6. Enable Preserve Old Settings as a Virtual Copy to maintain a virtual copy of the existing photo in the catalog with its current metadata and develop settings. If you keep this option disabled, you will overwrite the settings for the existing photo.

7. Enable Replace Non-Raw Files Only (TIFF, PSD, JPEG) to preserve any versions in raw file format when replacing negative files. This option is only available when the catalog you are importing from includes negative master files.

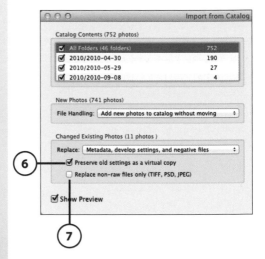

No Exact Duplicates!

Any photos that are exact dupli-
cates (with identical metadata
and develop settings in both cata-
logs) will not be imported

8. Click the Import button.

As the photos import, their respec-
tive thumbnails begin to appear in
the library Content area. The status
indicator in the upper left of the
module displays the import progress.

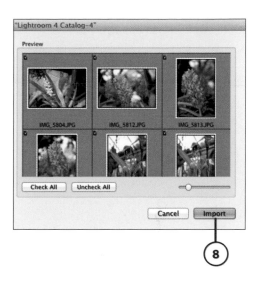

Importing Photos via Tethered Capture

Lightroom 4 enables you to perform
a tethered capture session without
having to rely on your camera's
manufacturer-supplied software. As
you shoot, Lightroom downloads
the captured files from the camera
to a specific folder on your drive, and
adds them to your Lightroom catalog
automatically.

1. Plug your camera into your com-
puter. Make sure the memory
card is inserted and the camera
is turned on. Then choose File,
Tethered Capture, Start Tethered
Capture.

2. In the Tethered Capture Settings
dialog box, enter a name in the
Session Name field.

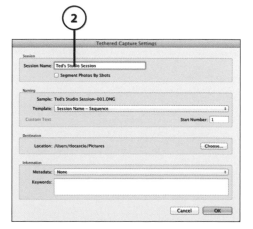

3. Choose a file-naming preset from the Template drop-down list. To create a custom preset, choose Edit and enter your preferred settings in the Filename Template Editor dialog box.

4. By default, the captured photos are placed into *username/*Pictures (Mac) or *username\My*Documents\My Pictures (Win). If you'd like to place the photos into a different location, click Choose. In the Choose Folder dialog box that appears, browse to a different folder on your disk and click Choose.

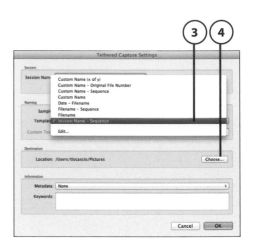

5. Choose an option from the Information portion of the dialog box.

Metadata adds the metadata via a preexisting metadata preset, which you can choose from the drop-down list provided. You can create a metadata preset by choosing New, entering the info in the New Metadata Preset dialog box, and clicking Create.

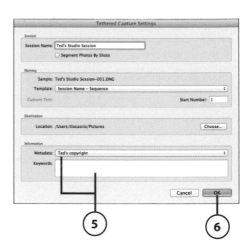

Keywords enables you to add keywords to the images by entering them in the field provided. Separate each keyword with a comma.

6. Click OK.

7. Lightroom displays the Tethered Capture Window. Click the Capture button to take photos and import them into the catalog automatically.

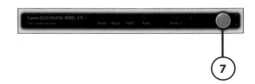

Keyboard Shortcuts

Press Shift+Cmd+T (Mac) or
Shift+Ctrl+T (Win) to take a
capture.

8. To end the tethered capture
 session, choose File, Tethered
 Capture, Stop Tethered Capture,
 or click the Close button in the
 upper-right corner of the Tethered
 Capture window.

Using Auto Import

Lightroom also contains an Auto Import feature, which provides an alterna-
tive way to conduct a tethered photo shoot. In this scenario, you must rely
on your camera's manufacturer-supplied software to download captured files
from the camera to a specific folder location on your drive as you shoot. If
you set up this folder as a watched folder in Lightroom, the photos are auto-
matically imported into the current catalog.

Setting Up a
Watched Folder

1. Choose File, Auto Import, Auto
 Import Settings.

2. Lightroom displays the Auto Import Settings dialog box. To specify a watched folder, click the Choose button at the top of the dialog box.

3. Lightroom displays the Auto-Import from Folder dialog box. Navigate to the preferred folder on your system or create a new one by clicking the New Folder button; then click Choose. Note that the watched folder must be empty when you choose it.

4. By default, the selected photos are moved to *username/*Pictures (Mac) or *username*\My Documents\My Pictures (Win). If you'd like to move the photos to a different location, click Choose in the Destination section of the Auto Import Settings dialog box. In the Choose Folder dialog box that appears, browse to a different folder on your disk and click Choose.

5. Enter a descriptive name in the Subfolder Name field. The default name is Auto Imported Photos.

6. Choose a file-naming preset from the File-Naming drop-down list. To create a custom preset, choose Custom Settings and enter your preferred settings in the Filename Template Editor dialog box.

7. Choose an option from the
 Information portion of the Auto
 Import Settings dialog box.

 Develop Settings enables you to
 apply adjustments by choosing
 any one of the available develop
 presets.

 Metadata adds the metadata via
 a preexisting metadata preset,
 which you can choose from the
 drop-down list provided. You
 can create a metadata preset by
 choosing New, entering the info
 in the New Metadata Preset dia-
 log box that appears, and clicking
 Create.

 Keywords enables you to add
 keywords to the images by enter-
 ing them in the field provided.
 Separate each keyword with a
 comma.

 Initial Previews enables you to
 choose the quality of preview
 Lightroom generates at import.
 Choose Minimal for a quicker
 import as you continue tethered
 shooting. High-quality 1:1 pre-
 views can always be rendered
 later.

8. Click OK to apply the Auto Import
 settings.

9. Choose File, Auto Import, Enable
 Auto Import.

The photos are automatically
imported into the current Lightroom
catalog and saved in the Auto Import
destination folder.

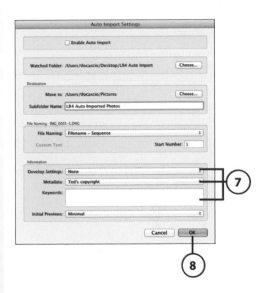

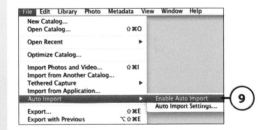

Exporting Photos from a Catalog

It's not uncommon for a professional photographer's Lightroom workflow to include more than one computer—usually a master desktop system accompanied by a portable laptop. This scenario involves exporting a catalog, or portions of a catalog, so that work can be done remotely on a laptop. You can apply ratings, keywords, and metadata to images exported without negatives, but you can only apply develop settings to images exported with negatives.

Export a Catalog Without Negatives

1. Choose File, Export as Catalog.

2. Lightroom displays the Export as Catalog dialog box. Enter a name for the catalog in the Save As field.

3. If you'd only like to export the photographs that you currently have selected in the Library module or Filmstrip, then you must enable the Export Selected Photos Only option. Otherwise, all the photographs in the entire catalog are exported.

4. Choose a save location for the new catalog on your system and click Export Catalog.

Lightroom creates a new catalog file (.lrcat) and saves it in the specified folder.

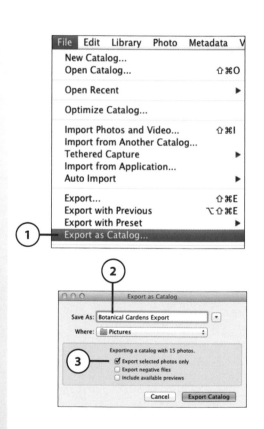

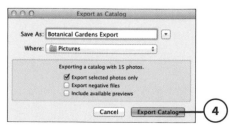

It's Not All Good

Exporting without negatives can severely limit what you can do with a catalog inside Lightroom. For example, when you export without negatives, you cannot use the Develop module or the Library module Quick Develop panel to adjust the photos.

Export a Catalog with Negatives

1. Under the File menu, choose Export as Catalog.

2. Lightroom displays the Export as Catalog dialog box. Enter a name for the catalog in the Save As field.

3. If you'd only like to export the photographs that you currently have selected in the Library module or Filmstrip, then you must enable the Export Selected Photos Only option. Otherwise, all the photographs in the entire catalog will be exported.

4. Enable the Export Negative Files option to include all the master files associated with the photographs in their native, unflattened state.

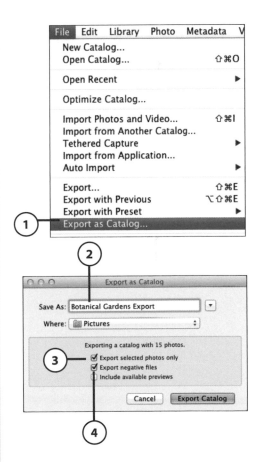

5. Choose a save location for the new catalog on your system and click Export Catalog.

Lightroom creates a new .lrcat file saved in the folder you specified. It also creates a subfolder containing the master negatives.

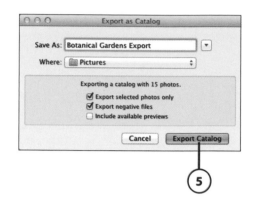

Export a Catalog with Previews

1. Choose File, Export as Catalog.

2. Lightroom displays the Export as Catalog dialog box. Enter a name for the catalog in the Save As field.

3. If you'd like to only export the photographs that you currently have selected in the Library module or Filmstrip, then you must enable the Export Selected Photos Only option. Otherwise, all the photographs in the entire catalog are exported.

4. Enable the Include Available Previews option to include all Library Grid thumbnails, standard resolution Loupe views, and available 1:1 rendered views.

5. Choose a save location for the new catalog on your system and click Export Catalog.

Lightroom copies the photos and creates a new .lrcat file saved in the folder you specified. It also creates an .lrdata file that contains the thumbnails and preview image data.

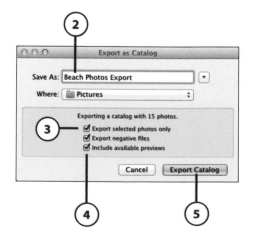

>>>Go Further

INCLUDE PREVIEWS WHEN EXPORTING WITHOUT NEGATIVES

Enabling the Include Available Previews option is crucial when exporting a catalog without negatives. This is because you cannot re-render previews for a catalog that has been exported without the master negatives. Therefore, you should always choose Render Standard-Sized Previews from the Library, Previews submenu in the Library module before exporting the catalog without negatives. For full-resolution previews, choose Render 1:1 Previews from the Library menu.

Renaming Photos

In addition to adding keywords to your photos in Lightroom, it's also good organizational practice to rename your photos to something more descriptive than the default serial code that your camera assigns. Doing so can make it much easier to manage and track your images as you work with them. Lightroom enables you to rename the images during the import process, or rename them later, after they've already been imported.

Rename Photos at Import

1. To rename the files as you import them, enable the Rename Files option in the File Renaming panel of the Import dialog box.

2. Choose a file-naming preset from the File Naming drop-down list. To create a custom preset, choose Edit and enter your preferred settings in the Filename Template Editor dialog box.

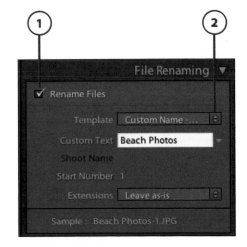

3. Click the Import button.

The photos are renamed as they are imported into the current Lightroom catalog. As the photos import, their respective thumbnails begin to appear in the Library Content area. The status indicator in the upper-left corner of the module displays the import progress.

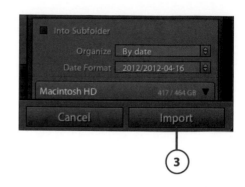

Rename Photos After Import

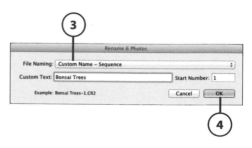

1. Select the photos you would like to rename from the Library module Content area or the Filmstrip.

2. Under the Library menu, choose Rename Photos.

Keyboard Shortcuts

Press Function+F2 to apply the Rename Photos command quickly.

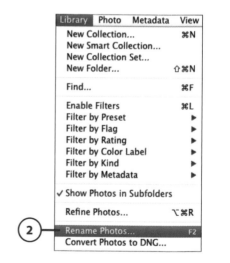

3. In the Rename Photos dialog box, choose a file-naming preset from the File Naming drop-down list. To create a custom preset, choose Custom Settings and enter your preferred settings in the Filename Template Editor dialog box.

4. Click OK.

The selected catalog photos are renamed.

Learn to change view
magnification with
the Navigator panel.

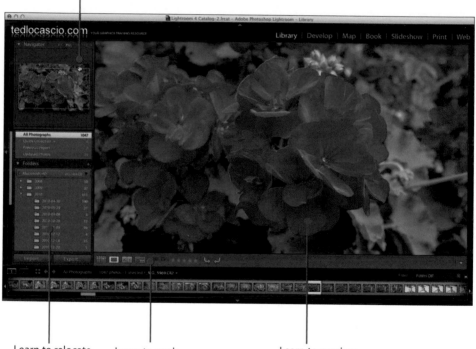

Learn to relocate
photos on your
system with the
Folders panel.

Learn to work
with the Library
Toolbar.

Learn to preview
selected photos in
Loupe view.

In this chapter, you learn the various ways you can preview photos in the Library module.

Previewing Photos in the Library Module

After you import your photos into a Lightroom catalog, the next step is to preview them in the Library module. There are various panels, tools, and view modes that you can use to sort, filter, and preview your photos in the Library.

In this chapter, you learn how to use the Catalog panel and Filter Bar to locate specific groups of images to work with, and how to use the Folders panel to move or rename the system folders where your catalog images are stored. You also learn how to locate and select images in Grid View mode, and then use the Navigator panel to preview them in both standard and close-up Loupe views.

This chapter also explains how to preview multiple images in Compare view and Survey view. In addition, you learn how to quickly apply useful commands by utilizing the controls available in the customizable Library Toolbar. You also find out how to locate and select images using the Filmstrip.

Library Module Panels

The panels that appear in the left sidebar while working in the Library module can be extremely helpful. The Catalog panel helps you locate specific groups of images in your catalog and the Folders panel helps you locate and move images on your system. The Navigator panel enables you to change the view magnification when viewing an image in Loupe view.

Navigator Panel

The Navigator is the topmost panel in the left sidebar. The Navigator is useful for zooming and scrolling around an image in Loupe view.

1. To display the Navigator panel, choose Window, Panels, Navigator.

Keyboard Shortcuts

Press Control+Cmd+0 (Mac) or Ctrl+Shift+0 (Win) to show or hide the Navigator panel quickly.

2. Select any photograph from the Library Content area or the Filmstrip.

3. At the top of the Navigator panel, click any of the following zoom buttons to display the image in Loupe view mode:

FIT—Click to fit the entire image in the Content area.

FILL—Click to fill the entire Content area with the image.

1:1—Click to view the image at 100% of its size in the Content area.

Custom View—Choose a zoom ratio from the Navigator panel flyout menu.

4. When displaying the photo in FILL, 1:1, or Custom View modes, click and drag the Navigator target icon to change the image area displayed in the Content area.

Cursor Power

Cursor position determines what photo is displayed in the Navigator. To preview a different image in the Navigator, hover the cursor over its thumbnail in the Filmstrip. You can also preview the first image in a folder or a collection by hovering the cursor over its name in the Folders panel or Collections panel.

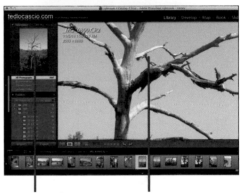

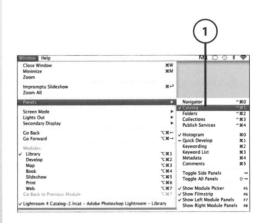

Dragging the Navigator target adjusts the view.

Catalog Panel

The Catalog panel enables you to control which catalog images are displayed in the Content area. You can choose to display every image in the catalog or choose to only display images that are part of a temporary collection.

1. To display the Catalog panel, choose Window, Panels, Catalog.

Keyboard Shortcuts

Press Control+Cmd+1 (Mac) or Ctrl+Shift+1 (Win) to show or hide the Catalog panel quickly.

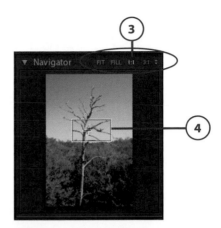

2. To view all the photographs in the current catalog, select All Photographs from the Catalog panel.

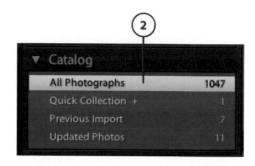

Select All First

To ensure accurate search results, be sure to select All Photographs from the Catalog panel before performing a filtered search.

3. As you work in Lightroom, various other items appear in the Catalog panel, including the following:

Current Import

Quick Collection

Previous Import

Already In Catalog

Previous Export as Catalog

Missing Files

Updated Photos

Select any of these items in the Catalog panel to display just those images in the Content area.

Quick Collection displayed in the Content area.

Folders Panel

The Folders panel displays your system's folder hierarchy for images that have been added to the current Lightroom catalog. If the images are stored in more than one volume, each disk is displayed with a separate volume header.

1. To display the Folders panel, choose Window, Panels, Folders.

Keyboard Shortcuts

Press Control+Cmd+2 (Mac) or
Ctrl+Shift+2 (Win) to show or hide
the Folders panel quickly.

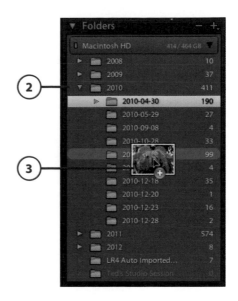

2. Click the toggle arrows to reveal
 your system's folder hierarchy and
 display each folder's contents.

3. Click and drag any image from
 the Content area to move it from
 one folder to another. You can
 also rearrange the hierarchy of
 folders by repositioning them in
 the Folders panel. Any changes
 made to the folder structure in
 Lightroom are reflected at the
 system level.

System Warning!

When applying the previous step,
a warning dialog box reminds you
that this change is reflected on
the system level.

4. To rename a folder, right/Control-
 click it in the Folders panel and
 choose Rename from the contex-
 tual menu. Enter the new name
 in the Rename Folder dialog box
 and click Save.

Folders Panel Language

The green light in the Folders
Panel header signifies that the
drive is connected and has stor-
age space available. The two num-
bers in the header indicate the
amount of free space available
versus the capacity of the drive.
Missing folders are displayed in
gray with a question mark icon.

>>Go Further

HOW DO I RELINK MISSING FOLDERS FROM THE FOLDERS PANEL?

Changes made to the folder structure at the system level cause the folders to appear as missing in the Lightroom Folders panel.

To relink missing folders in Lightroom, you must select them from the Folders panel, then right-click or Control-click (Mac) and choose Find Missing Folder from the contextual menu. In the Select New Location dialog box, browse to the folder's new system location and click Choose.

Library Toolbar

The Toolbar is located below the Content area and above the Filmstrip. You can use the Toolbar to access certain commands and apply them quickly. By clicking the various buttons displayed in the Toolbar, you can accomplish certain tasks, such as switching view modes, increasing or decreasing the amount of thumbnails displayed in Grid view, changing thumbnail sort order from ascending to descending (or vice versa), and much more.

Library Toolbar Display Options

1. To display the Library Toolbar, choose View, Show Toolbar.

Keyboard Shortcuts
Press T to show or hide the Library Toolbar quickly.

Customize the Toolbar
You can customize the Toolbar to display the button commands you apply most. Note also that you can create a different Library Toolbar setup for both Grid view and Loupe view modes.

2. Choose which tools you would like to display from the Library Toolbar flyout menu. In Grid View, these options include Painter, Sorting, Flagging, Rating, Color Label, Rotate, Navigate, Slideshow, Thumbnail Size, and Info.

 In Loupe view, these options include Sorting, Flagging, Rating, Color Label, Rotate, Navigate, Slideshow, Zoom, and Info.

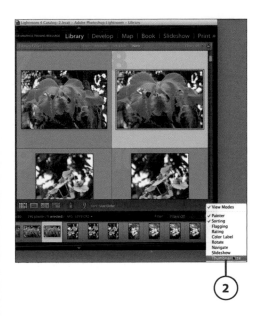

Easy Access

The Toolbar is also accessible in the other Lightroom modules. You can access the Toolbar with different options in the Develop, Map, Book, Slideshow, Print, and Web modules.

Filter Bar

The Filter Bar is located below the Module picker and above the Content area. It is hidden by default, but you can access it quickly by pressing the backward slash key (\). You can use the Filter Bar to search for photos by text (such as filename), attribute (such as rating or color label), or metadata stored in the file (such as shot date or camera type).

Perform a Detailed Image Search

1. To display the Filter Bar, choose View, Show Filter Bar.

2. Click the Text button to display the Text Filter options in the Filter Bar.

3. Click the Attribute button to display the Attribute Filter options in the Filter Bar.

4. Click the Metadata button to display the Metadata Filter options in the Filter Bar.

Keyboard Shortcuts

Shift-click the Text, Attribute, or Metadata buttons to show their respective options in the Filter Bar alongside all other visible options. Shift-click the buttons again to hide them.

Choosing View Options

In Grid view, you can choose to display the thumbnails, and any additional info and clickable markers, in compact (the default option) or expanded cells. Loupe view enables you to zoom and scroll around a single image in the Content area of the Library module. Each view mode contains its own set of options, which you can choose by clicking the Grid or Loupe view tab of the View Options dialog box.

Choose Grid View General Cell Options

1. Choose View, View Options.

Keyboard Shortcuts

Press Cmd+J (Mac) or Ctrl+J (Win) to display the Library View Options dialog box quickly.

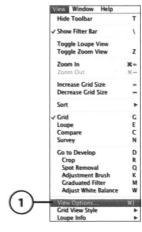

2. In the Library View Options dialog box, click the Grid View tab.

3. Enable Show Grid Extras.

4. Enable any of the following general Grid View options:

 Show Clickable Items on Mouse Over Only displays clickable items, such as Quick Collection markers and rotation buttons, only when mousing over a grid cell.

 Tint Grid Cells with Label Colors applies color labels to the image thumbnail border.

 Show Image Info Tooltips displays tooltips when mousing over items in a grid cell.

5. Choose which icons to display in the grid cell. Options include Flags, Thumbnail Badges, Quick Collection Markers, and Unsaved Metadata.

Choose Grid View Compact Cell Options

1. Choose View, View Options.

2. In the Library View Options dialog box, click the Grid View tab.

3. Enable Show Grid Extras.

4. Choose Compact Cells from the top drop-down list.

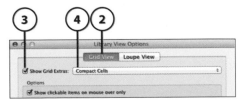

5. Enable any of the following Compact Cell Extra grid view options:

 Index Number displays a large dimmed number in the cell background.

 Top Label displays extra image info above the thumbnail. Choose which info to display from the drop-down list provided.

 Rotation displays clickable rotation icons in the bottom corners of the grid cell. You can use these icons to rotate the photo clockwise or counter-clockwise.

 Bottom Label displays extra image info below the thumbnail. Choose which info to display from the drop-down list provided.

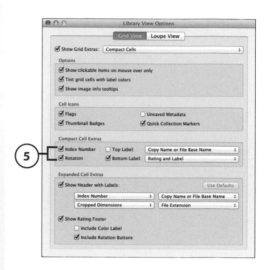

Choose Grid View Expanded Cell Options

1. Choose View, View Options.

2. In the Library View Options dialog box, click the Grid View tab.

3. Enable Show Grid Extras.

4. Choose Expanded Cells from the top drop-down list.

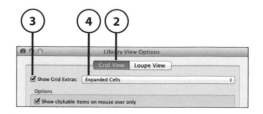

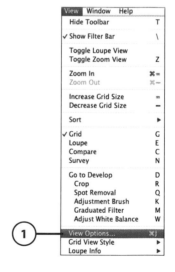

5. Enable any of the following Expanded Cell Extra grid view options:

Show Header with Labels displays extra image info in a header above the thumbnail. Choose which info to display from the four drop-down lists provided.

Show Rating Footer displays ratings in a footer area below the thumbnail. You can also choose to display color labels and rotation buttons in the footer. Note that all the footer options are clickable, enabling you to apply ratings and color labels, and rotate the photo clockwise or counter-clockwise.

Setting Loupe View Options

1. Choose View, View Options.

2. In the Library View Options dialog box, click the Loupe View tab.

3. Enable Show Info Overlay.

4. Choose which info to display for Loupe Info 1 and Loupe Info 2 from the drop-down lists provided.

Keyboard Shortcuts

Press Cmd+I (Mac) or Ctrl+I (Win) to show or hide the Info Overlay in Loupe View mode. Press I to toggle between Info 1 and Info 2.

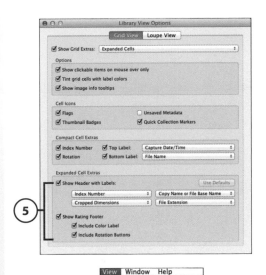

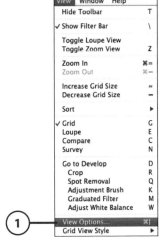

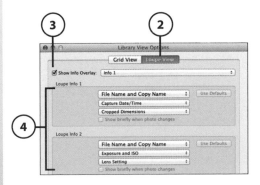

5. Choose to display either Info 1 or Info 2 from the top drop-down list.

The chosen info is displayed in the upper-left corner of the photo in Loupe view.

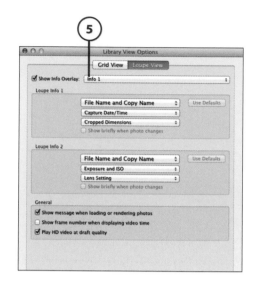

Show Briefly

If the Show Info Overlay option is disabled, you can enable the Show Briefly When Photo Changes option. Doing so displays the Info Overlay for just a few seconds in Loupe view.

Browsing and Selecting Photos in the Library Grid

In Grid view, you can scroll through catalog photos by clicking and dragging the scroll bar located to the right of the Content area. You can select an image by clicking its thumbnail in the grid, or select multiple adjacent images by Shift-clicking. To select multiple non-adjacent images, Cmd+click (Mac) or Ctrl+click (Win). The primary (or active) selection is always highlighted in a lighter shade of gray and is the image that appears in the Navigator panel.

Browse Photos in the Catalog

1. If you're not already in Grid view, choose Grid from the View menu or click the Grid View button in the Library Toolbar.

Keyboard Shortcuts

Press G to enter Grid View mode quickly.

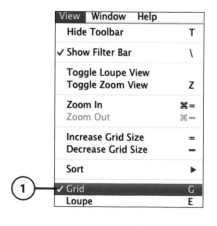

2. In the Toolbar, click and drag the Thumbnails slider to the right to increase the size of the thumbnails; click and drag to the left to decrease their size.

Keyboard Shortcuts

Press the plus (+) key to increase the cell size by one cell per row; press the minus (-) key to decrease by one cell per row.

3. Click any thumbnail in the grid to select it.

Keyboard Shortcuts

Shift+click to select multiple adjacent photos; Cmd+click (Mac) or Ctrl+click (Win) to select multiple non-adjacent photos.

4. Click the top, bottom, or side bar arrows to hide the side panels, Filmstrip, or Module Picker. Doing so expands the Content area and creates more room for the thumbnails.

Keyboard Shortcuts

Press Tab to show or hide the side panels; press Shift+Tab to show or hide the side panels, Filmstrip, and Module Picker all at once.

With both side panels, the Filmstrip, and the Module Picker hidden.

Browsing and Selecting with the Filmstrip

You can use the Filmstrip to locate and select images from the catalog in the same way that you can with the Grid. The benefit to using the Filmstrip is that it is accessible in all modules, not just the Library. The downside is that, unlike the Grid, you can't display as much info surrounding the thumbnails. However, there is a preference in the Interface tab of the Preferences dialog box that gives you the option to display ratings and picks in the Filmstrip.

Browse and Select Images in Any Module

1. If the Filmstrip is not already visible, choose Window, Panels, Show Filmstrip, or click the up arrow located at the bottom of the interface.

2. To resize the Filmstrip, click its top edge and drag it up or down.

3. The current file path is displayed at the top of the Filmstrip. To access a recent resource, choose one from the drop-down list provided.

4. Use the slider bar, or click the side arrows to scroll through the thumbnails manually.

Keyboard Shortcuts

Press Fn+F6 to show or hide the Filmstrip quickly. Use the left or right arrow keys to select the previous or next photo in the Filmstrip. As you press the arrow keys, hold down Shift to select multiple adjacent photos in the Filmstrip.

Navigating in Loupe View

In Loupe View mode, you can only view one image at a time in the Content area (when multiple images are selected in the grid or Filmstrip, the image displayed in Loupe view is the primary selection). However, you can select other images to view in Loupe view, without having to return to Grid view. By clicking the left and right arrow keys in Loupe view, you can display the previous or next photos in the catalog or in your current catalog selection.

Use Arrow Keys in Loupe View ▶

1. Click any thumbnail in the grid to select it.

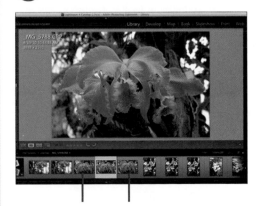

What Is a Target Image?

If you have multiple thumbnails selected, the primary selection (the image with the lightest shade of gray surrounding it) is the target image. This is also the photo that appears in the Navigator panel.

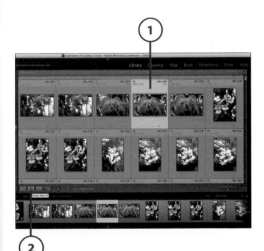

2. To open the primary selected photo in Loupe View mode, choose View, Loupe, or click the Loupe View button in the Library Toolbar. You can also double-click any thumbnail in the grid to open it in Loupe View mode.

The photo is displayed so that it either fits in the Content area or fills it, depending on which option you clicked last in the Navigator panel.

Click the left/right arrow keys to display the previous or next catalog images in Loupe View mode.

Use the left/right arrow keys to display the previous/next catalog images.

Selections and Loupe View

Note that if you have multiple thumbnails selected, you will only be able to display those images in Loupe View mode.

Changing Loupe Zoom Views

There are two different ways that you can view images in Loupe view: in standard Loupe view or close-up Loupe view. Entering standard Loupe view is the same as clicking either the FIT or FILL buttons in the Navigator panel; entering close-up Loupe view is the same as clicking either the 1:1 or custom magnification buttons.

Toggle Zoom Views ▶

1. Click any thumbnail in the grid to select it.

2. To open the primary selected photo in standard Loupe View mode, choose Loupe from the View menu, or click the Loupe View button in the Library Toolbar. You can also double-click any thumbnail in the grid to open it in standard Loupe View mode.

Keyboard Shortcuts

Press E to enter Loupe View mode quickly.

The photo is displayed so that it either fits in the Content area or fills it, depending on which option you clicked last in the Navigator panel.

3. To enter close-up Loupe view, choose View, Toggle Zoom View. Doing so zooms in to the photo at either 1:1 magnification or a custom view setting, depending on which option you clicked last in the Navigator panel.

Keyboard Shortcuts

Press Z to toggle zoom views quickly. You can also toggle zoom views quickly by clicking the image in the Content area.

Working in Compare View

In addition to Grid view and Loupe view, the Library module also contains a Compare view, which enables you to select two similiar images from the Grid or Filmstrip and view them side by side in the Content area. Doing so can help you decide which photo to work with in the Develop module or output in the Print module. In Compare view, the primary selection becomes the Select photo, and the secondary image becomes the Candidate. You can choose to sync the magnification levels and scroll locations for both photos, or unsync them and compare the photos using different view settings.

Compare Photos Side-by-Side

1. In Grid view or the Filmstrip, Shift+click to select two adjacent photos; Cmd+click (Mac) or Ctrl+click (Win) to select two non-adjacent photos.

2. To open the selected photos in Compare View mode, choose Compare from the View menu, or click the Compare View button in the Library Toolbar.

Keyboard Shortcuts

Press C to enter Compare View mode quickly.

Both photos are displayed so that they either fit in the Content area or fill it, depending on which option you clicked last in the Navigator panel. The primary selected photo is displayed to the left with a white border, and the Candidate photo to the right. The white border indicates which image is targeted.

Switch Image Focus

You can switch the focus to the Candidate photo by clicking it in the Content area. Doing so places the white border around the photo and enables you to work with it in the Navigator panel.

3. With the Link Focus option enabled, drag the Zoom slider to change the magnification level for both photos.

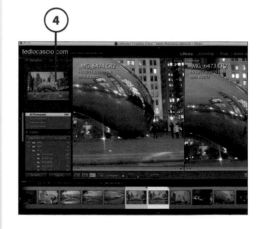

Disable Link Focus

With the Link Focus option disabled, you can view the photos at different magnification levels and scroll locations.

4. Click and drag over the targeted photo to scroll to a different area, or move the target icon in the Navigator panel.

5. Click the Swap button in the Library Toolbar to make the Candidate the Select photo and vice versa.

6. Click the Make Select button in the Library Toolbar to make the Candidate the Select photo and apply the next photo in the Filmstrip as the new Candidate.

Keyboard Shortcuts

You can use the up arrow key to apply the Make Select command, or he down arrow key to apply the Swap command.

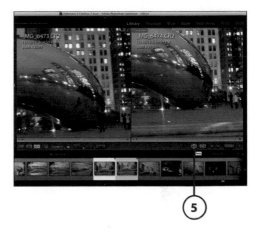

7. Click the left or right arrow buttons in the Library Toolbar to select the previous or next photo in the Filmstrip as the Candidate.

Keyboard Shortcuts

You can also use the left or right arrow keys to select the previous or next photo as the Candidate.

8. Click Done to display the primary selected photo in Loupe View.

Lightroom indicates which photo is the Select photo and which is the Candidate by displaying icons in the Filmstrip. A hollow diamond appears in the upper-right corner of the Select photo's Filmstrip thumbnail. A filled-in diamond appears in the upper-right corner of the Candidate photo's thumbnail.

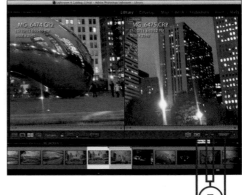

Working in Survey View

Survey view is similar to Compare view in that it enables you to select and preview more than one image at a time. However, in Compare view, you can only select two images from the Grid or Filmstrip and view them in the Content area, whereas in Survey view, you can select and preview an entire series of images. You can access clickable markers by hovering your mouse over an image in Survey view. This is a great way to apply ratings, labels, or flags to a related series of photos in Lightroom.

Preview Multiple Selected Photos ▶

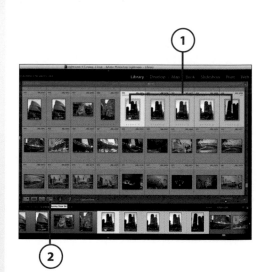

1. In Grid view or the Filmstrip, Shift+click to select multiple adjacent photos; Cmd+click (Mac) or Ctrl+click (Win) to select multiple non adjacent photos.

2. To open the selected photos in Survey View mode, choose Survey from the View menu, or click the Survey View button in the Library Toolbar.

Keyboard Shortcuts
Press N to enter Survey View mode quickly.

The photos are displayed as large as possible in the Content area. The primary selected photo is displayed with a white border.

Change Primary Selection

You can change your primary selection by clicking a different photo in the Content area, or by clicking the left/right arrow keys or buttons in the Library Toolbar. Doing so places the white border around the photo and enables you to work with it in the Navigator panel.

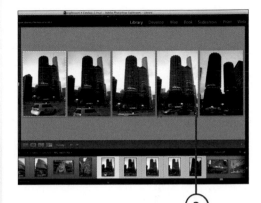

3. When you hover over an image in the Content area, a white X appears in the lower-right corner of the thumbnail. Click the X to remove the image from the current selection and from Survey view.

The thumbnails automatically resize to fill the extra space in the Content area.

Learn to group
photos into stacks.

Learn to flag reject
images without
removing them.

Learn to apply color
labels to photos.

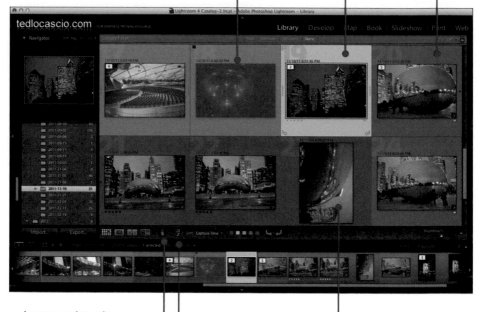

Learn to paint ratings,
labels, and flags with
the Painter tool.

Learn to rotate
images in either
direction.

Learn to sort images
and change sort
direction.

In this chapter, you learn how to organize catalog photos in the Library module.

→ Rotating Images
→ Flipping Images
→ Rating Images
→ Flagging Images
→ Rejecting Images
→ Applying Color Labels
→ Creating a Custom Color Label Set
→ Organizing with the Painter Tool
→ Sorting Images
→ Working with Stacks
→ Removing Photos
→ Deleting Photos

Organizing Images in the Library

The key to good photo asset management is to maintain a well-organized photo catalog. This can prove to be a daunting task when you are managing thousands of photos at a time. Thankfully, Lightroom includes several organizational features that can help you manage large photo libraries with ease.

In this chapter, you learn how to rotate and flip photos so that they appear the way you like in the Library Content area. You also learn how to apply searchable attributes, such as star ratings, pick or reject flags, and custom color labels.

This chapter also explains how to control the sort order for the thumbnails in the Content area and Filmstrip. You learn the various ways you can sort images, as well as how to change their sort direction from ascending to descending and vice versa.

Lastly, you learn how to conserve room in the Content area by stacking related photos into groups, and how to conserve room in the catalog by removing unusable photos.

Rotating Images

If you take your photos using a digital camera that embeds camera orientation metadata (portrait or landscape), then Lightroom automatically rotates the image thumbnails in the Library Content area accordingly. If not, then you can click the Rotate buttons or apply the Rotate Left (CCW) or Rotate Right (CW) commands.

Rotate Clockwise or Counterclockwise

1. In Grid view of the Library module, select any image thumbnail (or multiple image thumbnails) that you'd like to rotate.

Keyboard Shortcuts

Shift+click to select multiple adjacent photos; Cmd+click (Mac) or Ctrl+click (Win) to select multiple non-adjacent photos.

2. Cick the Rotate buttons in the Library Toolbar or choose Photo, Rotate Left (CCW) or Rotate Right (CW).

Show Rotate Buttons

Choose Rotate from the Toolbar fly-out menu (on the far right of the Toolbar) to display the Rotate buttons.

The selected thumbnail(s) appear rotated in the Content area and Filmstrip.

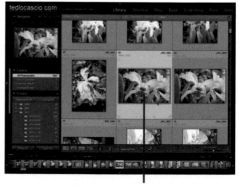

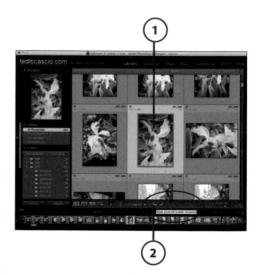

Lightroom rotates the image counterclockwise.

ROTATE IMAGES WITH THE CONTEXTUAL MENU COMMANDS

You can also rotate images that are selected in the Library Grid or Filmstrip. To access the contextual menu, Control+click (Mac) or right-click on the selected thumbnail(s) in the Content Grid or Filmstrip. You can then choose Rotate Left (CCW) or Rotate Right (CW) to rotate the selected image(s).

Flipping Images

In addition to rotating images in the Library, you can also flip them in the opposite horizontal or vertical direction from the way they were originally shot. Doing so can sometimes improve an image's composition, as long as it's not too obvious that the photo has been flipped.

Flip Images to Face the Opposite Direction

1. Select any image thumbnail (or multiple image thumbnails) from the Grid or Filmstrip.

2. Choose Photo, Flip Horizontal or Flip Vertical.

The selected photo(s) appear flipped in the Content area and Filmstrip.

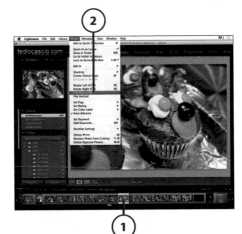

Lightroom flips the image horizontally.

Rating Images

One excellent way to organize your catalog images is to categorize them by rating. Lightroom enables you to apply ratings from zero to five stars. After you apply them, you can then use the Filter bar or Filmstrip filter controls to search for specific catalog images based on their ratings. Ratings are stored in an image's metadata and are accessible in other applications, such as Adobe Bridge.

Apply Star Ratings to Your Catalog Images

1. Select any image thumbnail (or multiple image thumbnails) from the Grid or Filmstrip.

2. Choose Photo, Set Rating and then select a star rating from the flyout submenu. You can also Control+click (Mac) or right-click and choose one from the contextual menu.

Toolbar Star Icons
If you've chosen to display them, you can also apply a rating by clicking one of the star icons in the Toolbar.

Keyboard Shortcuts
Press the keyboard numbers 0 through 5 to assign a specific numbered rating quickly. Press the right bracket key to increase the rating; press the left bracket key to decrease it.

Lightroom applies the rating to the image.

If the Show Grid Extras view option is enabled, Lightroom displays the rating in the grid cell.

APPLY IMAGE RATINGS IN THE LIBRARY THUMBNAIL GRID CELL

You can also apply a rating to an image by clicking in its grid cell in the llbrary Grid. When the Show Grid Extras view option is enabled, and click-able options are made visible, you can click on the star ratings in the grid cell to apply them.

When using this method, it is not necessary to select a cell prior to apply-ing the rating.

Flagging Images

Another way to label your best images as top picks from a photoshoot is to mark them as flagged. When you flag an image, and the Show Grid Extras view option is enabled, a flag icon is displayed in the upper-left corner of the grid cell. You can then apply a filtered search for all flagged images and dis-play just those photos in the Content area.

Mark Catalog Images as Flagged

1. Select any image thumbnail (or multiple image thumbnails) from the Grid or Filmstrip.

2. Choose Photo, Set Flag and then select Flagged or Unflagged from the fly-out submenu. You can also Control+click (Mac) or right-click and select either option from the contextual menu.

Toolbar Flag Icons

If you've chosen to display it, you can also flag or unflag an image by clicking the flag icon in the Toolbar.

Keyboard Shortcuts

Press P to mark an image as Flagged. Press U to mark an image as Unflagged. Press the ` (left apostrophe) key to toggle flag status. Press Cmd+Up arrow (Mac) or Ctrl+Up arrow (Win) to increase flag status. Press Cmd+Down arrow (Mac) or Ctrl+Down arrow (Win) to decrease flag status.

If the Show Grid Extras view option is enabled, Lightroom displays the flag in the respective grid cells.

Lightroom flags the selected images.

Rejecting Images

In addition to marking your top image picks as flagged, you can also mark all your out-of-focus or generally unusable photos as rejects. You should consider adopting this method as an alternative to deleting those images that you consider unusable. You never know when a photo that might not be suitable for one project could wind up being useful for another.

Mark Catalog Photos as Rejected

1. Select any image thumbnail(s) from the Grid or Filmstrip.

2. Choose Photo, Set Flag and select Rejected from the fly-out submenu. You can also Control+click (Mac) or right-click and select it from the contextual menu.

Toolbar Reject Icon

You can also reject an image by clicking the reject icon in the Toolbar or by pressing X.

Applying Color Labels

With color labels, you have the freedom to associate whatever interpretations you like to each color. For example, you may assign a red color label to mean "reject" or a green label to mean "good to print." You can save these interpretations in a Color Label Set. Note that all applied color labels are specific to the color label set that is currently chosen. If you use Lightroom with Bridge, be sure to assign the same interpretations to the colors in both applications. Doing so ensures that there will be no color label metadata conflicts.

Categorize Images with Color Labels

1. Choose Color Label Set from the Metadata menu and select one of the three default sets: Bridge Default, Lightroom Default, or Review Status.

2. Select any image thumbnail (or multiple image thumbnails) from the Grid or Filmstrip.

3. Choose Photo, Set Color Label and then select a color from the fly-out submenu. You can also Control+click (Mac) or right-click and select one from the contextual menu.

Keyboard Shortcuts

Press the keyboard numbers 6 through 9 to assign a color label quickly: red (6), yellow (7), green (8), and blue (9). There is no keyboard shortcut for purple.

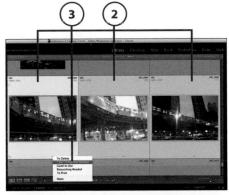

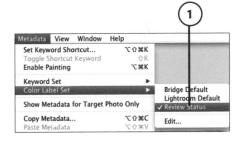

Lightroom applies the color label to the images.

Creating a Custom Color Label Set

Lightroom includes three default Color Label Sets: Bridge Default, Lightroom Default, and Review Status. However, you are not limited to working with just these three presets. You can edit them and save as many custom color label-presets of your own as you like.

Edit and Save a Color Label Set

1. Choose Color Label Set from the Metadata menu and select Edit.

2. Choose a Color Label Set from the Preset drop-down list.

3. Enter new text in the respective color fields.

4. From the Preset menu, choose Save Current Settings as New Preset.

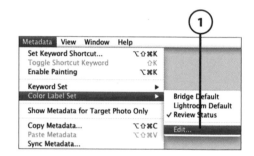

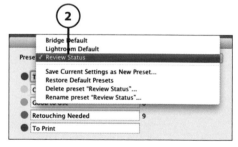

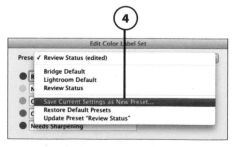

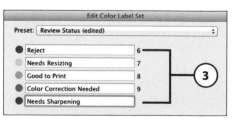

5. Enter a name for the preset and click Create.

Lightroom adds the new set to the Color Label Set Preset list.

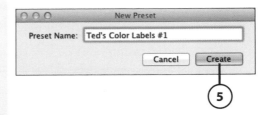

Organizing with the Painter Tool

The Painter tool enables you to apply the same attributes to multiple images in Grid View quickly, without having to select them first. You can use the Painter tool as an alternative to working with clickable grid cell items to apply ratings, flags, and color labels. The Painter tool also remembers your last settings, so you can quickly apply them to other thumbnails the next time you select the tool.

Paint Ratings, Flags, and Labels ▶

1. You must be in Grid view to access the Painter tool. Choose Metadata, Enable Painting. Or if you've chosen to display the Painter icon in the Toolbar, you can click it to access the tool.

Keyboard Shortcuts
Press Option+Cmd+K (Mac) or Alt+Ctrl+K (Win) to enable or disable the Painter tool quickly.

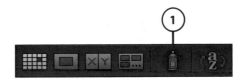

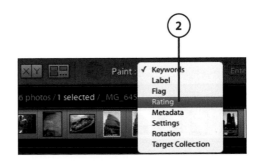

2. Choose Rating, Flag, or Label from the Paint drop-down list.

Watch Where You Click!
Click directly on the thumbnail (not the grid cell) to apply attributes with the Painter tool.

3. When you choose Rating or Label, the star rating and color label options appear next to the drop-down list. Select a star rating or a color label before painting with the tool.

When choosing Flag, you must choose an option from the drop-down list that appears. Options include Flagged (the default), Unflagged, or Rejected.

4. Hover over any thumbnail in the Grid and click with the Painter tool to apply the chosen rating, color label, or a flag.

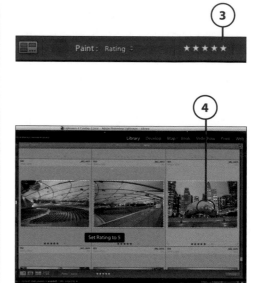

Sorting Images

Lightroom enables you to control how the image thumbnails are sorted in the Library Content area and the Filmstrip. The most common way to sort is by Capture Time, but you can also sort by Added Order, or Edit Time, or by applied attributes such as Rating, Pick (flag), and Label Color or Label Text. You can change the way the thumbnails are sorted at any time.

Choose a Content Sorting Option

1. Under the View menu, choose a sort option from the Sort sub-menu. Or if you've chosen to display the Sort tools in the Toolbar, you can choose an option from the Sort drop-down list.

Lightrom displays the image thumbnails accordingly in the Content area and Filmstrip.

In the example shown here, the images are sorted by capture time.

Capture time in the upper left of each cell.

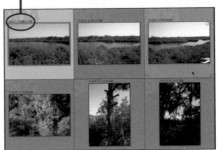

SORTING IMAGE THUMBNAILS MANUALLY

>Go Further

You can sort thumbnails manually when viewing a group of photos that have been saved in a collection or folder. To reposition them manually, simply click and drag them to a new spot in the Grid or Filmstrip.

Note that Lightroom does not allow you to sort thumbnails manually when viewing all photographs in a catalog.

Change Sort Direction

After you choose how you would like to sort the thumbnails in the Content area and Filmstrip, you can also choose whether to display them in ascending or descending order.

1. Under the View menu, choose ascending or descending from the Sort submenu. Or if you've chosen to display the Sort tools in the Toolbar, you can click the Sort Direction icon.

The image thumbnails are displayed accordingly in the Content area and Filmstrip.

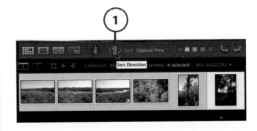

Lightroom reverses the sort direction.

Working with Stacks

Lightroom's Stacking feature enables you to group related photos into a condensed stack in the Library Grid. By grouping images into stacks, you can save room in the Content area and ultimately spend a lot less time scrolling through thumbnails to find a specific image you'd like to work with. Note that grouping images into stacks only affects the way the thumbnails are displayed in the Grid. It does not change the location of the files on your system.

Group Related Photos into a Virtual Stack

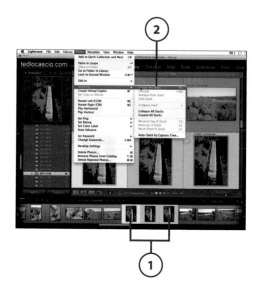

1. Select any image thumbnail (or multiple image thumbnails) from the Grid or Filmstrip.

Keyboard Shortcuts
Shift+click to select multiple adjacent photos; Cmd+click (Mac) or Ctrl+click (Win) to select multiple non-adjacent photos.

2. Choose Photo, Stacking, Group into Stack. You can also Control+click (Mac) or right-click and select Stacking, Group into Stack from the contextual menu.

 Lightroom creates the group. The number of images in the stack is displayed in the upper-left corner of the topmost thumbnail.

3. To expand the stack, click the left or right edge of the topmost thumbnail, or choose Photo, Stacking, Expand Stack. You can also Control+click (Mac) or right-click and select Stacking, Expand Stack from the contextual menu.

Keyboard Shortcuts
Press Cmd+G (Mac) or Ctrl+G (Win) to create a stack quickly. Press S to expand or collapse a stack quickly.

Promote a Photo to the Top of the Stack

By default, when you create a stack, the first image selected is automatically positioned at the top. However, you can choose a different image from within the stack to represent the group at any time.

1. Select the stack from the Grid.

2. Click the left or right edge of the topmost thumbnail, or choose Photo, Stacking, Expand Stack. You can also Control+click (Mac) or right-click and select Stacking, Expand Stack from the contextual menu.

3. Select the image in the stack to promote to the top.

4. Choose Photo, Stacking, Move to Top of Stack. You can also Control+click (Mac) or right-click and select Stacking, Move to Top of Stack from the contextual menu.

The image thumbnail is displayed at the top of the stack and remains visible even when the stack is collapsed.

Lightroom expands the stack.

Remove Photos from a Stack

Lightroom also enables you to remove a grouped image (or several grouped images) from a stack. When you do, Lightroom places the image thumbnails outside the group and back in the main Library Grid.

1. Select the stack from the Grid.

2. Click the left or right edge of the topmost thumbnail, or choose Photo, Stacking, Expand Stack. You can also Control+click (Mac) or right-click and select Stacking, Expand Stack from the contextual menu.

Keyboard Shortcuts

Press S to expand or collapse a stack quickly.

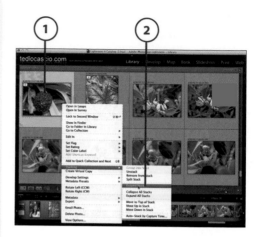

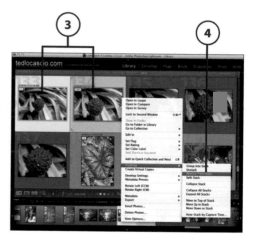

3. Select the image(s) in the stack to remove.

4. Choose Photo, Stacking, Remove from Stack. You can also Control+click (Mac) or right-click and select Stacking, Remove from Stack from the contextual menu.

The image thumbnail is removed from the stack and placed outside the group in the Library Grid.

Unstack Photos

In Lightroom, image stacks are extremely flexible and are never permanent. You can release a stacked group of images at any time.

1. Select the stack from the Library Grid. It does not matter if it is expanded or collapsed.

2. Choose Photo, Stacking, Unstack. You can also Control+click (Mac) or right-click and select Stacking, Unstack from the contextual menu.

Keyboard Shortcuts

Press Shift+Cmd+G (Mac) or Shift+Ctrl+G (Win) to unstack quickly.

The stack is released and the image thumbnails are no longer grouped together.

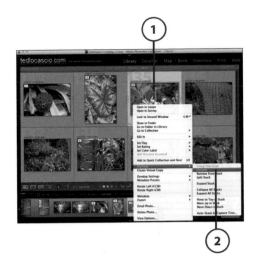

Lightroom releases the stacked group of photos.

Removing Photos

Not every photo is perfect. To avoid cluttering up your catalog with unusable images, it is possible to remove them from the database. However, you should consider keeping copies of these photos on your computer's hard disk, just in case you find another use for them down the road.

Remove an Image from the Catalog

1. From the Grid or Filmstrip, select the image thumbnail(s) for the photo(s) you want to remove from the catalog.

2. Choose Photo, Remove Photo from Catalog. Note that this command is not available via the contextual menu.

Lightroom removes the image(s) from the catalog; however, the original file still remains on your computer's hard disk.

Deleting Photos

Although it's always a good idea to keep copies of all your images (both good and bad) stored somewhere, you can still delete them from both the catalog and hard disk at the same time. However, just as a safeguard, Lightroom places these photos in your system's Trash (Mac) or Recycle Bin (Win) without emptying it.

Delete from the Catalog and Hard Disk

1. From the Grid or Filmstrip, select the image thumbnail(s) for the photo(s) you want to delete.

2. Choose Photo, Delete Photo, or press the Delete key. You can also Control+click (Mac) or right-click the thumbnail and select Delete Photo from the contextual menu.

3. Click Delete from Disk.

Bypass the Warning

To bypass the warning dialog box, choose Photo, Remove Photos from Catalog or press Option+Delete (Mac) or Alt+Delete (Win).

Lightroom removes the image(s) from the catalog and places it in the system's Trash (Mac) or Recycle Bin (Win). Note that the image is not officially deleted from the hard disk until you manually empty the Trash/Recycle Bin.

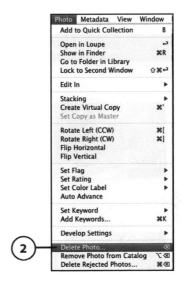

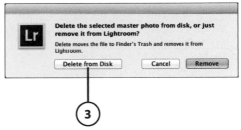

Learn to apply metadata
and keywords to
multiple images at once.

Learn to apply
keywords to photos.

Learn to apply keywords
with the Painter tool.

Learn to create
and apply metadata presets.

In this chapter, you learn how to apply and edit metadata and keywords to catalog images.

→ Working with Metadata
→ Working with Keywords

4

Working with Metadata and Keywords

Every photo captured with a digital camera contains information embedded within the file. This information, referred to as "metadata," includes specifics about the camera and the settings used to take the shot. Metadata also includes other useful information, such as capture time, file size, format, dimensions, and image resolution.

Keywords are descriptive tags stored in the metadata of your photos. The benefit to applying keywords is that you can later perform a filtered keyword search to locate specific images in your catalog. There's no better way to keep your catalog organized.

In this chapter, you learn how to add custom metadata and utilize metadata presets. You also learn how to organize and apply your keywords by hierarchy and utilize Lightroom's Keyword Set and Keyword Suggestions features.

Working with Metadata

In addition to the basic metadata info embedded in the photos by your camera, you can also add information in Lightroom, such as photographer copyright and contact info, captions and titles, and scene location. Any ratings and color labels that you apply are also stored in the file's metadata.

Change Metadata Panel View Modes

The Metadata panel view modes enable you to access the metadata you need without taking up a lot of room onscreen.

1. Choose Window, Panels, Metadata to display the Metadata panel.

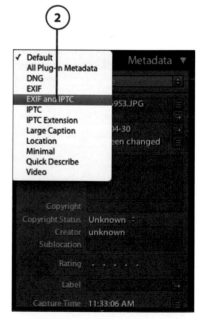

Keyboard Shortcuts
Press Cmd+4 (Mac) or Ctrl+4 (Win) to display the Metadata panel quickly.

2. Select a view mode from the Metadata panel drop-down list.

 The Metadata panel view changes to display the chosen view mode.

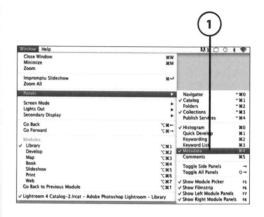

Quick Links
Certain Metadata panel items contain action arrow buttons that serve as quick links. For example, if you click the Folder button, Lightroom opens the Folders panel and highlights the folder in which the selected photo is stored on your system.

Add Custom Metadata

The Metadata panel not only displays the information embedded in a file by the camera, it also enables you to add your own metadata.

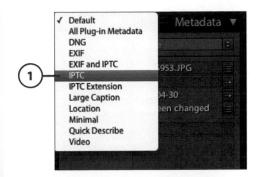

1. Select IPTC from the Metadata panel drop-down list.

2. Click in any of the editable fields of the Metadata panel to enter your own image-specific information.

 Lightroom embeds the added information in the catalog database.

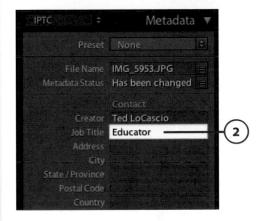

EDIT A SELECTED PHOTO'S FILENAME USING THE METADATA PANEL

>>>Go Further

You can also edit a selected photo's filename using the Metadata panel. But keep in mind that Lightroom is not set up like Adobe Bridge (the browser application that comes with the Creative Suite). Lightroom does not enable you to click on a photo's filename in the Content area (when made visible in View Options) and type in something else. Instead, you must type the new name in the File Name field of the Metadata panel. Note that this can be done in any Metadata panel view mode.

Edit and Save a Metadata Preset

Certain metadata, such as copyright and contact info, should be applied to every image in your catalog. Rather than entering the same info repeatedly to every image, try saving it as a metadata preset.

1. Choose Edit Metadata Presets from the Metadata menu or Edit Presets from the Metadata panel Preset list.

2. In the Edit Metadata Presets dialog box, enter new image-specific information in the fields available.

3. Check only the boxes for the items you would like to include in the Metadata preset. In most cases, items such as Caption, Label, Rating, and Title are specific to each individual photo; therefore, you might not want to save them as part of a preset. Blank fields that are checked will also be saved as part of a preset.

Avoid Overwriting Fields

Always remember that all checked items saved in a metadata preset overwrite the existing info when applying the preset to an image. If you do not want a specific field, such as Keywords, to appear blank after applying the preset, do not check the blank Keywords field in the Edit Metadata Presets dialog box.

4. Click Done.

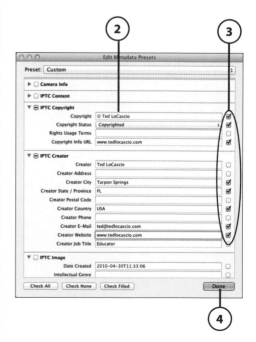

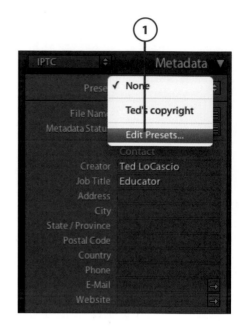

5. In the dialog box that appears, click Save As.

6. In the New Preset dialog box that appears, enter a name in the field and click Create.

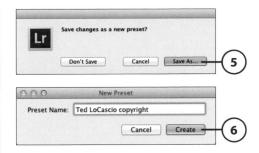

Delete a Custom Metadata Preset

To remove a custom metadata preset from Lightroom, you must select it from the Preset list in the Edit Metadata Prests dialog box and choose the Delete Preset command.

1. Choose Edit Metadata Presets from the Metadata menu or Edit Presets from the Metadata panel Presets list.

2. Select the custom preset from the Presets list.

3. Choose Delete Preset from the Presets list.

 Lightroom displays a warning dialog box reminding you that ths operation cannot be undone.

4. Click the Delete button.

 Lightroom removes the custom metadata preset from the Presets list.

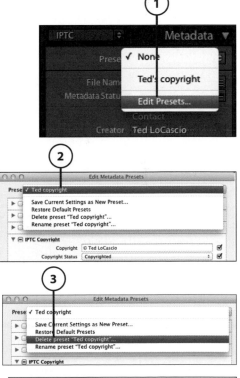

Edit Metadata for Multiple Images

You can also apply the same metadata info to multiple images at once by selecting them and entering new info in the Metadata panel.

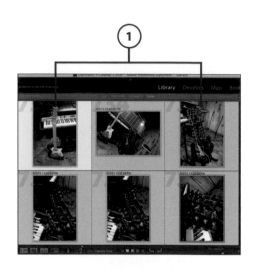

1. Select the image thumbnails in Grid view of the Library module.

Keyboard Shortcuts

Shift+click to select multiple adjacent photos; Cmd+click (Mac) or Ctrl+click (Win) to select multiple non-adjacent photos.

2. Enter new image-specific information in the editable fields of the Metadata panel.

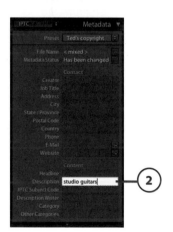

Target Photo Metadata

When the Show Metadata for Target Photo Only command is selected, the Metadata panel displays only info for the target photo.

3. In the warning dialog box that appears, click Apply to Selected.

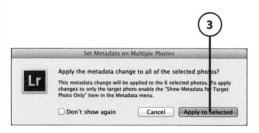

Mixed Metadata

Note that when multiple images are selected and they contain different metadata, Lightroom displays <mixed> in the corresponding Metadata panel fields.

Save Metadata to XMP

In addition to what is stored in the catalog file, Lightroom also gives you the option to write metadata info to the internal XMP space for JPEG, TIFF, PSD, and DNG files, and to XMP side-car files for proprietary raw images. Doing so ensures that all the meta-data is recognized when opening your images in other applications, such as Bridge and Camera Raw.

1. Under the Lightroom menu (Mac) or the Edit menu (Win), choose Catalog Settings.

Keyboard Shortcuts

Press Cmd+Option+comma (Mac) or Ctrl+Alt+comma (Win) to dis-play the Catalog Settings dialog box quickly.

2. Click the Metadata tab in the Catalog Settings dialog box.

Keyboard Shortcuts

You can also use the left and right arrow keys to quickly toggle between tabs in any dialog box.

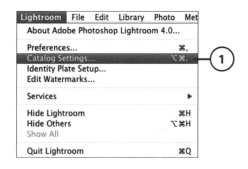

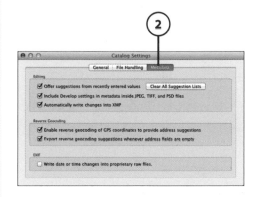

It's Not All Good

When you choose to include Lightroom develop settings in the XMP meta-data for JPEG, TIFF, and PSD files, any attempts to open these images in Photoshop result in them opening in Camera Raw. This happens even if the Camera Raw preference for opening JPEGs and TIFFs is disabled.

3. Enable the Automatically Write Changes into XMP option.

4. To write Lightroom Develop module and Quick Develop settings to the XMP for all JPEG, TIFF, and PSD files, enable the Include Develop Settings in Metadata inside JPEG, TIFF, and PSD files option.

5. Close the Catalog Settings dialog box.

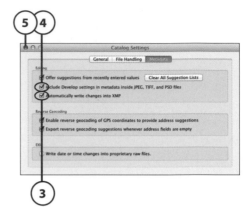

Synchronize Metadata Settings ▶

If you have all the metadata info that you'd like to share already applied to a particular photo, then you can use the syncing feature to apply these settings to other photos in a selection.

1. Select the images in Grid view of the Library module. Note that Lightroom synchronizes the metadata with the settings currently applied to the target photo.

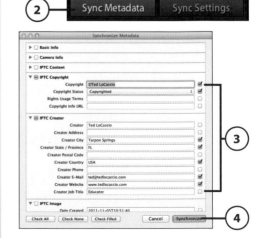

2. Choose Sync Metadata from the Metadata menu, or click the Sync Metadata button located in the lower-right corner of the Lightroom interface.

3. In the Synchronize Metadata dialog box, check the metadata items to synchronize with the target photo in your selection.

4. Click Synchronize.

 Lightroom synchronizes the specified metadata info.

Edit Capture Time

When you forget to set the date and time correctly in your camera, the capture time embedded in the metadata of all your photos appears incorrect. Thankfully, you can fix this problem in Lightroom.

1. Select the image(s) in Grid view of the Library module.

2. Choose Edit Capture Time from the Metadata menu, or click the Edit Capture Time button located next to the Capture Time field in the Metadata panel.

Only in Default View

The Edit Capture Time button appears only when displaying the Default View mode in the Metadata panel.

3. Choose an option from the Edit Capture Time dialog box.

 Adjust to a Specified Date and Time enables you to enter an entirely new date and time in the Corrected Time field.

 Shift by Set Number of Hours (Time Zone Adjust) enables you to correct the capture date time zone. Select the number of hours to add or subtract from the list provided.

 Change to File's Creation Date automatically changes the capture date to match the file's creation date.

4. Click the Change All button.

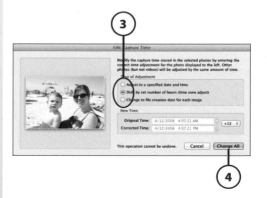

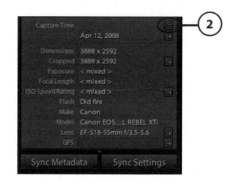

Working with Keywords

The best way to keep your catalog organized is to tag your images with keywords. When you add keywords to an image, you can later perform a filtered keyword search to locate the image quickly. Keywords can be added when you import your photos into a catalog, or after you import them via the Keywording and Keyword List panels. You can also apply keywords using the Painter tool.

Add Keywords with the Keywording Panel ▶

1. Choose Window, Panels, Keywording to display the Keywording panel.

2. Select the image(s) in Grid view of the Library module.

3. Enter the keywords in the top field of the Keywording panel, separated by commas. Lightroom displays any keywords already applied to the photo in the central field of the panel.

 Note that the keywords you type into the Keywording panel are not added to the selected photos until you press Return (Mac) or Enter (Win).

Keyword Hierarchies

Keyword hierarchies enable you to store groups of related keywords inside larger keyword categories. To create a keyword hierarchy, include a greater than (>) character between keywords.

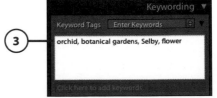

Add Keywords to the Keyword List Panel

1. Choose Window, Panels, Keyword List to display the Keyword List panel.

2. Click the Create New Keyword Tag (+) button in the Keyword List Panel.

3. In the Create Keyword Name dialog box that appears, enter the keyword into the Keyword Tag field.

4. Enter related words in the Synonyms field separated by commas in order to search for a keyword by association. Adding synonyms instead of adding multiple related keywords prevents you from cluttering up the keyword list.

5. Choose any of the following dialog box options.

 Include on Export includes the keyword when exporting any photos that are tagged with it.

 If the keyword is part of a hierarchy, enabling Export Containing Keywords includes all higher-level keyword tags when exporting any photos tagged with it.

 Export Synonyms includes synonyms when exporting any photos tagged with the keyword.

 Add to Selected Photos applies the keyword to the photo(s) you currently have selected in the Content area or Filmstrip.

6. Click the Create button.

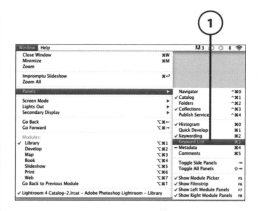

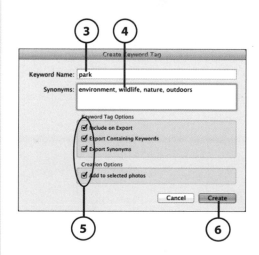

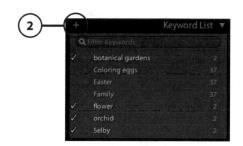

Add Keywords by Dragging

1. Choose Window, Panels, Keyword List to display the Keyword List panel.

Keyboard Shortcuts

Press Cmd+3 (Mac) or Ctrl+3 (Win) to display the Keywording panel quickly.

2. Select the image(s) in Grid view of the Library module.

3. Drag the selected thumbnail(s) over the keyword in the Keyword List panel, or drag the keyword over the selected photo(s) in the Content area.

 Lightroom adds the keyword to the selected photos.

Keyword Search

You can perform a filtered keyword search in the Keyword List panel. To do so, type the name of the keyword in the Filter Keywords field located at the top of the Keyword List panel. When you do, Lightroom filters the list to display just those keywords.

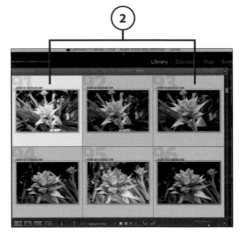

APPLY AND REMOVE KEYWORDS FROM THE KEYWORD LIST PANEL

You can also apply and remove a keyword by clicking the check box next to its name in the Keyword List panel. In Grid view, select the image(s) that you'd like to apply keywords to. Click the check box that appears as you hover your mouse over the keyword name in the Keyword List panel. Doing so applies it to your selection. Click it again to remove the keyword from the selected photos.

Add Keywords with the Painter Tool

1. If it's not already visible, choose Show Toolbar from the View menu.

Keyboard Shortcuts
Press T to display the Library Toolbar quickly.

2. To display the Painter tool icon in the Library toolbar, choose Painter from the Library Toolbar drop-down list.

3. Click the Painter tool icon in the Library toolbar.

4. Choose Keywords from the Paint drop-down list.

5. Enter the keywords in the Library Toolbar field.

6. To tag the image(s), click directly on the thumbnail for each one (not the surrounding cell areas). Note that you do not have to select the image(s) prior to paint-ing with the Painter tool.

7. When you finish applying key-words with the Painter tool, click the Done button in the Library Toolbar.

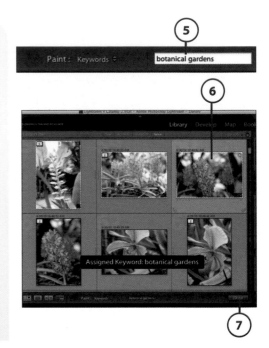

APPLY METADATA PRESETS WITH THE PAINTER TOOL

>Go Further

To apply metadata presets with the Painter tool, choose Metadata from the Toolbar Paint list; then choose the preset from the Toolbar Preset list. Click directly on the thumbnail (not the surrounding cell areas) of the image(s) to apply the preset.

Add Keywords During Image Import ▶

1. With your camera or card reader plugged into your computer, choose File, Import Photos and Video, or click the Import button in the lower-left corner of the Library module interface.

2. After choosing the necessary import options from the import dialog box (see Chapter 1, "Getting Started with Lightroom 4," to learn more about importing photos into a catalog), enter keywords in the Keywords field. Separate each keyword with a comma.

3. Click the Import button.

Remove Keywords via the Keyword List Panel

1. Choose Window, Panels, Keyword List to display the Keyword List panel.

Keyboard Shortcut

Press Cmd+3 (Mac) or Ctrl+3 (Win) to display the Keywording panel quickly.

2. Select a keyword and click the Delete selected keyword tag (–) button in the Keyword List panel, Control+click (Mac) or right-click on the keyword in the Keyword list panel, and choose Delete from the contextual menu.

Lightroom removes the keyword from the catalog database and from any photos tagged with it.

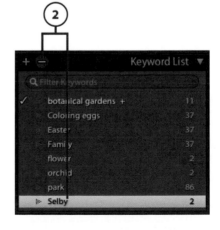

Remove Keywords via the Contextual Menu

To remove a keyword from a photo, but not from the Keyword List panel, you must choose Remove This Keyword from Selected Photo from the contextual menu.

1. Choose Window, Panels, Keyword List to display the Keyword List panel.

2. In Grid view of the Library module, select any image thumbnail or multiple image thumbnails.

3. Control+click (Mac) or right-click on the keyword in the Keyword list panel, and choose Remove This Keyword from Selected Photo from the contextual menu.

 Lightroom removes the keyword from the selected photo(s).

Updating Metadata

If the Automatically Write Changes into XMP option (in Catalog Settings) is not enabled when you remove a keyword, then the image's XMP metadata needs to be updated. To view unsaved metadata warnings in grid cells, enable the Unsaved Metadata preference in View Options. To update a photo's metadata, click the unsaved metadata cell icon or choose Metadata, Save Metadata to Files.

>Go Further

CREATING KEYWORD HIERARCHIES VIA THE CONTEXTUAL MENU

You can also create a keyword hierarchy using a contextual menu command. To do so, Control+click (Mac) or right-click on any existing keyword in the Keyword List panel and choose Create Keyword Tag Inside "selected keyword" from the contextual menu.

Create a Keyword Set

Lightroom enables you to edit and save groups of commonly used keywords into keyword sets.

1. Choose Window, Panels, Keywording to display the Keywording panel.

Keyboard Shortcuts
Press Cmd+2 (Mac) or Ctrl+2 (Win) to display the Keywording panel quickly.

2. Click the foldout triangle to reveal the Keyword Set portion of the Keywording panel.

3. Choose Edit Set from the Keyword Set drop-down list.

4. In the Edit Keyword Set dialog box, use the fields provided to enter the keywords. Lightroom allows for a minimum of one and a maximum of nine in a set.

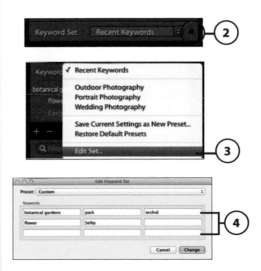

5. Choose Save Current Settings as New Preset from the Preset drop-down list.

6. In the New Preset dialog box, enter a name in the Preset Name field.

7. Click Create.

8. Click Change in the Edit Keyword Set dialog box.

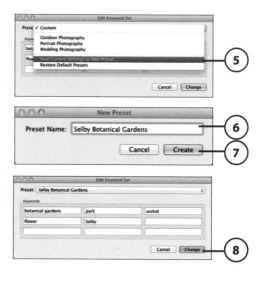

Apply Keywords with Keyword Sets

1. Choose Window, Panels, Keywording to display the Keywording panel.

2. Click the foldout triangle to reveal the Keyword Set portion of the Keywording panel.

3. Choose a Keyword Set from the drop-down list provided (the default set is Recent Keywords). Note that Lightroom displays a maximum of nine keywords in the Keyword Set portion of the Keywording panel.

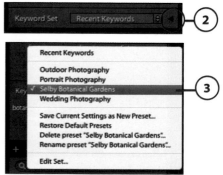

4. Select the image(s) in Grid view of the Library module.

5. Click any keyword in the Keyword Set to apply it to the selected photo(s).

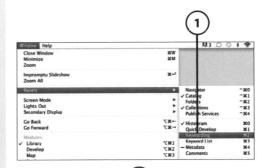

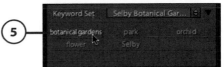

Use Keyword Suggestions

The Keyword Suggestions feature compares the keywords currently applied to the selected photo(s) with those applied to photos taken around the same capture time. Using this logic system, Lightroom can suggest additional related keywords for you to work with.

1. Choose Window, Panels, Keywording to display the Keywording panel.

2. In Grid view of the Library module, select any image(s) to apply keywords to.

3. Click the foldout triangle to reveal the Keyword Suggestions portion of the Keywording panel. Note that Lightroom displays a maximum of nine related keywords in the Keyword Suggestions portion of the Keywording panel.

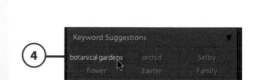

4. Click any keyword in the Keyword Suggestions portion of the Keywording panel to apply it to the selected photos.

Apply Keywords and Metadata with Auto Sync

Auto Sync applies keywords and metadata to selected images simultaneously as you enter info in the Keywords and Metadata panels.

1. Select the images in Grid view of the Library module or the Filmstrip.

2. Choose Metadata, Enable Auto Sync. If the primary selected photo is currently displayed in Loupe view, you can also click the Auto Sync toggle button.

Keyboard Shortcuts

Press Option+Shift+Cmd+A (Mac)
or Alt+Shift+Ctrl+A (Win) to apply
the Enable Auto Sync command.

3. As described earlier in this chap-
 ter, proceed to add keywords
 and/or metadata to the images
 using the controls available in the
 Keywording and Metadata panels.

 Note that when you auto sync
 metadata, Lightroom displays a
 warning dialog box. To proceed,
 click Apply to Selected.

 The keywords and metadata are
 applied to all the selected images
 simultaneously.

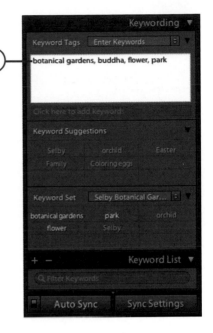

Learn to filter images by GPS data.

Learn to add images to the Quick Collection.

Learn to filter images by specific metadata information.

Learn to create smart collections.

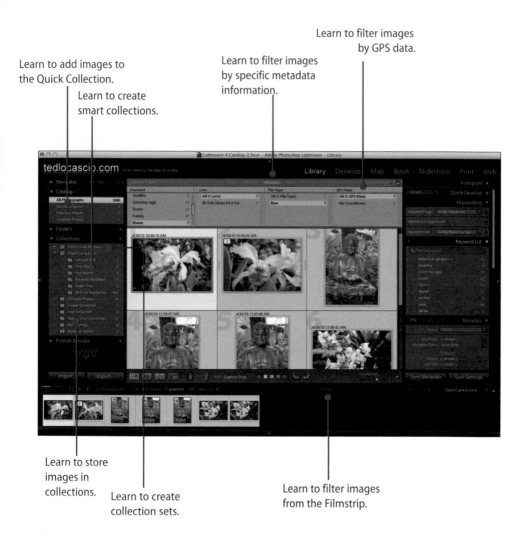

Learn to store images in collections.

Learn to create collection sets.

Learn to filter images from the Filmstrip.

In this chapter, you learn how to filter images
and save them to collections.

→ Searching with the Text Filter
→ Searching with the Attribute Filter
→ Searching with the Metadata Filter
→ Filtering with the Filmstrip Controls
→ Filtering by GPS Location
→ Saving Photos to Collections

5

Searching for Images

As you learned in Chapter 4, "Working with Metadata and
Keywords," you can add keyword tags, flags, ratings, color labels,
and IPTC metadata to your photos to easily identify them when con-
ducting a filtered search.

In this chapter, you learn how to use the Filter Bar to search for
images that contain specific text data, such as filename or key-
words, or that have certain attributes applied, such as flags, ratings,
and color labels. You also learn how to use the Metadata Filter to
conduct an advanced search.

This chapter also teaches you how to save your search results into
temporary Quick or Target Collections, or into permanent collec-
tions stored in the Lightroom database.

Searching with the Text Filter

By taking the time to add keywords, custom metadata, or apply custom file-names to your images, you can later use the text filter option to locate them easily in your catalog. You can refine your search by entering certain characters preceding the text in the filter search field.

Perform a Text Search

1. To display the Filter Bar, choose View, Show Filter Bar.

Keyboard Shortcuts
Press \ (backslash key) to show or hide the Filter Bar quickly.

2. Click the Text button to display the Text Filter options in the Filter Bar.

3. Choose a text search option from the Target drop-down list. Options include Any Searchable Field, Filename, Copy Name, Title, Caption, Keywords, Searchable Metadata, Searchable IPTC, Searchable EXIF, or Any Searchable Plug-in Field.

4. Choose a search limit option from the Rule drop-down list. Options include Contain, Contain All, Contain Words, Don't Contain, Start With, End With, Are Empty, and Aren't Empty.

Click the Magnifying Glass
By clicking the search field magnifying glass, you can access a combined drop-down list with all target and rule search options.

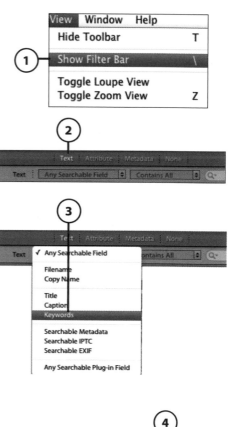

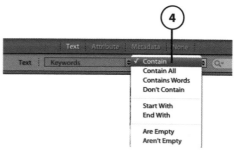

5. Type a text term in the Filter Bar search field.

 Lightroom displays all images that match the current search criteria in the Content area and Filmstrip.

Keyboard Shortcuts

Choose Library, Find or press Cmd+F (Mac) or Ctrl+F (Win) to go directly to the search field in the Filter Bar.

Clear the Search Field

Click the X icon in the search field to clear the current search term.

Perform a Refined Text Search

1. To display the Filter Bar, choose View, Show Filter Bar.

2. Click the Text button to display the Text Filter options in the Filter Bar.

3. Choose a text search option from the Target drop-down list.

4. Choose Contain from the Rule drop-down list.

5. In the Filter Bar search field, enter a + (plus symbol) before the search term. Doing so is the same as choosing Starts With from the Rule drop-down list.

6. In the Filter Bar search field, enter an ! (exclamation point) before the next search term. Doing so indicates which words to exclude from the search.

Searching with the Attribute Filter

In addition to filtering images by text data, you can also filter them by applied attribute, such as flag status (pick or reject), star rating, color label, or a combination of all three. You can also use the Attribute filter to display just those images that are virtual copies (for more about creating virtual copies in Lightroom, see Chapter 9, "Develop Module Workflow").

Filter Photos by Flag Status

1. To display the Filter Bar, choose View, Show Filter Bar.

Keyboard Shortcuts

Press \ (backslash key) to show or hide the Filter Bar quickly.

2. Click the Attribute button to display the Attribute Filter options in the Filter Bar.

3. Click any of the Flag icons in the Filter Bar. Options include Flagged Only, Unflagged Only, and Rejected Only. Note that it is possible to enable more than one of these flag filter options at a time.

Lightroom displays all images that match the current search criteria in the Content area and Filmstrip.

Filter Photos by Rating ▶

1. To display the Filter Bar, choose View, Show Filter Bar.

2. Click the Attribute button to display the Attribute Filter options in the Filter Bar.

3. To access the Rule drop-down list, click the symbol that is currently displayed between the star icons and the word "Rating" in the Filter Bar. Choose an Attribute Filter rule from the list provided. Options include Rating Is Greater Than or Equal To, Rating Is Equal To, and Rating Is Less Than or Equal To.

4. Click a star icon to determine which photos are displayed in the Content area. The lowest rating (1 star) is on the left and the highest (5 stars) is on the right.

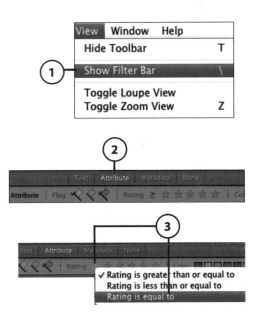

Disable the Rating Filter

Click the star icon a second time to disable the rating filter.

Lightroom displays all images that match the current search criteria in the Content area and Filmstrip.

Filter Photos by Color Label ▶

1. To display the Filter Bar, choose View, Show Filter Bar.

2. Click the Attribute button to display the Attribute Filter options in the Filter Bar.

3. Click any of the Color Label icons in the Filter Bar to indicate which colors to search for. Note that it is possible to include multiple colors in your search.

 Lightroom displays all images that match the current search criteria in the Content area and Filmstrip.

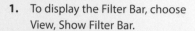

Disable the Label Filter

Click the color label icon a second time to disable the filter.

Display Images with No Color Label

To display images that have no color label applied, click the gray color swatch in the Filter Bar.

Identify Color Label Definitions with Tooltips

Hover the mouse over any color label button to display its color label definition (as specified in the Color Label Set) in a tooltip.

Filter Photos by Kind ▶

1. To display the Filter Bar, choose View, Show Filter Bar.

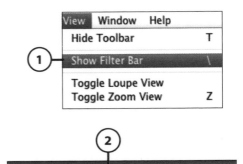

Keyboard Shortcuts
Press \ (backslash key) to show or hide the Filter Bar quickly.

2. Click the Attribute button to display the Attribute Filter options in the Filter Bar.

3. Click the Kind buttons in the Filter Bar.

 Master Photos displays only master photos in the Content area.

 Virtual Copies displays only virtual copies in the Content area.

 Movies displays only movie files in the Content area.

 Lightroom displays all images that match the current search criteria in the Content area and Filmstrip.

Lock Filter Settings
To lock filter settings, click the lock toggle icon on the right side of the Filter bar. Doing so enables you to maintain filter settings as you navigate to a different folder.

Searching with the Metadata Filter

The Metadata Filter enables you to display images based on specific metadata info, such as date, keywords, file type, and camera model. The Metadata Filter columns are also customizable. You can set them up in various configurations to conduct an advanced filter search. You can also adjust the height of the Metadata Filter by clicking and dragging the bottom bar up or down.

Filter Photos by Metadata Info

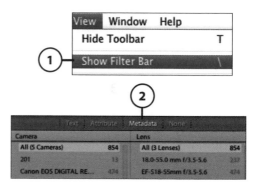

1. To display the Filter Bar, choose View, Show Filter Bar.

2. Click the Metadata button to display the Metadata Filter options in the Filter Bar.

3. Click in the upper-right corner of the Filter Bar to choose a metadata preset from the drop-down list.

4. Click the top of any column to access the metadata drop-down list and choose custom metadata filter settings.

5. Under each column, click the metadata items to add as search criteria.

Keyboard Shortcuts

Shift+click to select multiple adjacent items; Cmd+click (Mac) or Ctrl+click (Win) to select multiple nonadjacent items.

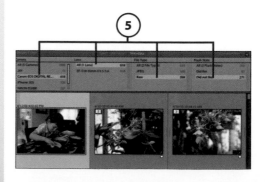

Lightroom displays all images that match the current search criteria in the Content area and Filmstrip.

ADDING AND REMOVING METADATA FILTER COLUMNS

Lightroom enables you to add and remove Metadata Filter columns (up to eight total), by clicking the upper-right corner of any existing Filter column and choosing Add Column or Remove This Column from the drop-down list provided.

Save a Metadata Filter Preset

Filter presets give you quick access to specific images, such as all flagged photos in a catalog or all unrated photos. Lightroom enables you to save and recall your own custom Metadata Filter settings as presets.

1. To display the Filter Bar, choose View, Show Filter Bar.

2. Click the Metadata button to display the Metadata Filter options in the Filter Bar.

3. Click the top of any column to access the metadata drop-down list to choose custom metadata filter settings.

4. Under each column, click the metadata items to add as search criteria.

5. Click in the upper-right corner of the Filter Bar to access the drop-down list and choose Save Current Settings as New Preset.

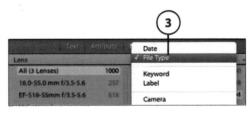

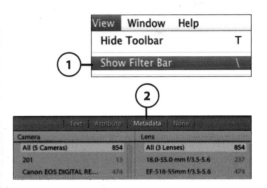

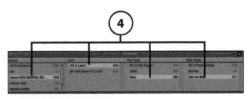

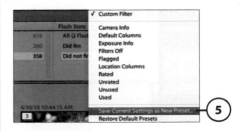

6. In the New Preset dialog box, enter a name for the preset and click Create.

The new preset is added to the Metadata Filter preset list.

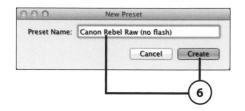

Filtering with the Filmstrip Controls

The Filter Bar can take up a lot of space on your screen, especially when the Metadata Filter options are made visible. To save space on the screen, you can apply attribute filters and apply Metadata Filter presets from the Filmstrip instead of from the Filter Bar. The attribute filter icons and the Metadata Filter preset list all appear and function in the same way as they do in the Filter Bar.

Filter Photos from the Filmstrip

1. Choose Window, Panels, Show Filmstrip, or click the up arrow located at the bottom of the interface to display the Filmstrip.

Keyboard Shortcuts

Press F6 to show or hide the Filmstrip quickly.

Selecting Photos with the Filmstrip Filter

You can also use the Filmstrip filter controls to select photos. Cmd+click (Mac) or Ctrl+Click (Win) on any Flag or Color Label icon to select photos with those attributes applied.

2. Apply any of the Filmstrip filters.

Flag Status works by clicking any of the Flag icons to indicate which photos to display. Options include Flagged Only, Unflagged Only, and Rejected Only. Note that it is possible to enable more than one of these flag filters at a time.

Rating works by clicking a star icon to indicate which photos to display. The lowest rating (1 star) is on the left and the highest (5 stars) is on the right.

Color Label works by clicking any of the Color Label icons to indicate which photos to display. Note that it is possible to include multiple colors in your search.

Lightroom displays the images that match the current search criteria.

Metadata Preset works by choosing a metadata preset from the drop-down list provided.

Lightroom displays all images that match the current search criteria in the Content area and Filmstrip.

Filtering by GPS Location

If your digital camera records GPS data, or if you've tagged your photos in the Map module (see Chapter 12, "Mapping Photos"), you can use the Metadata Filter to display images based on their capture location.

Filter Photos by GPS Information

1. To display the Filter Bar, choose View, Show Filter Bar.

2. Click the Metadata button to display the Metadata Filter options in the Filter Bar.

3. Click the top of any column to access the metadata drop-down list and choose GPS Data.

Lightroom displays all images that match the current search criteria in the Content area and Filmstrip.

Saving Photos to Collections

Lightroom enables you to save your search results into temporary Quick or Target Collections, or into permanent collections that are stored in the Lightroom database. You can also create a collection hierarchy by organizing them into related sets. You can even add images to collections automatically by utilizing smart collections. This feature enables you to assign specific rules to a collection based on search criteria, such as keywords, metadata, ratings, color labels, capture date, and file type. If the images match the search criteria, then Lightroom automatically adds them to the smart collection.

Save Photos to the Quick Collection

The Quick Collection is a great feature for temporarily saving your search results. Although you are allowed only one Quick Collection per catalog, you can continue to add photos to it or remove them at any time.

1. Use the Filter Bar or Filmstrip filter controls to locate the photos to save in the Quick Collection.

2. Select the photos from the Grid or Filmstrip.

Keyboard Shortcuts

Press Cmd+A (Mac) or Ctrl+A (Win) to apply the Select All command quickly.

3. Choose Photo, Add to Quick Collection, or Control+click (Mac) or right-click (Win) and choose the command from the contextual menu.

Keyboard Shortcuts

Press B to add or remove selected photos to and from the Quick Collection. Press Cmd+B (Mac) or Ctrl+B (Win) to display the Quick Collection images in the Content area and Filmstrip.

Lightroom displays a circle in the upper-right corner of the image thumbnail.

Lightroom displays a circle in the upper-right corner of the image thumbnail to indicate that it is now part of the Quick Collection.

>Go Further

SAVE THE CURRENT QUICK COLLECTION AS A PERMANENT COLLECTION

To do so, choose File, Save Quick Collection, or press Cmd+Opt+B (Mac) or Ctrl+Alt+B (Win). In the Save Quick Collection dialog box that appears, enter a name for the collection. To remove the photos from the Quick Collection after saving, enable the Clear Quick Collection After Saving option and click Save.

Set a Target Collection ▶

You can target any permanent collection and make it behave like the Quick Collection for as long as it is targeted. Target Collections are ideal for grouping photos together temporarily for further processing.

1. To display the Collections panel, choose Window, Panels, Collections.

Keyboard Shortcuts

Press Control+Cmd+3 (Mac) or Ctrl+Shift+3 (Win) to show or hide the Collections panel quickly.

2. Control+click (Mac) or right-click the collection from the Collections panel and choose Set As Target Collection from the contextual menu.

 Lightroom displays a white + icon next to the collection name in the Collections panel to indicate that it is now targeted.

3. Select the photos to add to the temporary collection from the Grid or Filmstrip.

4. Choose Photo, Add to Target Collection, or Control+click (Mac) or right-click and choose the command from the contextual menu.

 Lightroom displays a circle in the upper-right corner of the image thumbnail to indicate that it is now part of the Target Collection.

Create a Collection

A collection is a specific group of photos saved in the Lightroom database. You can select a collection from the Collections panel and display just those images in the Grid and Filmstrip.

1. To display the Collections panel, choose Window, Panels, Collections.

2. Select the images to include in the collection from the Grid or Filmstrip.

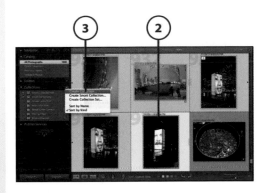

3. Choose Library, New Collection, or click the plus icon (+) in the upper-right corner of the Collections panel and choose Create Collection from the drop-down list.

4. Enter a name for the collection in the Create Collection dialog box.

5. From the Placement section, choose which set to save the collection into. If you prefer not to save the collection as part of a set, choose Top Level.

6. Enable the Include Selected Photos option.

7. To make virtual copies of the selected photos, enable the Make New Virtual Copies option. Note that doing so adds the virtual copies to the collection without the master photos.

8. Click Create.

 Lightroom adds the generic collection to the Collections panel.

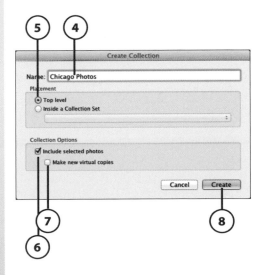

Create a Collection Set

Lightroom enables you to organize your collections into folders, called collection sets. By placing your collections into related folder groups, you can create a collection hierarchy. Doing so helps keep the Collections panel organized and makes it much easier for you to locate specific groups of photos.

1. To display the Collections panel, choose Window, Panels, Collections.

Keyboard Shortcuts

Press Control+Cmd+3 (Mac) or Ctrl+Shift+3 (Win) to show or hide the Collections panel quickly.

2. To access the panel menu, click the plus icon (+) in the upper-right corner of the Collections panel. Choose Create Collection Set from the drop-down list.

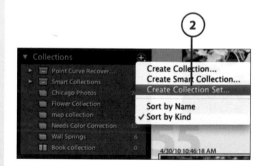

>Go Further CREATE MODULE-SPECIFIC COLLECTIONS

In the Collections panel, Lightroom displays a module-specific icon next to any collection created in the Book, Slideshow, Print, and Web modules. When you double-click a module-specific collection from the Collections panel, Lightroom selects the photos from the catalog and takes you directly to that module.

3. In the Create Collection Set dialog box, enter a name for the collection set.

4. From the Set drop-down list, choose what set to save the collection set into. If you prefer not to nest the collection set inside of an existing set, choose Top Level.

5. Click Create.

 Lightroom adds the collection set to the Collections panel.

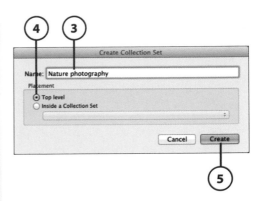

Create a Smart Collection

With smart collections, you can assign a specific set of rules that ultimately determines what images are automatically added to them. You can create smart collections based on specific search criteria.

1. To display the Collections panel, choose Window, Panels, Collections.

Keyboard Shortcuts
Press Control+Cmd+3 (Mac) or Ctrl+Shift+3 (Win) to show or hide the Collections panel quickly.

2. To access the panel menu, click the plus icon (+) in the upper-right corner of the Collections panel. Choose Create Smart Collection from the drop-down list.

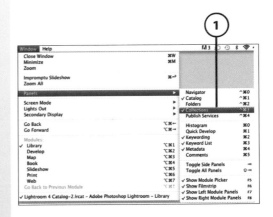

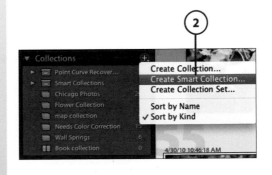

3. In the Create Smart Collection dialog box, enter a name for the collection set.

4. From the Set drop-down list, choose what set to save the smart collection into. If you prefer not to save the smart collection as part of a set, choose Top Level.

5. In the rules area of the dialog box, choose the preferred settings from the Target and Rule drop-down lists and click Create.

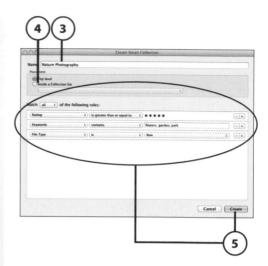

Add and Remove Rules

Click the plus symbol (+) to the right of the dialog box to add a rule. Click the minus symbol (-) to remove a rule.

Share a Smart Collection

It is possible to import smart collections into catalogs or share smart collections with other Lightroom users. To do so, you must export the smart collection settings from one Lightroom catalog and then import them into another.

1. To display the Collections panel, choose Window, Panels, Collections.

2. Control+click (Mac) or right-click the smart collection from the Collections panel and choose Export Smart Collection Settings from the contextual menu.

3. In the Save dialog box, enter a name for the .lrsmcol file in the Save As field.

4. Choose a save location for the file on your system and click Save.

 Lightroom creates a .lrsmcol file in the location you specified.

5. From the Collections panel, Control+click (Mac) or right-click the collection set into which you'd like to add the smart collection. Choose Import Smart Collection Settings from the contextual menu.

6. In the Import Smart Collection dialog box, navigate to the .lrsmcol file and click Import.

 Lightroom adds the smart collection to the collection set and automatically adds any photos that meet the smart collection criteria.

Learn to apply Quick Develop settings to multiple images at once.

Learn to apply a crop ratio setting.

Learn to apply Quick Develop presets.

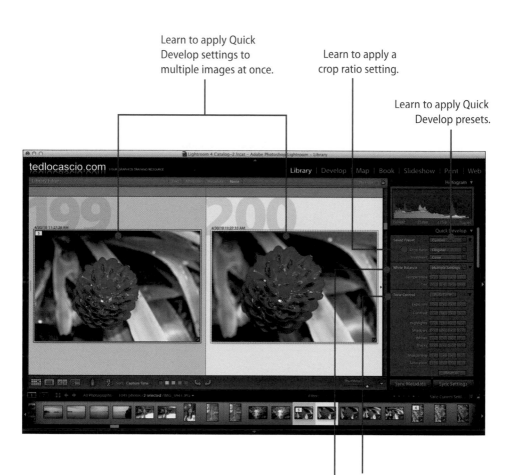

Learn to apply Quick Develop tonal adjustments.

Learn to apply a White Balance preset.

In this chapter, you learn how to edit images in the Library module with Quick Develop.

→ Applying Quick Develop Presets

→ Cropping Photos with Quick Develop

→ Applying Quick Develop Color Adjustments

→ Adjusting Vibrance and Saturation
 with Quick Develop

→ Converting to Black and White with Quick Develop

→ Applying Quick Develop Tonal Adjustments

→ Adjusting Clarity and Sharpness
 with Quick Develop

Using Quick Develop

Quick Develop enables you to apply basic image adjustments from within the Library module. Note that develop settings are never permanent, no matter where or how they are applied. Therefore, you can always open your images individually in the Develop module later and fine-tune any settings you applied with Quick Develop. You can also remove develop settings at any time and return the images to their original state.

In this chapter, you learn how to apply saved develop settings to multiple selected images via the Quick Develop Saved Preset drop-down list. You also learn how to use Quick Develop to crop photos and convert them to grayscale. In addition, you learn how to use the controls in the Quick Develop panel to perform color adjustments and make tonal corrections.

Applying Quick Develop Presets

At the top of the Quick Develop panel is a Saved Preset drop-down list, which gives you access to some useful saved develop settings. The presets are grouped into eight categories. Choose a preset from any of the creative groups to quickly apply a creative effect, such as antique lighting or a sepia tone. Choose a preset from the General category to apply a basic adjustment, such as auto tone correction or grayscale conversion. There are also two Tone Curve presets: one that applies a flat adjustment and one that creates a medium plus contrast. You can also remove a color cast by choosing a preset from the White Balance drop-down list in the Quick Develop panel.

Apply Saved Develop Settings

1. To display the Quick Develop panel, choose Window, Panels, Quick Develop.

Keyboard Shortcuts
Press Cmd+1 (Mac) or Ctrl+1 (Win) to show or hide the Quick Develop panel.

2. From the Library Grid or Filmstrip, select the images to adjust.

3. Choose a Quick Develop preset from the Saved Preset drop-down list.

 Lightroom applies the Quick Develop settings to all the selected images.

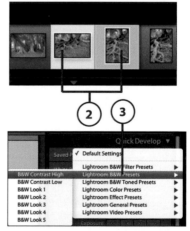

Lightroom applies the Quick Develop preset.

Apply Preset White Balance Adjustments with Quick Develop

Whenever you take photos with the white balance set incorrectly on your camera, the images usually contain an undesirable color cast (a predominant color in the overall image). To correct this, you can choose a white balance preset from the Quick Develop panel.

1. To display the Quick Develop panel, choose Window, Panels, Quick Develop.

2. From the Library Grid or Filmstrip, select the images to adjust.

Keyboard Shortcuts

Shift+click to select multiple adjacent photos; Cmd+click (Mac) or Ctrl+click (Win) to select multiple nonadjacent photos.

3. Choose a white balance setting from the White Balance dropdown list. For JPEGs, TIFFs, and PSDs, the only available white balance preset option, other than As Shot or Custom, is Auto. For DNG and proprietary raw files, there are many more presets, including Auto, Daylight, Cloudy, Shade, Tungsten, Fluorescent, and Flash.

Lightroom applies the white balance preset to all the selected images.

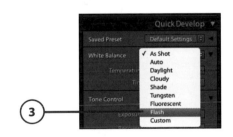

Lightroom applies the White Balance preset.

Cropping Photos with Quick Develop

By choosing a setting from the Quick Develop Crop Ratio drop-down list, you can apply the same crop ratio to multiple selected photos at once. The Crop Ratio list includes all the most commonly used print sizes, such as 4" x 5", 5" x 7", and 8" x 10", but you can also choose Custom to apply a specific aspect ratio to the crop. Note that the Quick Develop crop ratio commands enable you to trim only the selected photos evenly.

Apply a Preset Crop Ratio

1. To display the Quick Develop panel, choose Window, Panels, Quick Develop.

2. From the Library Grid or Filmstrip, select the images to crop.

3. In the Saved Preset section of the Quick Develop panel, choose a Quick Develop crop ratio setting from the Crop Ratio drop-down list.

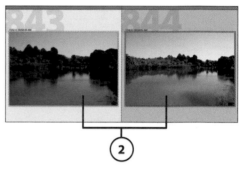

Custom Aspect Ratio

To apply a custom aspect ratio, choose Enter Custom. Enter the preferred settings in the Enter Custom Aspect Ratio dialog box and click OK.

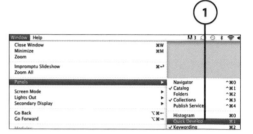

Lightroom trims the selected photos evenly at either side.

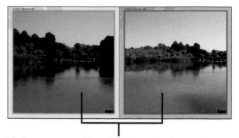

Lightroom applies the Crop Ratio setting.

Applying Quick Develop Color Adjustments

With Quick Develop, Lightroom enables you to apply the same Temperature and Tint adjustments to multiple images at once. With these controls, you can adjust the white balance of an image manually. By doing so, you can either remove an undesirable color cast or create a cooling or warming color cast effect.

Adjust Color Temperature with Quick Develop

For hands-on control when applying a white balance adjustment, click the Temperature arrows. Clicking the arrows on the right makes the image appear warmer; clicking the arrows on the left makes it appear cooler.

1. To display the Quick Develop panel, choose Window, Panels, Quick Develop.

2. From the Library Grid or Filmstrip, select the images to adjust.

3. In the White Balance section of the Quick Develop panel, click the Temperature arrows on the right to make the image appear warmer. Click the arrows on the left to make the image appear cooler.

Single Versus Double Arrow

By clicking the single arrow buttons, you can apply smaller shifts in color. Clicking the double arrow buttons produces a more pronounced adjustment.

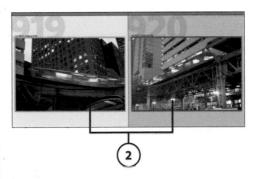

Lightroom applies the White Balance adjustment.

Apply Tint Adjustments with Quick Develop

You can use the Tint controls in Quick Develop to slightly offset any drastic color temperature adjustments you have applied to your images.

1. To display the Quick Develop panel, choose Window, Panels, Quick Develop.

2. From the Library Grid or Filmstrip, select the images to adjust.

3. In the White Balance section of the Quick Develop panel, click the Tint arrows on the right to apply a magenta tint. Click the arrows on the left to apply a green tint.

 Lightroom applies the tint adjustment to all the selected images.

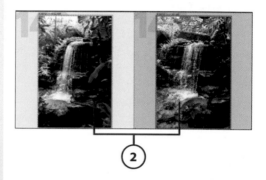

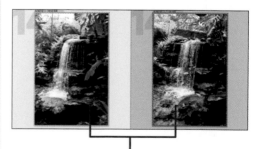

Lightroom applies the Tint adjustment.

Adjusting Vibrance and Saturation with Quick Develop

With Quick Develop, you can apply Vibrance and Saturation adjustments to multiple images at once from within the Library module. Both adjustments can enhance color vividness; however, there are some slight differences between the two processes.

Adjust Vibrance with Quick Develop

Vibrance, unlike Saturation, applies a nonlinear adjustment. Therefore, you can make dull colors appear more vivid without oversaturating the colors that already appear vivid in your photos.

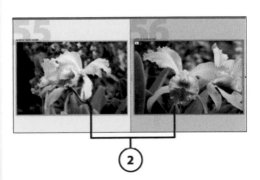

1. To display the Quick Develop panel, choose Window, Panels, Quick Develop.

2. From the Library Grid or Filmstrip, select the images to adjust.

3. In the Tone Control section of the Quick Develop panel, click the Vibrance arrows on the right to increase vividness of dull colors. Click the arrows on the left to decrease vibrance.

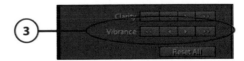

Single Versus Double Arrow

Click the single arrow buttons to apply a 5-unit shift in vibrance. Click the double arrow buttons to produce a 20-unit shift.

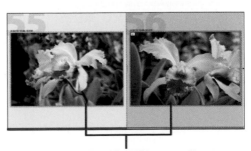

Lightroom applies the Vibrance adjustment to all the selected images.

Lightroom applies the Vibrance adjustment.

Adjust Saturation with Quick Develop

Saturation is similar to Vibrance in that you can use it to make colors appear more vivid in your images. However, unlike Vibrance, the Saturation applies a linear adjustment, which can oversaturate colors that already appear saturated.

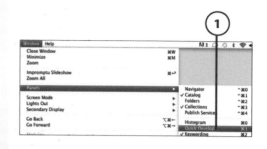

1. To display the Quick Develop panel, choose Window, Panels, Quick Develop.

2. From the Library Grid or Filmstrip, select the images to adjust.

3. Hold down Option (Mac) or Alt (Win) to convert the Vibrance control into a Saturation control, and then click the Saturation arrows on the right to increase color saturation. Click the arrows on the left to decrease saturation.

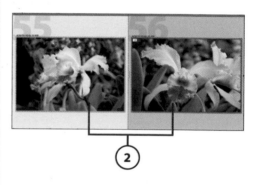

Single Versus Double Arrow

Click the single arrow buttons to apply a 5-unit shift in saturation. Click the double arrow buttons to produce a 20-unit shift.

Lightroom applies the Saturation adjustment to all the selected images.

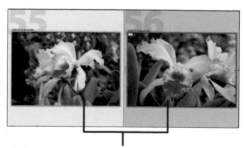

Lightroom applies the Saturation adjustment.

Converting to Black and White with Quick Develop

By choosing Black & White from the Quick Develop Panel Treatment drop-down list, you can desaturate any color images that you currently have selected and make them black and white. Keep in mind that when you do this, Lightroom does not actually convert the images to Grayscale mode. You can revert the images to full-color mode at any time by choosing Color from the Treatment list.

Desaturate Images with Quick Develop

1. To display the Quick Develop panel, choose Window, Panels, Quick Develop.

2. From the Library Grid or Filmstrip, select the images to convert.

3. Choose Black & White from the Treatment drop-down list.

Keyboard Shortcuts
Press V to convert the selected images to black and white quickly.

Lightroom converts the selected images to black and white.

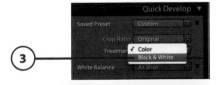

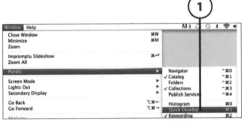

Lightroom converts the images to black and white.

Apply Quick Develop Tonal Adjustments

Quick Develop also enables you to adjust the shadows, midtones, and highlights for multiple images at once. Click the Auto Tone button for a quick overall tonal repair, or adjust the images manually using the Exposure, Contrast, Shadows, Highlights, Whites, and Blacks arrows.

Apply Quick Develop Auto Tone Adjustments

By clicking the Quick Develop Auto Tone button, you can apply an automatic correction to all the following develop settings: Exposure, Highlights, Blacks, Whites, and Contrast.

1. To display the Quick Develop panel, choose Window, Panels, Quick Develop.

2. From the Library Grid or Filmstrip, select the images to adjust.

3. Click the Auto Tone button in the Tone Control section of the Quick Develop panel.

 Lightroom applies the Auto Tone adjustment to all the selected images.

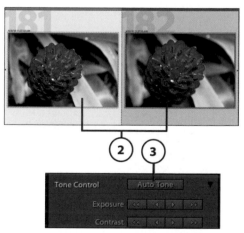

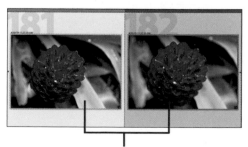

Lightroom applies the Auto Tone adjustment.

Adjust Exposure with Quick Develop

The Exposure control is the best place to start when applying manual tonal adjustments with Quick Develop. This is because the Exposure setting deter-mines the clipping point (where detail starts to get lost) in the highlight areas of an image.

1. To display the Quick Develop panel, choose Window, Panels, Quick Develop.

2. From the Library Grid or Filmstrip, select the images to adjust.

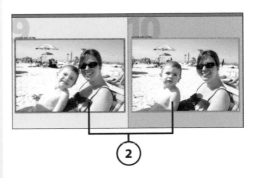

3. In the Tone Control section of the Quick Develop panel, click the Exposure arrows on the right to increase the Exposure setting. Click the arrows on the left to decrease the Exposure setting.

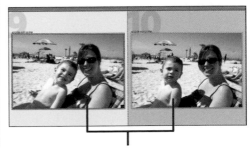

Single Versus Double Arrow

By clicking the single arrow but-tons, you can increase or decrease the exposure by ⅓ stop. Clicking the double arrow buttons increas-es or decreases the exposure by 1 stop.

Lightroom applies the Exposure adjustment.

Adjust Contrast with Quick Develop

By increasing contrast, you can greatly enhance the edge detail and overall color in your photographs. Flat, lifeless images that contain a predominant amount of midtones (as evidenced by a large hump in the middle of the histogram) can benefit greatly from a strong contrast adjustment.

1. To display the Quick Develop panel, choose Window, Panels, Quick Develop.

2. From the Library Grid or Filmstrip, select the images to adjust.

3. In the Tone Control section of the Quick Develop panel, click the Contrast arrows on the right to increase contrast. Click the arrows on the left to decrease it.

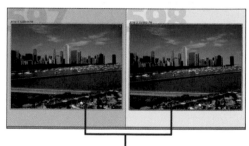

Single Versus Double Arrow

Click the single arrow buttons to apply a 5-unit shift in contrast. Click the double arrow buttons to produce a 20-unit shift.

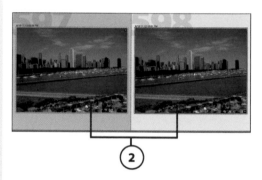

Lightroom applies the Contrast adjustment to all the selected images.

Lightroom applies the Contrast adjustment.

Apply Quick Develop Highlights Adjustments

By applying a Quick Develop Highlights adjustment, you can restore detail in the overexposed highlight areas of your images. You can also use Highlights to help offset a severe Exposure adjustment.

1. To display the Quick Develop panel, choose Window, Panels, Quick Develop.

2. From the Library Grid or Filmstrip, select the images adjust.

3. In the Tone Control section of the Quick Develop panel, click the Highlights arrows on the right to increase the adjustment and reveal highlight detail. Click the arrows on the left to decrease Highlights.

Single Versus Double Arrow

Click the single arrow buttons to apply a 5-unit shift. Click the double arrow buttons to produce a 20-unit shift.

Lightroom applies the Highlights adjustment to all the selected images.

Lightroom applies the Highlights adjustment.

Apply Quick Develop Shadows Adjustments

By applying a Quick Develop Shadows adjustment, you can restore detail in the underexposed shadow areas of your images. Shadows adjustments are great for correcting images that were shot with the light source positioned behind the subject, which results in the forefront objects being engulfed in shadow.

1. To display the Quick Develop panel, choose Window, Panels, Quick Develop.

2. From the Library Grid or Filmstrip, select the images to adjust.

3. In the Tone Control section of the Quick Develop panel, click the Shadows arrows on the right to increase the adjustment and reveal shadow detail. Click the arrows on the left to decrease the Shadows adjustment.

Single Versus Double Arrow

Click the single arrow buttons to apply a 5-unit shift. Click the double arrow buttons to produce a 15-unit shift.

Lightroom applies the Shadows adjustment to all the selected images.

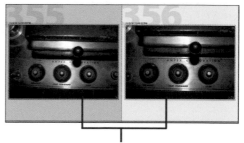

Lightroom applies the Shadows adjustment.

Adjust Whites with Quick Develop

The Whites adjustment in the Quick Develop panel enables you to control how much detail gets clipped in the highlight areas of your images.

1. To display the Quick Develop panel, choose Window, Panels, Quick Develop.

2. From the Library Grid or Filmstrip, select the images to adjust.

3. In the Tone Control section of the Quick Develop panel, click the Whites arrows on the right to increase the amount of highlight detail that gets clipped. Click the arrows on the left to decrease highlight clipping.

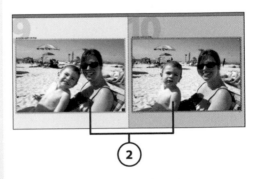

Single Versus Double Arrow

Click the single arrow buttons to apply a 1-unit shift. Click the double arrow buttons to produce a 5-unit shift.

Lightroom applies the Whites adjustment to all the selected images.

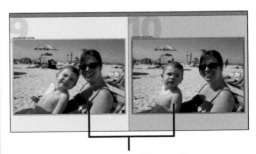

Lightroom applies the Whites adjustment.

Adjust Blacks with Quick Develop

The Blacks adjustment in the Quick Develop panel enables you to control how much detail gets clipped in the shadow areas of your images.

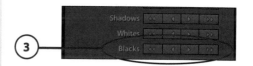

1. To display the Quick Develop panel, choose Window, Panels, Quick Develop.

2. From the Library Grid or Filmstrip, select the images to adjust.

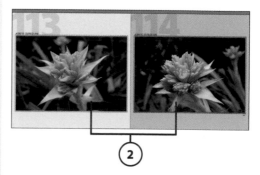

3. In the Tone Control section of the Quick Develop panel, click the Blacks arrows on the right to increase the amount of shadow detail that gets clipped. Click the arrows on the left to decrease black clipping.

Single Versus Double Arrow

Click the single arrow buttons to apply a 1-unit shift. Click the double arrow buttons to produce a 5-unit shift.

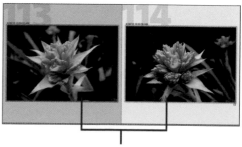

Lightroom applies the Blacks adjustment to all the selected images.

Lightroom applies the Blacks adjustment.

Adjusting Clarity and Sharpness with Quick Develop

You can also apply the same Clarity and Sharpness adjustments to multiple images at once with Quick Develop. Clarity adjustments create the illusion of sharpness by increasing contrast exclusively in the midtone areas of an image. Sharpness enhances areas of existing high contrast to create the illusion of better focus.

Adjust Clarity with Quick Develop

With Clarity, you can make your pictures appear clearer rather than sharper. This is done by increasing contrast in just the midtone areas of your photographs. In general, most digital images can benefit from a slight Clarity adjustment.

1. To display the Quick Develop panel, choose Window, Panels, Quick Develop.

2. From the Library Grid or Filmstrip, select the images to adjust.

3. In the Tone Control section of the Quick Develop panel, click the Clarity arrows on the right to increase midtone contrast and allow the midtone areas to stand out more. Click the arrows on the left to decrease clarity.

Single Versus Double Arrow

Click the single arrow buttons to apply a 5-unit shift in clarity. Click the double arrow buttons to produce a 20-unit shift.

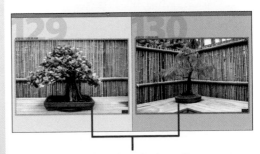

Lightroom applies the Clarity adjustment.

Apply Sharpening with Quick Develop

Although it is best to apply sharp-ening to images individually in the Develop module, you can apply an initial Sharpening adjustment to your photos using Quick Develop and then fine-tune them later. Quick Develop Sharpening does not give you access to the additional Sharpening sliders available in the Develop module.

1. To display the Quick Develop panel, choose Window, Panels, Quick Develop.

2. From the Library Grid or Filmstrip, select the images to sharpen.

3. Hold down Option (Mac) or Alt (Win) to convert Clarity into Sharpening, and then click the Sharpening arrows on the right to increase sharpening. Click the arrows on the left to decrease sharpening.

Single Versus Double Arrow

Click the single arrow buttons to apply a 5-unit shift in sharpening. Click the double arrow buttons to produce a 20-unit shift.

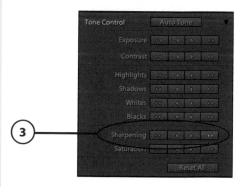

Lightroom applies the Sharpening adjustment to all the selected images.

Learn to eliminate unwanted color casts.

Learn to correct the white balance with the White Balance Selector.

Learn to understand the histogram.

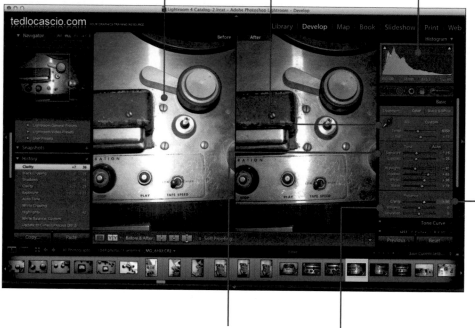

Learn to correct image exposure.

Learn to enhance colors with Vibrance and Saturation.

Learn to increase midtone contrast with Clarity.

In this chapter, you learn how to improve and enhance images in the Develop module.

→ Opening an Image in the Develop Module
→ Updating the Process Version
→ Cropping Images
→ Applying Tonal Adjustments
→ Applying Color Adjustments
→ Working with Tone Curves
→ Enhancing Color with HSL Adjustments
→ Correcting Chromatic Aberration
→ Working with Vignettes
→ Adding Film Grain

Adjusting Images in the Develop Module

The image-processing engine in Lightroom enables you to apply and edit multiple image adjustments in the Develop module without harming any pixels. This is because the adjustments are applied only when you export the photo as a rendered file, such as a TIFF or JPEG.

In the Develop module, you can crop an image, rotate it, correct its white balance, apply tonal and color enhancements, and apply various other adjustments without harming the original photo. Every adjustment you apply in the Develop module can be edited or removed at any time, and you can always restore your images to their original, "as shot" state.

In this chapter, you learn how to open an image in the Develop module and apply various develop setting adjustments.

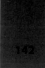
Opening a Photo in the Develop Module

With Lightroom, you can only work with a single image at a time in the Develop module. Therefore, you must first select the image that you would like to work with from the Library module Grid and then open the image in the Develop module workspace. You can also select the image from the Filmstrip, which is always accessible in every Lightroom module. Note that when multiple photos are selected from the Grid or Filmstrip, Lightroom opens the primary selected photo in the Develop module.

Open the Primary Image Selection in the Develop Module ▶

1. From the Library module Grid or the Filmstrip, select the photo to adjust.

2. Choose View, Go to Develop or click the Develop button in the upper-right corner of the interface.

Keyboard Shortcuts
Press D to apply the Go to Develop command quickly.

Lightroom displays the photo in the Content area of the Develop module.

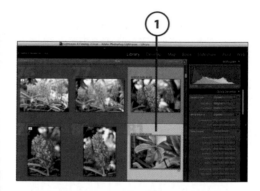

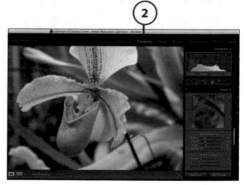

Updating the Process Version

The process version refers to the Camera Raw technology Lightroom uses to adjust and render photos in the Develop module. With process version 2012, the tone controls feature new algorithms for high-contrast images. Any images edited in Lightroom 3 use process version 2010, which features improved sharpening and noise-reduction from the previous process version (2003).

Update to the Current Process (2012) ▶

1. Select an image from the Library Grid or Filmstrip and open it in the Develop module.

2. Choose the current process from the Process list located at the top of the Camera Calibration panel, or click the Update icon (the exclamation mark) in the lower-right corner of the image.

Keyboard Shortcuts

Press Cmd+8 (Mac) or Ctrl+8 (Win) to display the Camera Calibration panel quickly.

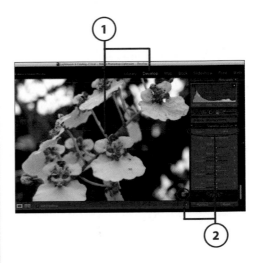

3. When you click the Update icon, a warning dialog box appears. Enable the Review Changes via Before/After option to display the image in compare mode after you update the process. To bypass this warning dialog box, enable the Don't Show Again option.

4. Click Update to apply the current process to the selected image, or click Update All Filmstrip Photos to update all images in the Filmstrip.

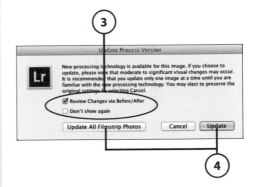

UPDATE TO THE CURRENT PROCESS (2012) FROM THE LIBRARY MODULE

To update to the current process, select a photo from the Library module Grid or the Filmstrip and choose Photo, Develop Settings, Update to Current Process (2012). You can also access this command by Control+clicking (Mac) or right-clicking the image thumbnail from the Library Grid or Filmstrip and choosing it from the contextual menu.

Cropping Images

Lightroom enables you to select an image from the Library module Grid or the Filmstrip and open it directly in Crop Overlay mode in the Develop module. You can also enter Crop Overlay mode from the Develop module by clicking the Crop Overlay button in the Tools panel. The Tools panel also enables you to apply a crop ratio preset, or perform a freeform crop using the Crop Frame tool.

Crop Using Crop Overlay Mode

1. From the Library module Grid or the Filmstrip, select the photo to crop.

2. Choose View, Crop. If you already have an image open in the Develop module, choose Tools, Crop.

 Lightroom displays the Tools panel at the top of the panels list in the interface and automatically selects the Crop Overlay button. A Crop Overlay bounding box also appears over the photo.

3. To adjust the crop edges, click and drag any corner or side bounding box handle. All adjustments are made relative to the center of the crop. The areas outside the crop bounding box appear shaded.

4. After adjusting the crop the edges, click and drag the cursor inside the bounding box to reposition the image relative to the crop.

5. Click the Close button in the Tools panel to apply the crop.

Resetting the Crop Overlay Bounding Box

You can reset the Crop Overlay bounding box at any time. To do so, click the Reset button in the bottom-right corner of the Tools panel.

Lightroom applies the crop dimensions to the image.

Crop with the Crop Frame Tool

1. From the Library module Grid or the Filmstrip, select the photo to crop.

2. Choose View, Crop. If you already have an image open in the Develop module, choose Tools, Crop.

Keyboard Shortcuts

Press R to apply the Crop command quickly.

Lightroom displays the Tools panel in the interface and automatically selects the Crop Overlay button. A Crop Overlay bounding box also appears over the photo.

3. To access the Crop Frame tool, click the Crop Frame tool icon in the Tools panel.

4. To create a freeform crop, click and drag over the image with the Crop Frame tool.

Lightroom applies the crop.

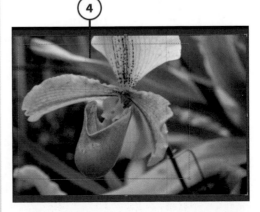

The Crop Frame tool returns to the Tools panel as soon as you finish defining the crop.

5. Click the Close button in the Tools panel to apply the crop.

Lightroom applies the crop dimensions to the image.

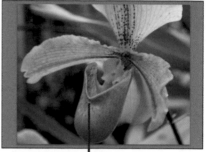

Lightroom applies the crop.

CHOOSE FROM SIX DIFFERENT CROP GUIDE OVERLAY CATEGORIES

>Go Further

To do so, choose a crop guide overlay category from the Tools, Crop Guide Overlay submenu. Options include Grid, Thirds, Diagonal, Triangle, Golden Ratio, and Golden Spiral. Press O to cycle through the Crop Guide Overlays. Press Shift+O to cycle through the Triangle, Golden Ratio, and Golden Spiral orientations.

Apply a Preset Crop Ratio

1. From the Library Grid or the Filmstrip, select the photo to crop.

2. Choose View, Crop. If you already have an image open in the Develop module, choose Tools, Crop.

Keyboard Shortcuts

Press R to apply the Crop command quickly.

Lightroom displays the Tools panel in the interface and auto-matically selects the Crop Overlay button. A Crop Overlay bounding box also appears over the photo.

3. Choose a Quick Develop crop ratio setting from the Crop Ratio drop-down list in the Tools panel.

Custom Aspect Ratio

To apply a custom aspect ratio, choose Enter Custom. Enter the preferred settings in the Enter Custom Aspect Ratio dialog box and click OK.

4. If necessary, click and drag the cursor inside the bounding box to reposition the image relative to the crop.

5. Click the Close button in the Tools panel to apply the crop.

Lightroom applies the crop dimensions to the image.

Lightroom applies the crop.

CONSTRAIN THE ASPECT RATIO AS YOU CROP AN IMAGE

>Go Further

To constrain the aspect ratio as you crop an image, click the Constrain Aspect Ratio button (the lock icon) in the Tools panel. With this option enabled, the current aspect ratio is preserved as you crop the image. If no crop settings have been applied yet, the aspect ratio is locked to the cur-rent image proportions.

Apply a Rotated Crop in Overlay Mode

There are certain instances where you might want to rotate an image and crop it at the same time, such as when attempting to straighten a crooked landscape photo.

1. From the Library module Grid or the Filmstrip, select the photo to crop.

2. Choose View, Crop. If you already have an image open in the Develop module, choose Tools, Crop.

 Lightroom displays the Tools panel in the interface and automatically selects the Crop Overlay button. A Crop Overlay bounding box also appears over the photo.

3. Click and drag the cursor outside the bounding box edges to rotate the image inside the crop area. Note that the Crop Overlay bounding box remains stationary.

4. Click the Close button in the Tools panel to apply the rotated crop.

 Lightroom applies the rotated crop to the image.

Lightroom applies the crop.

Apply a Rotated Crop with the Straighten Tool

1. From the Library module Grid or the Filmstrip, select the photo to crop.

2. Choose View, Crop. If you already have an image open in the Develop module, choose Tools, Crop.

Keyboard Shortcuts

Press R to apply the Crop command quickly.

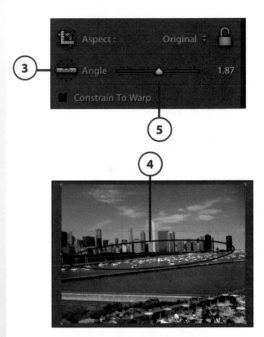

Lightroom displays the Tools panel in the interface and automatically selects the Crop Overlay button. A Crop Overlay bounding box also appears over the photo.

3. To access the Straighten tool, click the Straighten tool icon in the Tools panel.

4. To rotate the image, click and drag over the image with the Straighten tool.

The Straighten tool returns to the Tools panel as soon as you finish defining the rotation angle.

5. If necessary, fine-tune the rotation angle by dragging the Angle slider in the Tools panel to the left or right.

Scrubbie Sliders

Place the cursor over the Angle value to access "scrubbie" sliders. Click and drag to the left to decrease the value; click and drag to the right to increase it.

6. Click the Close button in the Tools panel to apply the rotated crop.

Lightroom applies the crop.

Applying Tonal Adjustments

The Develop module enables you to adjust the shadows, midtones, and highlights for individual images. You can click the Auto Tone button to apply a quick overall tonal adjustment, or adjust the image manually using the Exposure, Contrast, Shadows, Highlights, Whites, and Blacks sliders. With these controls, you can correct overexposed and underexposed images. In addition, you can enhance midtone contrast to reveal image detail by applying a Clarity adjustment.

Apply Auto Tone Adjustments

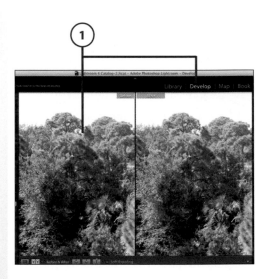

Auto Tone applies an automatic correction to all the following develop settings: Exposure, Highlights, Shadows, Blacks, Whites, and Contrast. Keep in mind that, like most auto adjustments, Auto Tone will not always give you perfect results. More often than not, Auto Tone is a good starting point for making further tonal adjustments.

1. Select an image from the Library Grid or Filmstrip and open it in the Develop module.

Keyboard Shortcuts
Press D to apply the Go to Develop command quickly.

Lightroom displays the photo in the Content area of the Develop module.

2. Choose Window, Panels, Basic to display the Basic panel.

3. Choose Settings, Auto Tone or click the Auto button in the Tone portion of the Basic panel.

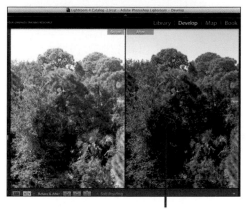

Keyboard Shortcuts

Press Cmd+U (Mac) or Ctrl+U (Win) to apply the Auto Tone command quickly.

Lightroom applies the Auto Tone adjustment to the image.

Lightroom applies the Auto Tone adjustment.

Set the Highlight Clipping Point

When applying manual tonal adjustments, the Exposure control is the best place to start. This is because the Exposure setting determines the clipping point (where detail starts to get lost) in the highlight areas of an image. In general, you should always set the highlight clipping point and then the shadow clipping point before making any further adjustments.

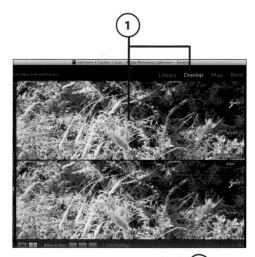

1. Select an image from the Library Grid or Filmstrip and open it in the Develop module.

 Lightroom displays the photo in the Content area of the Develop module.

2. Choose Window, Panels, Basic to display the Basic panel.

3. Drag the Basic panel Exposure slider to the right to increase the Exposure setting. Drag the slider to the left to decrease the Exposure setting.

Lightroom applies the Exposure adjustment to the image.

Threshold Mode

Press Option (Mac) or Alt (Win) as you drag the Exposure slider to view the image in Threshold mode. Doing so displays any areas in the image that are being clipped as you make the adjustment.

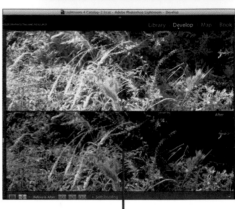

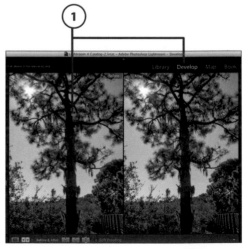

Lightroom applies the Exposure adjustment.

Set the Shadow Clipping Point

The Blacks slider enables you to control how much detail gets clipped in the shadow areas of your images. For certain images, you may not want a lot of visible detail lurking in the shadow areas. In these instances, you can apply a Blacks adjustment to expand the black clipping point and hide the unwanted shadow detail.

1. Select an image from the Library Grid or Filmstrip and open it in the Develop module.

Lightroom displays the photo in the Content area of the Develop module.

2. Choose Window, Panels, Basic to display the Basic panel.

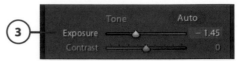

3. Drag the Basic panel Blacks slider to the left to increase the amount of shadow detail that gets clipped. Drag the slider to the right to decrease shadow clipping.

Threshold Mode

Press Option (Mac) or Alt (Win) as you drag the Blacks slider to view the image in Threshold mode. Doing so displays any areas in the image that are being clipped as you make the adjustment.

Lightroom applies the Blacks adjustment to the image.

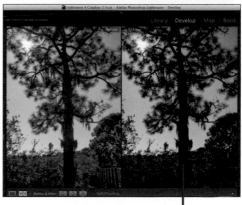

Lightroom applies the Blacks adjustment.

Correct an Overexposed Image ▶

Whenever the histogram displays a waveform pushed up against the right edge of the graph, it means that the image is clipping a considerable amount of detail in the highlight areas. You can correct overexposed images by reducing Exposure and increasing Highlights.

1. Select an image from the Library Grid or Filmstrip and open it in the Develop module.

Lightroom displays the photo in the Content area of the Develop module.

2. Choose Window, Panels, Basic to display the Basic panel.

3. Drag the Basic panel Exposure slider to the left to decrease the Exposure setting and reveal detail in the highlight areas. Note that reducing the Exposure setting will darken the overall image.

4. Drag the Basic panel Highlights slider to the left to reveal additional highlight detail without compromising the Exposure setting.

Shoot in Raw Format

Overexposure adjustments have a limited effect on JPEGs and TIFFs and are best used to correct raw master files.

Lightroom applies the adjustments.

Correct an Underexposed Image ▶

When the histogram displays a waveform pushed up against the left edge, it means that the image is clipping detail in the shadow areas. You can correct underexposed images by increasing the Exposure setting, then setting the new shadow clipping point with the Blacks slider, and finally, recovering detail in the shadow areas with a Shadows adjustment.

1. Select an image from the Library Grid or Filmstrip and open it in the Develop module.

 Lightroom displays the photo in the Content area of the Develop module.

2. Choose Window, Panels, Basic to display the Basic panel.

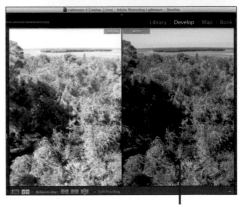

3. Drag the Exposure slider to the right to increase the Exposure setting and brighten the image overall.

Beware of Noise!

Increasing exposure for an under-exposed image can reveal a large amount of noise. This can be reduced using the Noise reduction controls in the Detail panel (see Chapter 11, "Reducing Noise and Sharpening").

4. Drag the Blacks slider to the left or right to determine the new shadow clipping point.

5. Drag the Shadows slider to the right to increase the adjustment and reveal additional shadow detail.

Lightroom applies the adjustments.

Adjust Midtone Contrast with Clarity ▶

With Clarity, you can make your images appear clearer rather than sharper. This is done by increasing contrast in the midtone areas of your photographs.

1. Select an image from the Library Grid or Filmstrip and open it in the Develop module.

 Lightroom displays the photo in the Content area of the Develop module.

2. Choose Window, Panels, Basic to display the Basic panel.

3. Drag the Clarity slider to the right to increase midtone contrast and allow the midtone areas stand out more. Drag the slider to the left to decrease clarity.

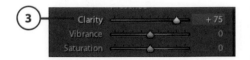

Lightroom applies the Clarity adjustment to the image. The effect can be subtle depending on the amount of midtone areas contained in your photos, but in general, most digital images can benefit from a slight Clarity adjustment.

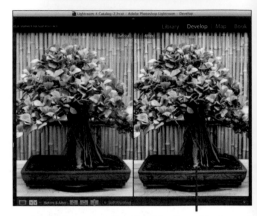

Lightroom applies the Clarity adjustment.

Applying Color Adjustments

In the Develop module, you can adjust the white balance of an image automatically using a preset or the White Balance Selector; or manually, by moving the Temperature and Tint sliders. This enables you to either remove an undesirable color cast, or create a cooling or warming effect. You can also enhance image colors using the Vibrance and Saturation controls.

Apply a White Balance Preset

Even if you're a seasoned pro who is careful about the white balance camera settings you choose, it can be difficult to select the right one when capturing a scene that contains mixed lighting conditions. Should you choose the wrong setting, you can correct the image in Lightroom by choosing a white balance preset.

1. Select an image from the Library Grid or Filmstrip and open it in the Develop module.

Lightroom displays the photo in the Content area of the Develop module.

2. Choose Window, Panels, Basic to display the Basic panel.

Keyboard Shortcuts

Press Cmd+1 (Mac) or Ctrl+1 (Win) to show or hide the Basic panel quickly.

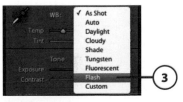

3. Choose a white balance setting from the Basic panel White Balance drop-down list. For JPEGs, TIFFs, and PSDs, the only available white balance preset option, other than As Shot or Custom, is Auto. For DNG and proprietary raw files, there are many more presets, including Auto, Daylight, Cloudy, Shade, Tungsten, Fluorescent, and Flash.

Keyboard Shortcuts

Press Cmd+Shift+U (Mac) or Ctrl+Shift+U (Win) to apply the Auto White Balance command quickly.

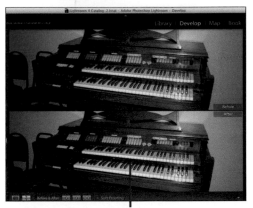

Lightroom applies the white balance preset.

Adjust White Balance with the Temperature and Tint Sliders

1. Select an image from the Library Grid or Filmstrip and open it in the Develop module.

 Lightroom displays the photo in the Content area of the Develop module.

2. Choose Window, Panels, Basic to display the Basic panel.

Keyboard Shortcuts

Press Cmd+1 (Mac) or Ctrl+1 (Win) to show or hide the Basic panel quickly.

3. Drag the Basic panel Temp slider to the right to make the image appear warmer. Drag the slider to the left to make the image appear cooler.

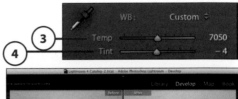

4. If necessary, you can offset the temperature adjustment slightly by dragging the Basic panel Tint slider. Drag the Tint slider to the right to apply a magenta tint; drag it to the left to apply a green tint.

Use the White Balance Selector

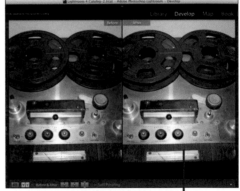

Lightroom applies the adjustments.

1. From the Library module Grid or the Filmstrip, select the photo to adjust.

2. Choose View, Adjust White Balance. If you already have an image open in the Develop module, choose Tools, White Balance Selector, or click the White Balance Selector icon in the Basic panel.

Keyboard Shortcuts

Press W to apply the Adjust White Balance command.

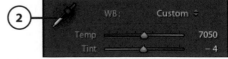

Lightroom displays the Basic panel in the interface and automatically selects the White Balance Selector.

3. Click in an area of the image that should appear neutral in color. Refer to the RGB percentages displayed at the bottom of the floating pixel magnifier to determine the neutrality of a color. The closer the RGB percentages are to each other, the more neutral the color is.

Auto Dismiss Option

When the Auto Dismiss option is enabled in the Toolbar, the White Balance Selector is automatically docked in the Basic panel after you click in the image. When it is disabled, you can click continously in the image, but must click the Done button in the Toolbar to apply the adjustment.

Lightroom applies the adjustment.

Enhance Color with Saturation

With Saturation, you can control how vivid the colors appear in your images. Unlike Vibrance, Saturation is a linear adjustment, which can oversaturate colors that already appear saturated in your images. In most cases, Vibrance is the better tool for increasing color vividness; however, Saturation is still useful for subduing colors to create a dramatic effect.

1. Select an image from the Library Grid or Filmstrip and open it in the Develop module.

Lightroom displays the photo in the Content area of the Develop module.

2. Choose Window, Panels, Basic to display the Basic panel.

Keyboard Shortcuts

Press Cmd+1 (Mac) or Ctrl+1 (Win) to show or hide the Basic panel quickly.

3. Drag the Saturation slider to the right to increase color saturation. Drag the slider to the left to decrease saturation.

Enhance Color with Vibrance

Vibrance, unlike Saturation, is a non-linear adjustment. Therefore, you can use it to make dull colors appear more vivid without oversaturating the colors that already appear saturated in your images. Vibrance also includes a built-in skin protector that automatically filters out colors that fall within the skin tone range.

1. Select an image from the Library Grid or Filmstrip and open it in the Develop module.

Lightroom displays the photo in the Content area of the Develop module.

2. Choose Window, Panels, Basic to display the Basic panel.

Lightroom applies the adjustment.

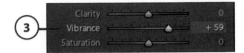

Keyboard Shortcuts

Press Cmd+1 (Mac) or Ctrl+1 (Win) to show or hide the Basic panel quickly.

3. Drag the Vibrance slider to the right to increase vividness of dull colors in the image. Drag the slider to the left to decrease vibrance.

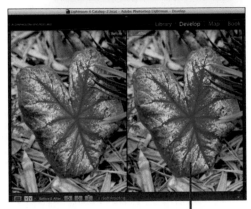

Lightroom applies the Vibrance adjustment.

Working with Tone Curves

The parametric sliders in the Tone Curve panel enable you to make tone curve adjustments based on descriptive image criteria. The tone curve is divided into four zones: Highlights, Lights, Darks, and Shadows. Note that you can also manipulate the curve graph manually by clicking and dragging any point up or down. With the Target Adjustment tool selected, you can click anywhere in the photo and drag up or down to darken or lighten that zone.

Apply a Point Curve Preset

1. Select an image from the Library Grid or Filmstrip and open it in the Develop module.

 Lightroom displays the photo in the Content area of the Develop module.

2. Choose Window, Panels, Tone Curve to display the Tone Curve panel.

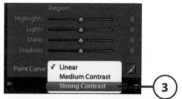

Keyboard Shortcuts

Press Cmd+2 (Mac) or Ctrl+2 (Win) to show or hide the Tone Curve panel quickly.

3. Choose a Tone Curve preset from the Point Curve drop-down list. Options include Linear, Medium Contrast, and Strong Contrast.

Linear Default

By default, with process version 2012, the Point Curve preset is set to Linear. This means that an automatic tone curve adjustment is not applied to your images upon import, as in previous process versions.

Lightroom applies the Point Curve preset.

Apply Tone Curves with the Parametric Sliders

1. Select an image from the Library Grid or Filmstrip and open it in the Develop module.

Lightroom displays the photo in the Content area of the Develop module.

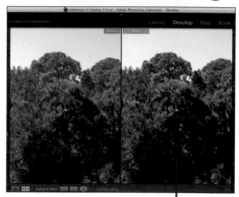

2. Choose Window, Panels, Tone Curve to display the Tone Curve panel.

Keyboard Shortcuts

Press Cmd+2 (Mac) or Ctrl+2 (Win) to show or hide the Tone Curve panel quickly.

3. Drag the Darks slider to the right to lighten the quarter tone areas in the image.

4. Drag the Shadows slider to the left to increase contrast in the overall image.

5. Drag the Lights slider to the right to lighten the three-quarter tone areas in the image.

6. Drag the Highlights slider to the left to compensate for any high-light clipping that occurs as a result of the Lights adjustment.

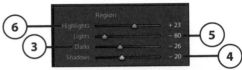

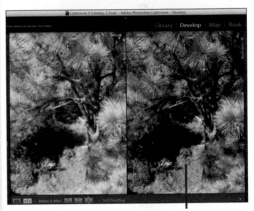

Lightroom applies the adjustment.

Apply Tone Curves with the Target Adjustment Tool

1. Select an image from the Library Grid or Filmstrip and open it in the Develop module.

Lightroom displays the photo in the Content area of the Develop module.

2. Choose Window, Panels, Tone Curve to display the Tone Curve panel.

Keyboard Shortcuts

Press Cmd+2 (Mac) or Ctrl+2 (Win) to show or hide the Tone Curve panel quickly.

3. To access the Target Adjustment tool, click the Target Adjustment icon in the Tone Curve panel or choose View, Target Adjustment, Tone Curve.

Keyboard Shortcuts

Press Cmd+Shift+Option+T (Mac) or Ctrl+Shift+Alt+T (Win) to access the Tone Curve Target Adjustment tool quickly.

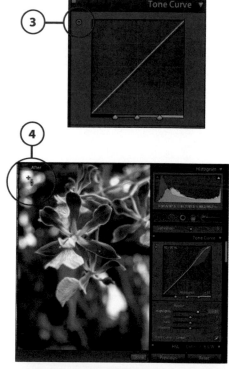

4. Click in an area of the image that you'd like to lighten and drag up with the tool. Lightroom adjusts the Tone Curve accordingly.

5. Click in an area of the image that you'd like to darken and drag down with the tool. Lightroom adjusts the Tone Curve accordingly.

Resetting Slider Controls

You can reset the Develop module slider controls by double-clicking them. Double-click any Develop module slider to reposition it to its original default setting.

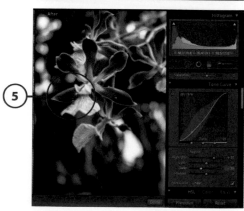

>>Go Further

CONTROL THE AMOUNT OF IMAGE AREA AFFECTED BY EACH PARAMETRIC TONE CURVE SLIDER

To increase or decrease the amount of image area affected by the parametric Tone Curve sliders, drag the Tone Range Split Points located at the bottom of the tone curve. By dragging the two outer Tone Range Split Points closer together, you can increase midtone contrast. By dragging them farther apart, you can decrease midtone contrast.

6. Turn off the Target Adjustment tool by clicking the Target Adjustment icon in the Tone Curve panel or by choosing Tools, Target Adjustment, None. You can also turn off the Target Adjustment tool by clicking the Done button in the Toolbar.

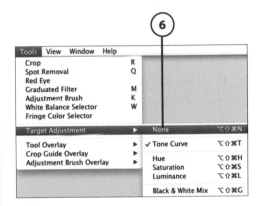

Keyboard Shortcuts

Press Cmd+Shift+Option+N (Mac) or Ctrl+Shift+Alt+N (Win) to turn off the Target Adjustment tool.

Apply Tone Curve Adjustments to Individual Channels ▶

1. Select an image from the Library Grid or Filmstrip and open it in the Develop module.

 Lightroom displays the photo in the Content area of the Develop module.

2. Choose Window, Panels, Tone Curve to display the Tone Curve panel.

3. In the bottom-right corner of the Tone Curve panel, click the Edit Point Curve button.

 Lightroom hides the Parametric tone Curve sliders.

4. Choose the color channel (Red, Green, or Blue) from the Channel drop-down list.

5. To access the Target Adjustment tool, click the Target Adjustment icon in the Tone Curve panel or choose View, Target Adjustment, Tone Curve.

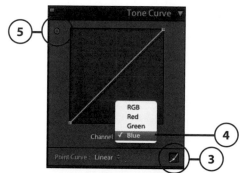

Keyboard Shortcuts

Press Cmd+Shift+Option+T (Mac) or Ctrl+Shift+Alt+T (Win) to access the Tone Curve Target Adjustment tool quickly.

6. To add more of the chosen color (red, green, or blue), click in an area of the image and drag up with the tool. Lightroom adjusts the Tone Curve accordingly.

7. To add more of the color that appears opposite of the chosen color on the color wheel (cyan, magenta, or yellow), click in an area of the image and drag down with the tool. Lightroom adjusts the Tone Curve accordingly.

8. Turn off the Target Adjustment tool by clicking the Target Adjustment icon in the Tone Curve panel or by choosing Tools, Target Adjustment, None. You can also turn off the Target Adjustment tool by clicking the Done button in the Toolbar.

Keyboard Shortcuts

Press Cmd+Shift+Option+N (Mac) or Ctrl+Shift+Alt+N (Win) to turn off the Target Adjustment tool.

Enhancing Color with HSL Adjustments

The controls in the HSL/Color/Black & White panel enable you to apply selective color adjustments. The HSL portion of the panel contains sliders for adjusting Hue, Saturation, and Luminance. These sliders are useful for correcting skin tone. The Color portion of the panel is merely a simplified version of the same controls. The Black & White portion of the panel is used for carrying out monochrome conversions, which you will learn more about in Chapter 10, "Working in Black and White."

Apply Selective Color Adjustments with the Hue Sliders ▶

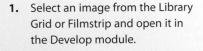

1. Select an image from the Library Grid or Filmstrip and open it in the Develop module.

 Lightroom displays the photo in the Content area of the Develop module.

2. Choose Window, Panels, HSL/
Color/Black & White to display the
HSL/Color/Black & White panel.

Keyboard Shortcuts

Press Cmd+3 (Mac) or Ctrl+3
(Win) to show or hide the HSL/
Color/Black & White panel quickly.

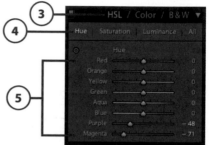

3. The HSL/Color/Black & White
panel displays the last set of con-
trols used. If the HSL controls are
not visible, click the HSL button at
the top of the HSL/Color/Black &
White panel.

4. Click the Hue button in the upper-
left corner of the HSL panel.

5. In the HSL panel, drag the Hue
sliders for the colors you'd like to
shift in the image.

Lightroom applies the Hue adjustment.

Apply Selective Color Adjustments with the Saturation Sliders

1. Select an image from the Library
Grid or Filmstrip and open it in
the Develop module.

Lightroom displays the photo in
the Content area of the Develop
module.

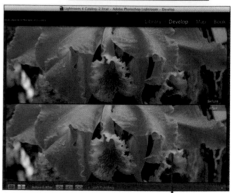

2. Choose Window, Panels, HSL/ Color/Black & White to display the HSL/Color/Black & White panel.

Keyboard Shortcuts

Press Cmd+3 (Mac) or Ctrl+3 (Win) to show or hide the HSL/ Color/Black & White panel quickly.

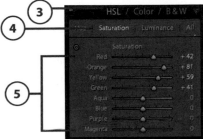

3. The HSL/Color/Black & White panel displays the last set of controls used. If the HSL controls are not visible, click the HSL button at the top of the HSL/Color/Black & White panel.

4. Click the Saturation button in the upper portion of the HSL panel.

5. In the HSL panel, drag the Saturation sliders for the colors you'd like to enhance in the image.

Apply Selective Color Adjustments with the Luminance Sliders

1. Select an image from the Library Grid or Filmstrip and open it in the Develop module.

 Lightroom displays the photo in the Content area of the Develop module.

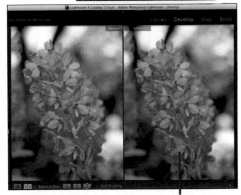

Lightroom applies the Saturation adjustment.

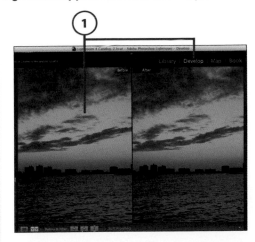

2. Choose Window, Panels, HSL/ Color/Black & White to display the HSL/Color/Black & White panel.

Keyboard Shortcuts

Press Cmd+3 (Mac) or Ctrl+3 (Win) to show or hide the HSL/ Color/Black & White panel quickly.

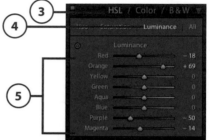

3. The HSL/Color/Black & White panel displays the last set of controls used. If the HSL controls are not visible, click the HSL button at the top of the HSL/Color/Black & White panel.

4. Click the Luminance button in the upper-right corner of the HSL panel.

5. In the HSL panel, drag the Luminance sliders for the colors you'd like to brighten or darken in the image.

Apply Selective Color Adjustments with the Target Adjustment Tool

1. Select an image from the Library Grid or Filmstrip and open it in the Develop module.

 Lightroom displays the photo in the Content area of the Develop module.

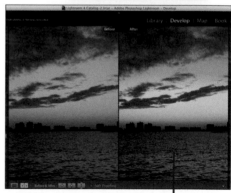

Lightroom applies the Luminance adjustment.

2. Choose Window, Panels, HSL/ Color/Black & White to display the HSL/Color/Black & White panel.

3. The HSL/Color/Black & White panel displays the last set of controls used. If the HSL controls are not visible, click the HSL button at the top of the HSL/Color/Black & White panel.

4. To access the Target Adjustment tool, click the Target Adjustment icon in the HSL/Color/B & W panel.

5. Choose Hue, Saturation, or Luminance from the Tools, Target Adjustment submenu.

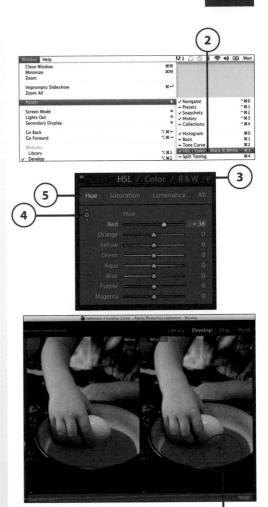

Keyboard Shortcuts

Press Cmd+Shift+Option+H (Mac) or Ctrl+Shift+Alt+H (Win) to access the Hue Target Adjustment tool. Press Cmd+Shift+Option+S (Mac) or Ctrl+Shift+Alt+S (Win) to access the Saturation Target Adjustment tool. Press Cmd+Shift+Option+L (Mac) or Ctrl+Shift+Alt+L (Win) to access the Luminance Target Adjustment tool.

6. Click in the area of the image that you'd like to adjust and drag up or down with the tool.

7. Turn off the Target Adjustment tool by clicking the Target Adjustment icon in the HSL/ Color/B & W panel or by choosing Tools, Target Adjustment, None. You can also turn off the Target Adjustment tool by clicking the Done button in the Toolbar.

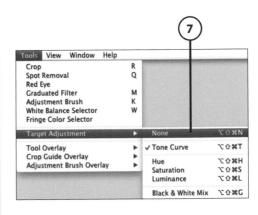

Correcting Chromatic Aberration

Chromatic aberration is caused by a camera's inability to focus red, green, and blue light wavelengths at an equal distance along the optical axis. As a result, color fringes appear around high-contrast edges in the image. This problem is especially common when shooting with certain wide-angle lenses. You can remove any unwanted color fringes by adjusting the Chromatic Aberration sliders located in the Lens Corrections panel.

Remove Color Halos

1. Select an image from the Library Grid or Filmstrip and open it in the Develop module.

 Lightroom displays the photo in the Content area of the Develop module.

2. Choose Window, Panels, Lens Corrections to display the Lens Corrections panel.

Keyboard Shortcuts

Press Cmd+6 (Mac) or Ctrl+6 (Win) to show or hide the Lens Corrections panel quickly.

3. Click the Color button located at the top of the Lens Corrections panel.

4. Enable the Remove Chromatic Aberration option.

5. If halos are still apparent throughout the image, even after enabling the Remove option, drag the Purple Hue or Green Hue sliders in the opposite direction of the halo's color. For example, if the halo is blue, drag the Purple Hue sliders to the right to add yellow. Control how much defringe to apply by dragging the Amount sliders to the right.

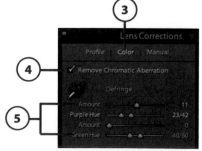

Fringe Color Selector

You can also correct chromatic aberration using the Fringe Color Selector by clicking the eyedropper icon in the Color portion of the Lens Corrections panel to select the tool. Click directly on the fringe colors in the image to correct them. Choose Tools, Fringe Color Selector or click the Done button in the Toolbar to disable the tool.

Lightroom removes the chromatic aberration.

Working with Vignettes

Vignetting can be viewed as either a problem or a desirable effect. Natural vignetting can occur when shooting with a wide-angle lens, expecially when shooting a landscape that contains a large expanse of sky, or when shooting a subject against a white background. This is evidenced by the darkening of the corner edges where there should be an even shade of tone or color. You can remove vignetting by adjusting the Lens Vignetting sliders. By the same token, you can also create vignetting effects in Lightroom. Post-Crop vignettes can be combined with Lens Correction vignettes to create interesting effects. Note that a photo does not need to be cropped to create a vignette with the Post-Crop Vignetting sliders.

Remove a Vignette ▶

1. Select an image from the Library Grid or Filmstrip and open it in the Develop module.

 Lightroom displays the photo in the Content area of the Develop module.

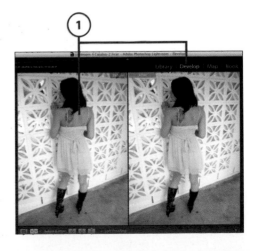

2. Choose Window, Panels, Lens Corrections to display the Lens Corrections panel.

Keyboard Shortcuts

Press Cmd+6 (Mac) or Ctrl+6 (Win) to show or hide the Lens Corrections panel quickly.

3. Click the Manual button located at the top of the Lens Corrections panel.

4. In the Lens Vignetting portion of the panel, drag the Amount slider to lighten the corners relative to the center. Drag the Midpoint slider to balance the vignette from the center to the edges.

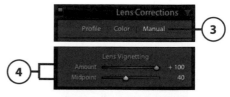

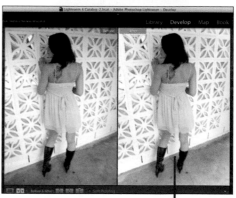

Lightroom removes the vignette.

Create a Vignette

1. Select an image from the Library Grid or Filmstrip and open it in the Develop module.

 Lightroom displays the photo in the Content area of the Develop module.

Keyboard Shortcuts

Press Cmd+7 (Mac) or Ctrl+7 (Win) to show or hide the Effects panel quickly.

2. Choose Window, Panels, Effects to display the Effects panel.

3. In the Post-Crop Vignetting portion of the Effects panel, choose an option from the Style drop-down list.

 Highlight Priority maintains highlight areas, but can also result in color shifts in darkened areas of the vignette. This option is best used with photos containing bright image areas, such as clipped specular highlights.

 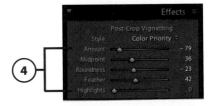

 Color Priority minimizes color shifts in darkened areas of the vignette, but cannot perform highlight recovery.

 Paint Overlay mixes the cropped image values with black or white pixels. This option can result in a flat appearance.

4. In the Post-Crop Vignetting portion of the Effects panel, choose the preferred settings.

 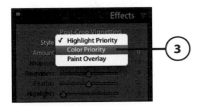

 Drag the Amount slider to darken or lighten the corners relative to the center.

 Drag the Midpoint slider to balance the vignette from the center to the edges.

 Drag the Roundness slider to the right to make the vignette appear circular.

 Drag the Feather slider to the right to soften the vignette edges. Drag it to the left to harden them.

 Drag the Highlights slider to the right to reveal highlight areas in the dark corners of the vignette.

Lightroom applies the vignette.

Adding Film Grain

In addition to Post-Crop Vignetting, the Effects panel also includes a Grain feature. This feature enables you to simulate film grain by adding noise to your digital images. You can use this effect to apply an aged look to a black-and-white photo or to simply make a digital image appear less "perfect."

Apply a Film Grain Effect

1. Select an image from the Library Grid or Filmstrip and open it in the Develop module.

 Lightroom displays the photo in the Content area of the Develop module.

2. Choose Window, Panels, Effects to display the Effects panel.

3. In the Grain portion of the Effects panel, choose the preferred settings.

 Drag the Amount slider to the right to increase the amount of grain added to the image; drag to the left to decrease.

 Drag the Size slider to the right to increase the size of grain added to the image; drag to the left to decrease.

 Drag the Roughness slider to the right to increase the roughness of the film grain texture; drag to the left to soften.

Lightroom applies the film grain effect.

Learn to apply local color
temperature adjustments.

Learn to apply adjustments
to specific areas of an image.

Learn to utilize
Adjustment Brush
presets.

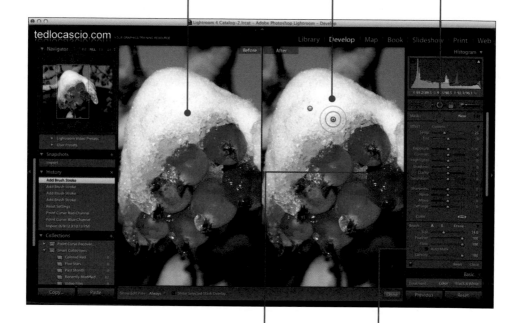

Learn to apply local
sharpening adjustments.

Learn to use the
Adjustment Brush in
Auto Mask mode.

In this chapter, you learn how to edit specific areas of an image.

→ Working with the Spot Removal Tool
→ Correcting Red Eye
→ Working with the Adjustment Brush
→ Utilizing Adjustment Brush Presets
→ Using the Graduated Filter Tool

8

Applying Localized Adjustments

The majority of adjustments you can apply to an image in the Develop module are administered globally (to the entire image). However, there is also a special group of tools that enables you to apply adjustments locally (to a specific area of the image).

In this chapter, you learn how to clone and heal with the Spot Removal tool, and how to correct red eye with the Red Eye Correction tool. You also learn how to apply adjustments to specific areas of an image with the Adjustment Brush, and how to edit effect settings for applied brush strokes simultaneously.

This chapter also teaches you how to create and save effect setting presets, and how to utilize the built-in Soften Skin preset. The final sections of this chapter teach you how to use the Graduated Filter tool to apply adjustments that gradually fade along a linear path.

Working with the Spot Removal Tool

In Clone mode, the Spot Removal tool enables you to remove blemishes, such as dust spots, from an image. In Heal mode, you can also use the tool to retouch skin in a portrait. One of the great things about editing images with this tool is that you can add as many spot circles to an image as you like and still be able to edit or remove them at any time.

Clone with the Spot Removal Tool

When you use the Spot Removal tool in Clone mode, Lightroom copies pixels using a feathered circle edge. You can add as many spot circles to the image as you like, and you can edit or remove them at any time.

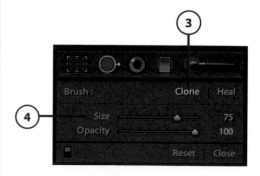

1. Select an image from the Library Grid or Filmstrip and open it in the Develop module.

 Lightroom displays the photo in the Content area of the Develop module.

2. To access the Spot Removal tool, choose Tools, Spot Removal, or click the Spot Removal icon in the Tools panel.

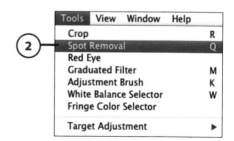

Keyboard Shortcuts
Press Q to toggle the Spot Removal tool on and off.

3. Click the Clone button.

4. Size the Spot Removal tool cursor by adjusting the Size slider.

Keyboard Shortcuts
Press the left bracket key ([) to decrease the cursor size; press the right bracket key (]) to increase it.

5. Use one of the following methods to remove a blemish from the image:

Click once over the blemish to create a spot circle and allow Lightroom to autoselect a sample point.

Click and drag outward to create the spot circle and manually select a sample point.

To size the spot circle as you create it, hold down Cmd (Mac) or Ctrl (Win) and draw a marquee over the blemish. Lightroom autoselects the sample point

Lightroom displays the source (thin) and destination (thick) spot circles in the image.

Blemish ⑤

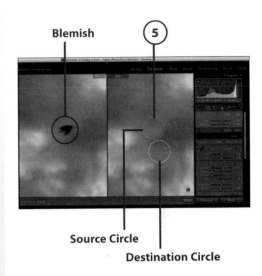

Source Circle

Destination Circle

Reposition the Source

If necessary, you can reposition the source circle by dragging it to another area of the image. As you do, Lightroom hides the destination circle so that you can preview the effect accurately.

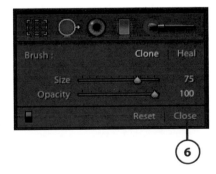

⑥

6. Click the Close button in the Tools panel to turn off the Spot Removal tool.

Edit Spot Removal Circles

Spot Removal circles remain editable. To display the spot circles again after clicking the Close button, simply choose Tools, Spot Removal, or click the Spot Removal icon in the Tools panel.

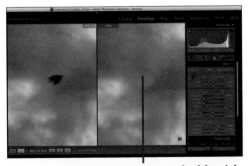

Lightroom removes the blemish.

Heal with the Spot Removal Tool

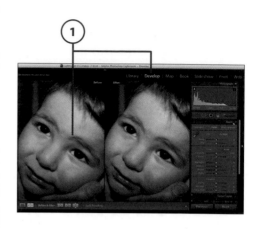

When you use the Spot Removal tool in Heal mode, Lightroom copies pixels and blends them around the inner edges of the spot circle. This results in a much softer cloning effect, which works best for retouching facial portraits.

1. Select an image from the Library Grid or Filmstrip and open it in the Develop module.

 Lightroom displays the photo in the Content area of the Develop module.

2. To access the Spot Removal tool, choose Tools, Spot Removal, or click the Spot Removal icon in the Tools panel.

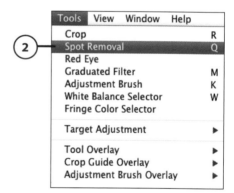

Keyboard Shortcuts

Press Q to toggle the Spot Removal tool on and off.

3. Click the Heal button in the Tools panel.

4. Size the Spot Removal tool cursor by adjusting the Spot Size slider.

Keyboard Shortcuts

Press the left bracket key ([) to decrease the cursor size; press the right bracket key (]) to increase it.

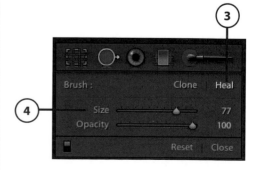

5. Use one of the following methods to remove a blemish from the image:

Click once over the blemish to create a spot circle and allow Lightroom to autoselect a sample point.

Click and drag outward to create the spot circle and manually select a sample point.

To size the spot circle as you create it, hold down Cmd (Mac) or Ctrl (Win) and draw a marquee over the blemish. Lightroom autoselects the sample point.

Lightroom displays the source (thin) and destination (thick) spot circles in the image.

Blemish ⑤

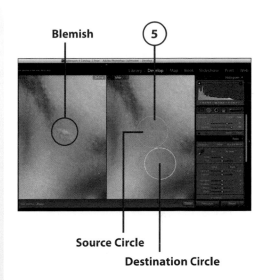

Source Circle
Destination Circle

Reposition the Source

If necessary, you can reposition the source circle by dragging it to another area of the image. As you do, Lightroom hides the destination circle so that you can preview the effect accurately.

⑥

6. Click the Close button in the Tools panel to turn off the Spot Removal tool.

Keyboard Shortcuts

To hide the spot circles as you work with the tool, press the H key. You can delete a spot circle by clicking to select it and then pressing Delete. To remove all spot circles from the image, click the Reset button in the Tools panel.

Lightroom removes the blemish.

Correcting Red Eye

Although many digital cameras now include an anti-red eye flash feature, it is sometimes better to rely on Lightroom's Red Eye Correction tool to fix this common problem. For example, it can be very difficult to capture spontaneous snapshots when you have to wait for your camera to fire a couple of pre-flashes before actually taking the picture. Also, there is an added benefit to relying on the Red Eye Correction tool in Lightroom because you can edit or remove any red eye corrections that you make at any time.

Remove Red Eye ▶

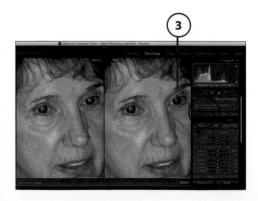

1. Select an image from the Library Grid or Filmstrip and open it in the Develop module.

 Lightroom displays the photo in the Content area of the Develop module.

2. To access the Red Eye Correction tool, choose Tools, Red Eye, or click the Red Eye Correction icon in the Tools panel.

3. Drag from the center of the eye outward, or simply click the center of the eye with the tool.

 Lightroom targets the red area that needs correcting and darkens it.

Adjust Pupil Size

If necessary, adjust the pupil size in the correction circle by dragging the Pupil Size slider in the Tools panel. You can also resize the correction circle itself by clicking and dragging its edge. Reposition the correction circle by clicking and dragging its center.

4. Adjust the pupil darkness by dragging the Darken slider.

5. Click the Close button in the Tools panel to turn off the Red Eye Correction tool.

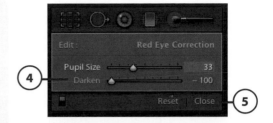

Lightroom corrects the red eye.

Working with the Adjustment Brush

The sliders in the Basic panel enable you to apply adjustments to an entire image. However, if you'd like to apply an adjustment to a specific area of an image, you must do so using the Adjustment Brush. To apply multiple effects at once, you must drag the Effect Sliders in the Tools panel. With these sliders you can apply myriad local adjustments, including color temperature, sharpening, color tinting, noise reduction, and more.

Apply Localized Adjustments with the Adjustment Brush

1. Select an image from the Library Grid or Filmstrip and open it in the Develop module.

 Lightroom displays the photo in the Content area of the Develop module.

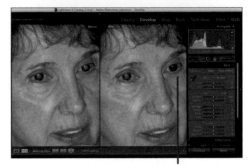

2. Choose Tools, Adjustment Brush.

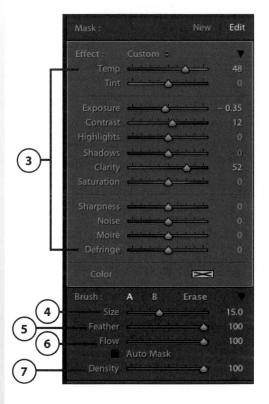

Keyboard Shortcuts

Press K to apply the Adjustment Brush command.

Lightroom automatically selects the Adjustment Brush in the Tools panel.

3. Adjust the sliders for the effects that you would like to apply.

4. Size the Adjustment Brush by adjusting the Size slider.

Keyboard Shortcuts

Press the left bracket key ([) to decrease the cursor size; press the right bracket key (]) to increase it.

5. Indicate the hardness or softness of the brush by adjusting the Feather slider.

Keyboard Shortcuts

Press Shift+left bracket key ([) to decrease the Feather amount; press Shift+right bracket key (]) to increase it.

6. Indicate the airbrush flow amount by adjusting the Flow slider.

7. Indicate the maximum brush opacity by adjusting the Density slider.

8. Click and drag over the image area that you'd like to adjust.

Lightroom adds a reference pin marker where you first clicked.

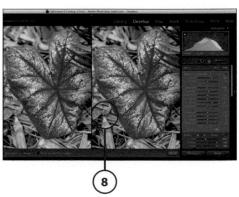

9. Click the Close button in the Tools panel to turn off the Adjustment Brush.

Switch Brush Settings

You can switch between two different Adjustment Brush settings. The A and B buttons in the Tools panel enable you to create two separate brush settings so you can easily switch between them as you work.

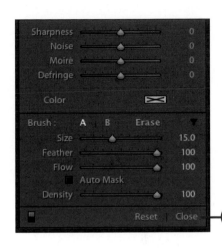

Edit Adjustment Brush Strokes

1. From the Library Grid or the Filmstrip, select a photo that contains localized adjustments made with the Adjustment Brush and open it in the Develop module.

 Lightroom displays the photo in the Content area of the Develop module.

2. Choose Tools, Adjustment Brush.

Keyboard Shortcuts

Press K to apply the Adjustment Brush command.

Lightroom automatically selects the Adjustment Brush in the Tools panel.

Show Tool Overlays

Make sure all tool overlays are visible by choosing Tools, Tool Overlay, Always Show.

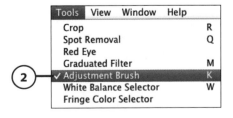

Keyboard Shortcuts

Press Shift+Cmd+H (Mac) or Shift+Ctrl+H (Win) to toggle tool overlay visibility on and off.

3. Select the pin marker for the strokes you would like to edit.

Highlight Affected Areas

When you hover the cursor over a pin marker, Lightroom highlights all image areas containing brush strokes in red.

4. Adjust the slider settings for the selected group of strokes. You can also add strokes with the Adjustment Brush or erase them.

Keyboard Shortcuts

Click the pin marker and hold down Option (Mac) or Alt (Win) and drag left or right to decrease or increase the effect.

5. Click the Close button in the Tools panel to turn off the Adjustment Brush.

Hide Adjustment Brush Edits

You can hide Adjustment Brush edits as you work with the tool. To do so, click the on/off button located in the bottom-left corner of the Tools panel. Doing so enables you to compare the before and after states of the image.

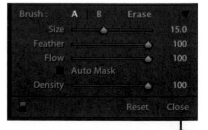

Use Auto Mask Mode

The Auto Mask option cleverly analyzes the color and tone of the area where you first click with the Adjustment Brush. As you add strokes, it applies the effect to matching areas in the image. It also resamples continously as you paint with the tool.

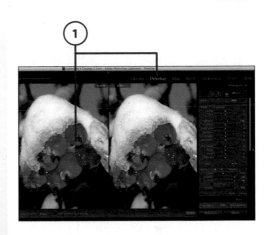

1. Select an image from the Library Grid or Filmstrip and open it in the Develop module.

 Lightroom displays the photo in the Content area of the Develop module.

2. Choose Tools, Adjustment Brush.

Keyboard Shortcuts

Press K to apply the Adjustment Brush command quickly.

Lightroom automatically selects the Adjustment Brush in the Tools panel.

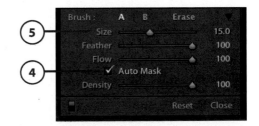

3. Using the sliders available in the Tools panel, choose the adjustment settings that you would like to apply. In this example, it's the Color effect.

4. Enable the Auto Mask mode option.

5. Size the Adjustment Brush by adjusting the Size slider.

Keyboard Shortcuts

Press the left bracket key ([) to decrease the cursor size; press the right bracket key (]) to increase it.

6. Indicate the hardness or softness of the brush by adjusting the Feather slider.

7. Indicate the airbrush flow of the brush by adjusting the Flow slider.

8. Indicate the maximum brush opacity by adjusting the Density slider.

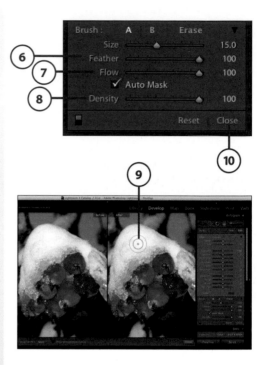

9. Click and drag over the image area that you'd like to adjust. In this example, it's the snow and ice that are targeted.

Lightroom adds a reference pin marker and analyzes the tone and color of the area where you clicked to generate the auto mask.

10. Click the Close button in the Tools panel to turn off the Adjustment Brush.

Hand Color a Black-and-White Image

Another creative way to work with the Adjustment Brush is to hand tint a black-and-white photo. As you paint, you can create a new stroke set for every color you apply. Doing so allows for greater editing control.

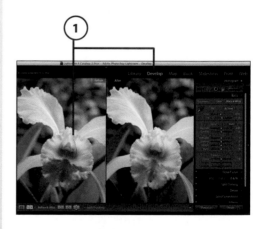

1. Select an image from the Library Grid or Filmstrip and open it in the Develop module.

Lightroom displays the photo in the Content area of the Develop module.

2. Choose Tools, Adjustment Brush.

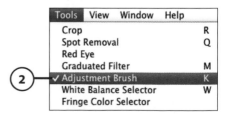

3. Click the Color swatch icon in the Tools panel.

4. Select a color by clicking inside the color spectrum, or by clicking one of the color preset swatches located at the top of the Color Picker window.

5. If necessary, adjust the Hue value using the "scrubbie" slider.

6. If necessary, adjust the Saturation level by dragging the slider.

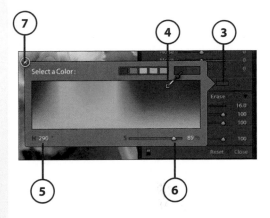

7. Click the Close button in the upper-left corner of the Color Picker window.

8. Enable the Auto Mask mode option in the Tools panel.

9. Size the Adjustment Brush by adjusting the Size slider in the Tools panel.

10. Indicate the hardness or softness of the brush by adjusting the Feather slider.

11. Indicate the airbrush flow of the brush by adjusting the Flow slider.

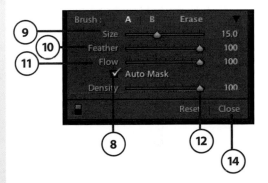

12. Indicate the maximum brush opacity by adjusting the Density slider.

13. Click and drag over the image areas to apply the color.

Lightroom adds a reference pin marker and applies the Color effect.

14. Click the Close button in the Tools panel to turn off the Adjustment Brush.

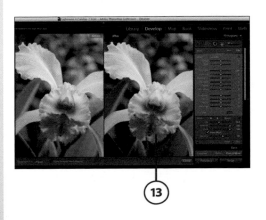

DISPLAY A TEMPORARY OVERLAY OVER PAINTED REGIONS

Lightroom enables you to display a temporary overlay of the regions painted over with the Adjustment Brush. To display the overlay, hover the Adjustment Brush cursor over the pin marker. Press Shift+O to cycle through the different mask overlay display colors (gray, red, green, or off).

Apply Localized Sharpening

In some cases, such as when working with a fashion photo or portrait image, you might want to apply extra sharpening to specific areas, such as the eyes, mouth, and hair. With the Adjustment Brush, you can boost midtone contrast by painting with increased Clarity settings. For stronger results, you can paint with the Sharpness effect.

1. Select an image from the Library Grid or Filmstrip and open it in the Develop module.

 Lightroom displays the photo in the Content area of the Develop module.

2. Choose Tools, Adjustment Brush.

 Lightroom automatically selects the Adjustment Brush in the Tools panel.

3. Increase the amount of clarity by dragging the Clarity slider to the right. For stronger sharpening, drag the Sharpness it to the right.

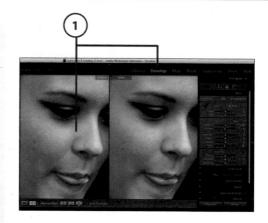

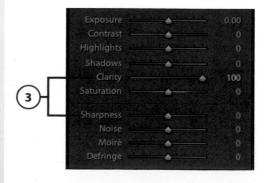

4. Size the Adjustment Brush by adjusting the Size slider.

5. Indicate the hardness or softness of the brush by adjusting the Feather slider.

6. Indicate the airbrush flow of the brush by adjusting the Flow slider.

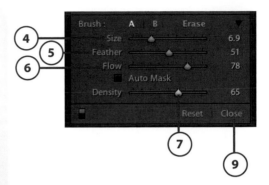

7. Indicate the maximum brush opacity by adjusting the Density slider.

8. Click and drag over the image areas that could use midtone contrast, such as the mouth, eyebrows, and nose in this example.

 Lightroom adds a reference pin marker and applies the sharpening effect.

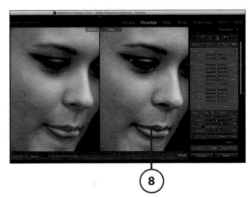

9. Click the Close button to turn off the Adjustment Brush.

Change Color Temperature Locally

The Tools panel also includes Temperature and Tint sliders that enable you to apply color temperature changes locally with the Adjustment Brush.

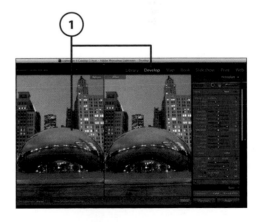

1. Select an image from the Library Grid or Filmstrip and open it in the Develop module.

 Lightroom displays the photo in the Content area of the Develop module.

2. Choose Tools, Adjustment Brush.

 Lightroom automatically selects the Adjustment Brush.

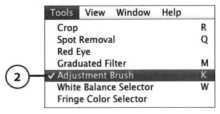

3. Drag the Temperature slider to the left to make the colors appear cooler. Drag it to the right to make them appear warmer. If necessary, use the Tint slider to offset the Temperature adjustment (see Chapter 7, "Adjusting Images in the Develop Module").

4. Size the Adjustment Brush by adjusting the Size slider.

5. Indicate the hardness or softness of the brush by adjusting the Feather slider.

6. Indicate the airbrush flow of the brush by adjusting the Flow slider.

7. Indicate the maximum brush opacity by adjusting the Density slider.

8. Click and drag over specific image areas to make them appear cooler or warmer.

 Lightroom adds a reference pin marker and applies the color temperature effect.

9. Click the Close button to turn off the Adjustment Brush.

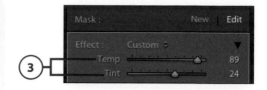

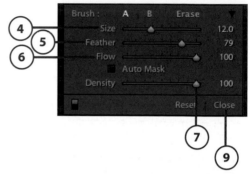

Remove Noise and Moiré Locally

With the Adjustment Brush, you can reduce luminance noise in the shadow areas of your images as well as reduce moiré artifacts (an irregular pattern of wavy lines that result from scanning a printed dot pattern).

1. Select an image from the Library Grid or Filmstrip and open it in the Develop module.

Lightroom displays the photo in the Content area of the Develop module.

2. Choose Tools, Adjustment Brush.

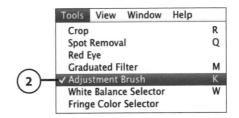

Lightroom automatically selects the Adjustment Brush in the Tools panel.

3. Drag the Noise slider to the right to decrease luminance noise in the shadow areas of the image as you paint with the Adjustment brush. Drag the Moiré slider to the right to decrease moiré artifacts and color aliasing.

4. Size the Adjustment Brush by adjusting the Size slider.

Keyboard Shortcuts

Press the left bracket key ([) to decrease the cursor size; press the right bracket key (]) to increase it.

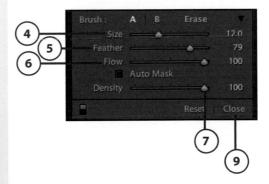

5. Indicate the hardness or softness of the brush by adjusting the Feather slider.

6. Indicate the airbrush flow of the brush by adjusting the Flow slider.

7. Indicate the maximum brush opacity by adjusting the Density slider.

8. Click and drag over shadow areas to remove noise and/or moiré artifacts.

Lightroom adds a reference pin marker and applies the noise and/or moiré reduction.

9. Click the Close button to turn off the Adjustment Brush.

Utilizing Adjustment Brush Presets

Lightroom enables you to save your favorite Adjustment Brush effect settings as presets. By choosing the preset from the Effect drop-down list in the Tools panel, you can instantly recall the effect combinations that you use most. Lightroom also ships with several useful Adjustment Brush Presets, including one for softening skin. Note that you can edit, update, and delete effect presets at any time.

Save Adjustment Brush Settings as a Preset

1. In the Develop module, choose Tools, Adjustment Brush, or click the Adjustment Brush icon in the Tools panel.

Keyboard Shortcuts

Press K to apply the Adjustment Brush command quickly.

2. In the Tools panel, adjust the sliders for the effects that you would like to save as a preset.

3. Choose Save Current Settings as New Preset from the Tools panel Effect menu.

4. In the New Preset dialog box, enter a name for the preset.

5. Click Create.

 Lightroom adds the preset to the Effect drop-down list.

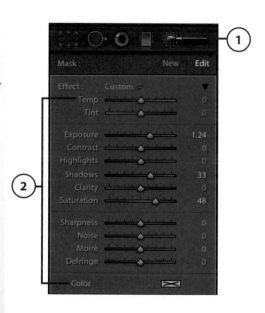

Apply the Soften Skin Brush Preset

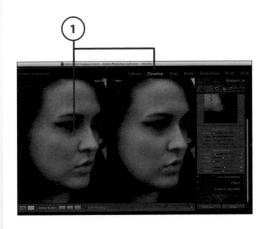

The Soften Skin preset that ships with Lightroom 4 combines a negative Clarity effect with a positive Sharpness adjustment. You can use this preset with the Adjustment Brush to soften specific areas of skin in a portrait image.

1. Select an image from the Library Grid or Filmstrip and open it in the Develop module.

 Lightroom displays the photo in the Content area of the Develop module.

2. Choose Tools, Adjustment Brush.

 Lightroom automatically selects the Adjustment Brush in the Tools panel.

3. Choose Soften Skin from the Tools panel Effect menu.

4. Size the Adjustment Brush by adjusting the Size slider.

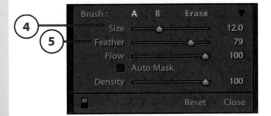

Keyboard Shortcuts
Press the left bracket key ([) to decrease the cursor size; press the right bracket key (]) to increase it.

5. Indicate the hardness or softness of the brush by adjusting the Feather slider.

Keyboard Shortcuts

Press Shift+left bracket key ([) to decrease the Feather amount; press Shift+right bracket key (]) to increase it.

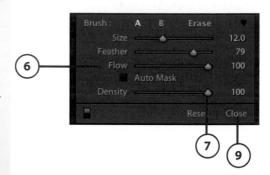

6. Indicate the airbrush flow of the brush by adjusting the Flow slider.

7. Indicate the maximum brush opacity by adjusting the Density slide.

8. Click and drag over the areas of skin that you'd like to soften.

 Lightroom adds a reference pin marker and applies the softening effect.

9. Click the Close button in the Tools panel to turn off the Adjustment Brush.

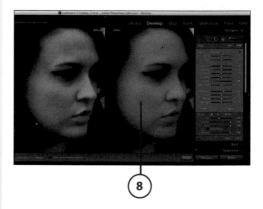

PAINT YOUR INITIAL BRUSHSTROKES WITH MAXIMUM EFFECT SETTINGS

>Go Further

It's important to understand that you can edit Adjustment Brush effect settings even after you apply them. Knowing this, it makes sense to paint initial brushstrokes with maximum effect settings in order to help you see the results of the effects as you work. You can always reduce the settings to a proper strength after you've covered the entire image area with brushstrokes.

Using the Graduated Filter Tool

With the Graduated Filter tool, you can apply adjustments that gradually fade along a linear path, from maximum strength to minimum strength. Graduated Filter effects can be used to add drama to an image, such as the landscape shown in this example.

Apply Linear Graduated Filter Fade Adjustments

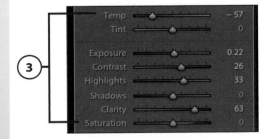

1. Select an image from the Library Grid or Filmstrip and open it in the Develop module.

 Lightroom displays the photo in the Content area of the Develop module.

2. To access the Graduated Filter tool, choose Tools, Graduated Filter, or click the Graduated Filter icon in the Tools panel.

Keyboard Shortcuts

Press M to access the Graduated Filter tool quickly.

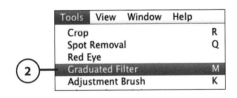

3. Using the controls available in the Tools panel, choose the adjustment settings that you would like to apply. In this example, it's a negative Exposure effect.

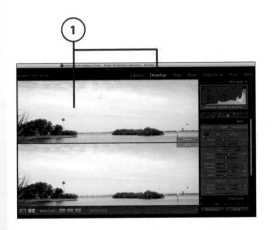

4. Click in the photo to determine the starting point for the Graduated Filter. Hold down the mouse button and drag in the picture to define the area that is affected. Release the mouse button at the point where the filter should stop.

Lightroom adds a reference pin marker and displays three parallel lines, which indicate the spread of the Graduated Filter.

5. If necessary, you can change the width of the spread by clicking and dragging any of the three parallel lines.

6. If necessary, you can rotate the graduated filter by hovering the cursor next to the pin marker and dragging up or down.

7. Click the Close button in the Tools panel to turn off the Adjustment Brush.

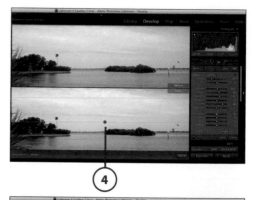

4

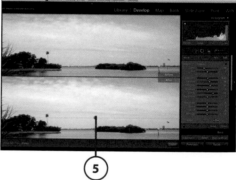

5

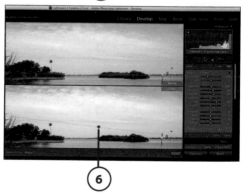

6

7

Learn to use the Destinatation
Gamut Warning.

Learn to create and apply
develop setting presets.

Learn to use proof preview.

Learn to utilize
soft proofing.

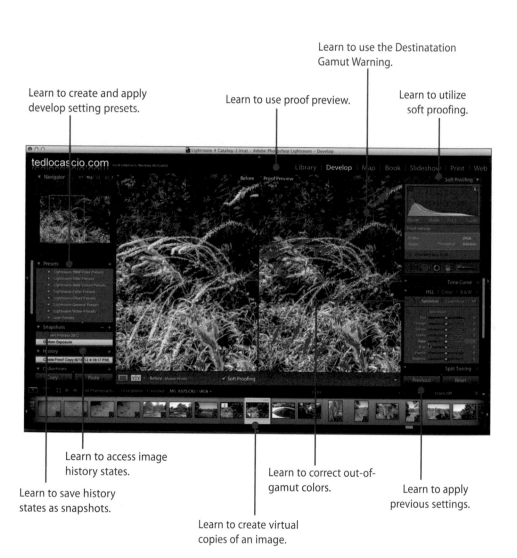

Learn to access image
history states.

Learn to correct out-of-
gamut colors.

Learn to save history
states as snapshots.

Learn to apply
previous settings.

Learn to create virtual
copies of an image.

In this chapter, you learn how to utilize soft proofing, snapshots, virtual copies, and more.

- → Accessing History States
- → Working with Snapshots
- → Creating Virtual Copies
- → Sharing Develop Settings
- → Resetting Images to Their Default Settings
- → Working with Soft Proofing

Develop Module Workflow

All the adjustments you apply to your images in Lightroom are non-destructive, which means that you can edit or remove the applied settings at any time. In this chapter, you learn how to access the various history states of an image via the History panel and store them as image variations in the Snapshots panel. You also learn how to create editable proxies of an image by utilizing Lightroom's virtual copy feature.

This chapter also teaches you how to share develop settings across two or more images. You learn how to synchronize specific settings, copy and paste them, and save your favorite setting combinations as presets.

Accessing History States

Lightroom remembers every develop setting that you apply to your images, even after you quit the application. Every adjustment that you apply to an image is stored in ascending order in the Develop module History panel. You can recall a previous history state at any time by clicking an adjustment from the History panel list.

Revert to Previous Develop States

1. Select an image from the Library Grid or Filmstrip and open it in the Develop module.

 Lightroom displays the photo in the Content area of the Develop module.

2. Choose Window, Panels, History to display the History panel.

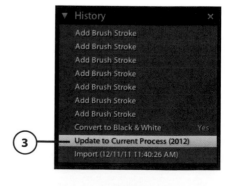

Keyboard Shortcuts
Press Control+Cmd+3 (Mac) or Ctrl+Shift+3 (Win) to show or hide the History panel quickly.

3. To revert to a previous history state, click the saved develop setting in the History panel.

Preview History States
You can preview a history state in the Navigator panel by hovering the cursor over the setting in the History panel.

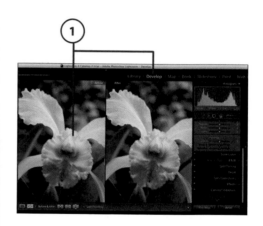

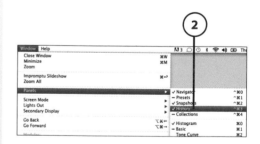

Rerecord History

If you apply new develop settings after selecting a previous history state in the History panel, all the settings that were recorded after the selected state are erased and replaced with the new settings.

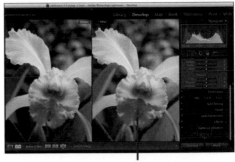

Lightroom displays the selected history state.

Working with Snapshots

Another way you can manage history states in Lightroom is to use the Snapshots feature. With Snapshots, you can store history states as image variations, so you can compare different versions of an image, such as black and white versus color, or cropped versus uncropped. You can recall these history states quickly and easily by saving them as snapshots, and selecting them from the Snapshots panel.

Save Snapshots

1. Select an image from the Library Grid or Filmstrip and open it in the Develop module.

 Lightroom displays the photo in the Content area of the Develop module.

2. Choose Window, Panels, History to display the History panel.

Keyboard Shortcuts

Press Control+Cmd+3 (Mac) or Ctrl+Shift+3 (Win) to show or hide the History panel quickly.

3. Select the history state that you would like to capture from the History panel.

4. Choose Window, Panels, Snapshots to display the Snapshots panel.

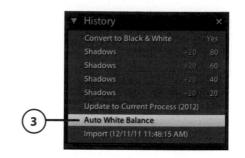

Keyboard Shortcuts

Press Control+Cmd+2 (Mac) or Ctrl+Shift+2 (Win) to show or hide the Snapshots panel quickly.

5. Choose Develop, New Snapshot, or click the Create Snapshot button (the + symbol) in the upper-right corner of the Snapshots panel.

Keyboard Shortcuts

Press Cmd+N (Mac) or Ctrl+N (Win) to apply the New Snapshot command quickly.

6. Enter a name in the New Snapshot dialog box Name field.

7. Click the Create button.

Lightroom stores the new snapshot in the Snapshots panel.

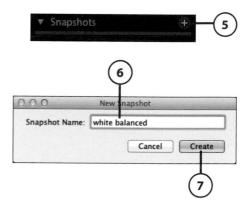

Preview Snapshots

You can preview a snapshot in the Navigator panel by hovering the cursor over the snapshot name in the Snapshots panel.

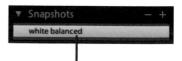

Lightroom stores the new snapshot in the Snapshots panel.

Sync Snapshots ▶

If you've already saved several snapshots of an image and then decide to apply critical adjustments to them, such as spot removal, you can update the snapshots by syncing the edits. The Sync Snapshots feature enables you to apply specific adjustments to all the snapshots at once.

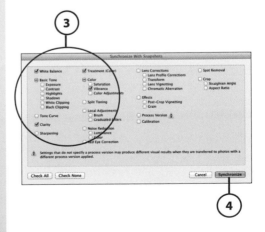

1. Select an image from the Library Grid or Filmstrip and open it in the Develop module.

 Lightroom displays the photo in the Content area of the Develop module.

2. Choose Settings, Sync Snapshots.

3. In the Synchronize with Snapshots dialog box, select the settings you would like to sync.

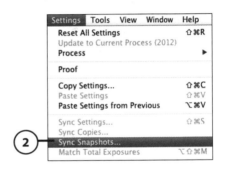

Sync Affects All Snapshots
When synchronizing snapshots, every snapshot saved in the Snapshots panel acquires the settings applied to the most recent one.

4. Click Synchronize.

 Lightroom updates the snapshots with the specified settings. Select any snapshot from the Snapshots panel to view the updates.

Creating Virtual Copies

A virtual copy is a proxy version of the original master image. It appears like a duplicate photo in the Library Grid and Filmstrip but is actually a visual representation of the master image that you can edit separately. Virtual copies enable you to apply different types of edits to an image and preview them next to each other in Compare or Survey view. You can also save virtual copies into collections.

Create a Proxy Version of a Master Image

1. From the Library Grid or Filmstrip, select the photo you're creating a virtual copy of.

2. Choose Photo, Create Virtual Copy.

Keyboard Shortcuts

Press Cmd+' (Mac) or Ctrl+' (Win) to apply the Create Virtual Copy command.

3. Lightroom automatically groups the virtual copy with the original master file in the Library module Grid and the Filmstrip.

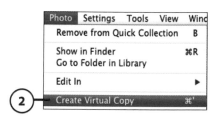

Virtual Copy Auto Display

When creating a virtual copy of an image while working in the Develop module, Lightroom automatically displays the virtual copy in the Content area.

Sharing Develop Settings

If your catalog contains multiple images of a particluar scene or object set in similar lighting conditions, you can share the same develop settings for all of them. By doing so, you can save development time. These features include synchronize, auto sync, copy/paste, apply previous, and the ability to create develop setting presets.

Synchronize Develop Settings ▶

The Sync Settings feature enables you to apply specific develop settings to multiple photos at once. When you import a series of photos containing the same subject matter and lighting conditions, you can apply develop settings to one of the photos and then sync those settings to the rest of the photos in the series.

1. From the Library Grid or Filmstrip, select the photos to sync.

Keyboard Shortcuts
Shift+click to select multiple adjacent photos; Cmd+click (Mac) or Ctrl+click (Win) to select multiple nonadjacent photos.

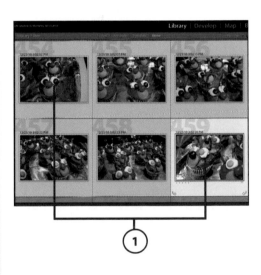

2. Click the Sync button (Develop module) or the Sync Settings button (Library module) located in the lower-right corner of the interface.

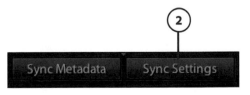

Keyboard Shortcuts
Press Cmd+Shift+S (Mac) or Ctrl+Shift+S (Win) to access the Synchronize Settings dialog box quickly.

3. In the Synchronize Settings dialog box, select the develop settings that you would like to sync.

Sync to the Target Image

When synchronizing develop settings, the selected photos acquire the settings applied to the primary (or target) selection.

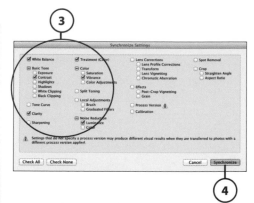

4. Click Synchronize.

Lightroom applies the develop settings to the selected photos and updates the thumbnails in the Library module Grid and Filmstrip.

Bypass the Synchronize Settings Dialog Box

You can bypass the Synchronize Settings dialog box and apply the last-used settings. To do so, press Option (Mac) or Alt (Win) as you click the Sync button in the Develop module.

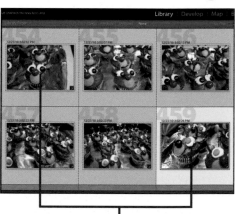

Lightroom synchronizes the chosen settings.

Use Auto Sync Mode ▶

When you apply develop settings to the target photo in Auto Sync mode, Lightroom automatically applies the same settings to the other images in the selection.

1. From the Develop module, select the photos to sync from the Filmstrip.

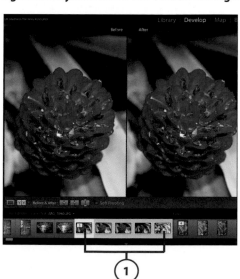

Keyboard Shortcuts

Shift+click to select multiple adjacent photos; Cmd+click (Mac) or Ctrl+click (Win) to select multiple nonadjacent photos.

2. To enable Auto Sync mode, click the toggle switch located next to the Sync button in the lower-right corner of the interface. Lightroom displays the words Auto Sync inside the button.

Auto Sync to the Target Image

When auto-synchronizing develop settings, the selected photos acquire the settings applied to the primary (or target) selection.

3. Apply develop settings to the primary (or target) photo in the selection.

Lightroom automatically applies the chosen develop settings to the selected photos and updates the thumbnails in the Library module Grid and Filmstrip.

Exit Auto Sync Mode

Lightroom remains in Auto Sync mode until you disable it. To exit Auto Sync mode, choose Settings, Disable Auto Sync, or click the Auto Sync toggle switch next to the Auto Sync button.

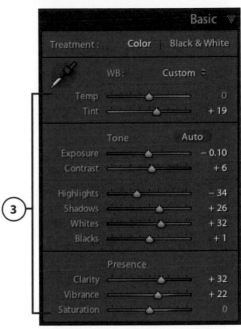

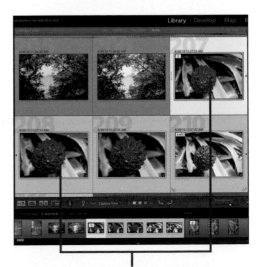

Lightroom synchronizes the settings.

Copy and Paste Develop Settings in the Develop Module

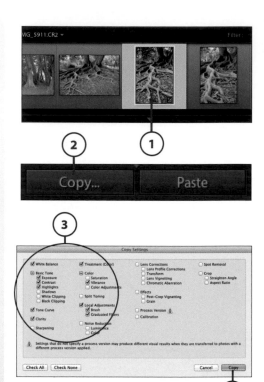

1. In the Filmstrip, select the photo to copy develop settings from.

2. Choose Edit, Copy or click the Copy button located in the lower-left corner of the Develop module interface. You can also Control-click (Mac) or right-click the image in the Content area (or the Filmstrip thumbnail) and choose Settings, Copy Settings.

Keyboard Shortcuts

Press Cmd+C (Mac) or Ctrl+C (Win) to apply the Copy command quickly.

3. Select the develop settings to copy.

4. Click Copy.

5. From the Filmstrip, select the photo(s) to paste the develop settings to.

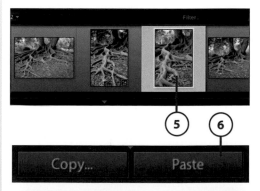

6. Choose Edit, Paste or click the Paste button located in the lower-left corner of the Develop module interface. You can also access the Paste command from the contextual menu.

Keyboard Shortcuts

Press Cmd+V (Mac) or Ctrl+V (Win) to apply the Paste command quickly.

Lightroom pastes the settings.

Copy and Paste Develop Settings in the Library Module

1. From the Library Grid or the Filmstrip, select the photo to copy develop settings from.

2. Choose Photo, Develop Settings, Copy Settings or Control-click (Mac) or right-click the thumbnail image in the Grid or Filmstrip and choose the command from the contextual menu.

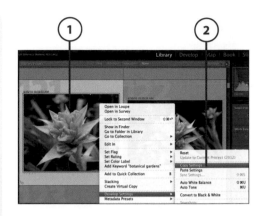

Keyboard Shortcuts
Press Cmd+C (Mac) or Ctrl+C (Win) to apply the Copy command quickly.

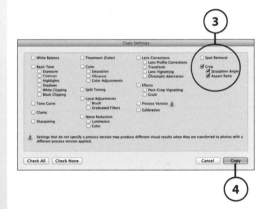

3. Select the develop settings to copy.

4. Click Copy.

5. From the Library Grid or the Filmstrip, select the photo(s) to paste the develop settings to.

6. Choose Photo, Develop Settings, Paste Settings or Control-click (Mac) or right-click the thumbnail image in the Grid or Filmstrip and choose the command from the contextual menu.

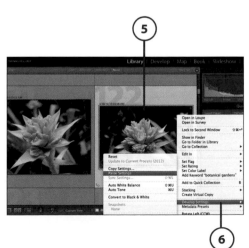

Keyboard Shortcuts

Press Cmd+V (Mac) or Ctrl+V (Win) to apply the Paste command quickly.

Lightroom applies the develop settings to the selected photo(s).

Lightroom pastes the settings.

Apply Previous Develop Settings

Lightroom temporarily stores the develop settings for every photo you select. You can apply all these settings to the next image you select by applying the Paste Settings from Previous command, or by clicking the Previous button in the lower-right corner of the Develop module interface.

1. Select an image from the Library Grid or Filmstrip and open it in the Develop module.

 Lightroom displays the photo in the Content area of the Develop module, and automatically copies all the settings currently applied to the image.

2. From the Filmstrip, select the photo(s) to paste the develop settings to.

3. Choose Settings, Paste Settings from Previous (Develop module) or Photo, Develop Settings, Paste Settings from Previous (Library module). You can also click the Previous button located in the lower-right corner of the Develop module interface.

Keyboard Shortcuts

Press Cmd+Option+V (Mac) or Ctrl+Alt+V (Win) to apply the Paste Settings from Previous command quickly.

Lightroom applies the develop settings to the selected photo(s).

Lightroom pastes the settings.

Save a Develop Setting Preset

Lightroom enables you to save your favorite develop setting combinations as presets. Doing so enables you to apply commonly used adjustments to multiple selected images with a simple click of a button.

1. Select an image from the Library Grid or Filmstrip and open it in the Develop module.

 Lightroom displays the photo in the Content area of the Develop module.

2. Choose Window, Panels, Presets to display the Presets panel.

Keyboard Shortcuts

Press Control+Cmd+1 (Mac) or Ctrl+Shift+1 (Win) to show or hide the Presets panel quickly.

3. Choose Develop, New Preset, or click the Create New Preset button (the + symbol) in the upper-right corner of the Presets panel.

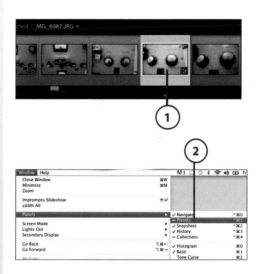

Keyboard Shortcuts

Press Cmd+Shift+N (Mac) or Ctrl+Shift+N (Win) to apply the New Preset command.

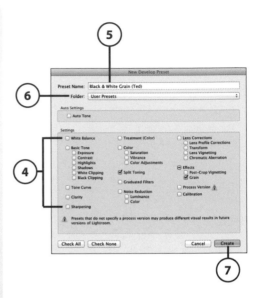

4. In the New Develop Preset dialog box that appears, select the develop settings that you would like to save.

5. Enter a name for the preset in the Preset Name field.

6. Choose a folder to save the preset in from the Folder drop-down list. The default is User Presets.

7. Click Create.

Resetting Images to the Default Settings

All the adjustments you apply in Lightroom are nondestructive. This means you can edit or remove them at any time. To remove all the settings at once, you can apply the Reset All Settings command (Develop module) or the Reset command (Library module), or you can click the Reset button located in the lower-right corner of the Develop module.

Remove All Develop Settings at Once

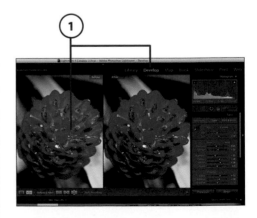

1. Select an image from the Library Grid or Filmstrip and open it in the Develop module.

 Lightroom displays the primary selected photo in the Content area of the Develop module.

2. Choose Settings, Reset All Settings. You can also click the Reset button located in the lower-right corner of the Develop module interface.

Keyboard Shortcuts

Press Cmd+Shift+R (Mac) or Ctrl+Shift+R (Win) to apply the Reset All Settings command quickly.

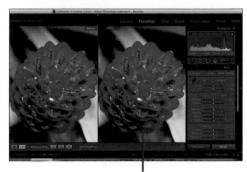

Lightroom removes the develop settings from the selected photo(s) and updates the thumbnail(s) in the Library module Grid and Filmstrip.

Lightroom removes the settings.

Working with Soft Proofing

With the soft proofing feature enabled, you can simulate how an image will appear when processed using a different color profile, especially one with a smaller color gamut, such as sRGB. For example, if the photo contains rich, vivid colors, they will appear muted when previewing them using a color profile that contains a limited color gamut. You can also soft proof images using a print-specific color profile, as well as paper-and-ink simulation, to determine how out-of-gamut colors will appear when printed.

Soft Proof Images

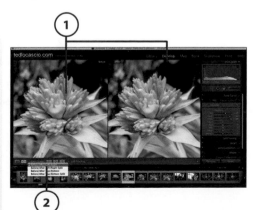

1. Select an image from the Library Grid or Filmstrip and open it in the Develop module.

 Lightroom displays the photo in the Content area of the Develop module.

2. From the Toolbar menu, choose Before/After Left/Right.

3. Enable the Soft Proofing option in the Toolbar.

 Lightroom automatically displays the Soft Proofing panel.

4. Choose a color profile from the Profile list. To load a custom color profile, choose Other from the Profile list.

5. Choose a rendering intent from the Intent list. Perceptual preserves out-of-gamut detail but can change in-gamut colors. Relative preserves color accuracy, but clips out-of-gamut detail.

 Lightroom displays the proof preview in the After state of the Content area.

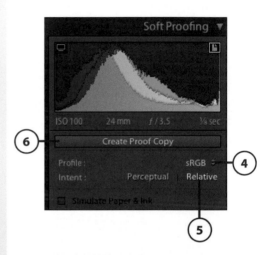

6. To create a virtual copy of the proof, click the Create Proof Copy button.

Keyboard Shortcuts

Press Cmd+apostrophe (Mac) or Ctrl+apostrophe (Win) to apply the Create Proof Copy command quickly.

Lightroom automatically groups the proof copy with the original master file.

Lightroom displays the proof preview.

Correct Out-of-Gamut Colors

The best way to correct out-of-gamut colors is to show the Destination Gamut Warning and then desaturate the colors using the Target Adjustment tool. This is best done to a proof copy of the selected image.

1. Select an image from the Library Grid or Filmstrip and open it in the Develop module.

 Lightroom displays the photo in the Content area of the Develop module.

2. From the Toolbar menu, choose Before/After Left/Right.

3. Enable the Soft Proofing option in the Toolbar.

 Lightroom automatically displays the Soft Proofing panel.

4. Choose a color profile and rendering intent from the Profile and Intent lists.

5. To create a virtual copy of the proof, click the Create Proof Copy button.

 Lightroom automatically groups the proof copy with the original master file.

6. Click the Destination Gamut Warning icon in the upper right of the histogram.

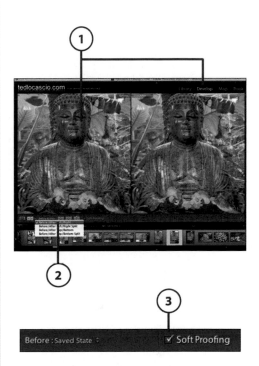

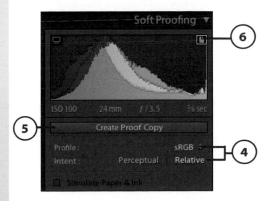

Lightroom displays a red highlight over any out-of-gamut colors in the image.

7. Choose Window, Panels, HSL/ Color/B&W to display the HSL/ Color/B&W panel.

Keyboard Shortcuts

Press Cmd+3 (Mac) or Ctrl+3 (Win) to show and hide the HSL/ Color/B&W panel quickly.

8. Click the HSL button at the top of the panel.

9. Click the Saturation button at the top of the panel.

10. Choose Tools, Target Adjustment, Saturation or click the Target Adjustment tool icon in the HSL/ Color/B&W panel.

Keyboard Shortcuts

Press Cmd+Shift+Option+S (Mac) or Ctrl+Shift+Alt+S (Win) to show and hide the HSL/Color/B&W panel quickly.

11. Click over any red highlighted area in the proof preview and drag down to desaturate the colors.

Lightroom removes the red highlight as the colors enter the in-gamut color space.

12. To disable the Target Adjustment tool, click the Done button in the Toolbar, or click the target Adjustment icon in the HSL/ Color/B&W panel.

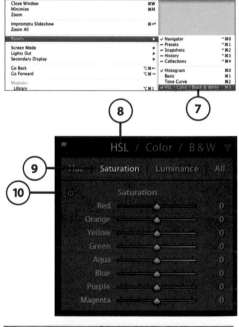

Lightroom displays a red highlight over any out-of-gamut colors in the image.

Learn to create a
split tone image.

Learn to apply tonal
adjustments to black-
and-white images.

Learn to convert a color image
to black and white.

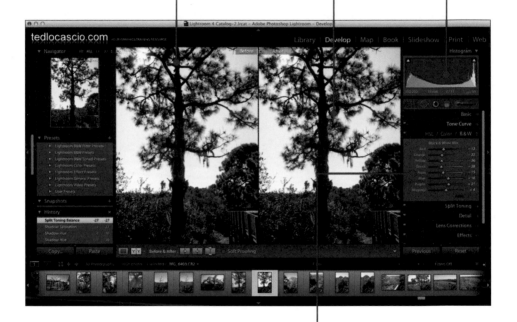

Learn to edit colors in a black-
and-white conversion.

In this chapter, you learn how to create and edit black-and-white images.

→ Converting Images to Black and White
→ Applying Grayscale White Balance Adjustments to Black-and-White Images
→ Applying Auto Black-and-White Adjustments
→ Applying Custom Black-and-White Adjustments
→ Creating a Split Tone Image

10

Working in Black and White

Black-and-white photography is an art form unto itself. Knowing this, the Adobe Lightroom developers created a "digital darkroom" environment that offers an incredible amount of creative control over your black-and-white conversions.

In this chapter, you learn how to convert your color images to black-and-white using the various controls available in the Develop module. You also learn how to apply white balance adjustments to black-and-white images, as well as how to utilize the Auto black-and-white mix feature.

This chapter also teaches you how to apply custom black-and-white adjustments using the sliders available in the Black & White panel. The final section explains how to apply color tints to the highlight and shadow areas of an image using the controls available in the Split Toning panel.

Converting Images to Black and White

When you apply the Convert to Black & White command, Lightroom does not convert the color image to Grayscale mode. Instead, it creates a desaturated version of the original color image, which remains in RGB mode. Lightroom blends the grayscale information that is contained in the individual red, green, and blue channels that make up the composite RGB image.

Apply the Convert to Black & White Command

1. Select an image from the Library Grid or Filmstrip and open it in the Develop module.

Lightroom displays the photo in the Content area of the Develop module.

2. Choose Window, Panels, Basic to display the Basic panel.

Keyboard Shortcuts

Press Cmd+1 (Mac) or Ctrl+1 (Win) to show or hide the Basic panel quickly.

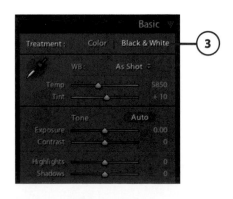

3. Choose Settings, Convert to Black & White, or click the Black & White button in the upper-right corner of the Basic panel. You can also click the B&W button located at the top of the HSL/Color/B&W panel.

Keyboard Shortcuts

Press V to apply the Convert to Black & White command quickly.

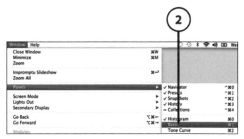

Lightroom converts the photo-
graph to black and white.

**Lightroom converts the photo to
black-and-white.**

Desaturate Using HSL Panel Saturation Sliders ▶

This B&W conversion method gives
you access to the Vibrance and
Saturation sliders in the Basic panel.
As described later in this chapter
(in the "Applying Custom B&W
Adjustments" section), you can use
these sliders to further enhance your
adjustments.

1. Select an image from the Library
 Grid or Filmstrip and open it in
 the Develop module.

 Lightroom displays the photo in
 the Content area of the Develop
 module.

2. Choose Window, Panels, HSL/
 Color/B&W to display the HSL/
 Color/B&W panel.

Keyboard Shortcuts

Press Cmd+3 (Mac) or Ctrl+3
(Win) to show or hide the HSL/
Color/B&W panel quickly.

3. The HSL/Color/B&W panel dis-
 plays the last set of controls used.
 If the HSL controls are not visible,
 click the HSL button at the top of
 the HSL/Color/B&W panel.

4. Click the Saturation button in the
 upper portion of the HSL panel.

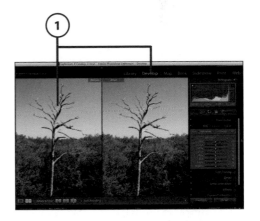

5. Drag all of the Saturation sliders in the HSL panel to –100, or enter –100 in the value field to the right of the sliders.

 Lightroom applies the Saturation adjustment to the image.

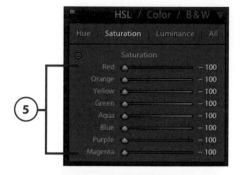

Lightroom desaturates the photo.

Applying White Balance Adjustments to Black-and-White Images

By dragging the Basic panel Temperature slider to the right, you can apply a warm white balance to the black-and-white image and produce much richer tones. By dragging the Temperature slider to the left, you can apply a cool white balance and produce much lighter tones. You can drag the Tint slider to enhance either the green or magenta tones in the image. By following up these white balance adjustments with an Auto Black & White adjustment, you can produce a well-balanced black-and-white image.

Adjust the Temperature and Tint Sliders

1. Select an image from the Library Grid or Filmstrip and open it in the Develop module.

 Lightroom displays the photo in the Content area of the Develop module.

2. Choose Window, Panels, Basic to display the Basic panel.

Keyboard Shortcuts

Press Cmd+1 (Mac) or Ctrl+1 (Win) to show or hide the Basic panel quickly.

3. Drag the Basic panel Temp slider to the right to make the image appear warmer, or drag it to the left to make it appear cooler.

4. Enhance the green or magenta tones in the converted image by dragging the Basic panel Tint slider.

 Lightroom applies the white balance adjustments to the image.

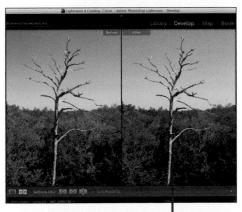

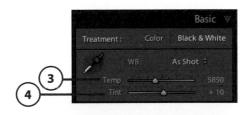

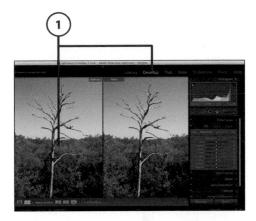

Lightroom applies the adjustments.

Applying Auto Black & White Adjustments

The Black & White panel contains an Auto button, which enables you to auto generate a black and white mix for the RGB image that you've converted to black-and-white. By clicking the Auto button, you are allowing Lightroom to auto adjust the color sliders in the Black & White panel. The Auto button generates a black-and-white mix based on the current white balance settings; therefore, it works hand-in-hand with the white balancing technique described on the previous page.

Apply an Automatic Black-and-White Mix

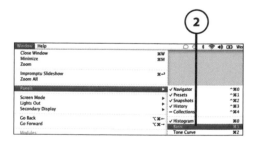

1. Select a converted black-and-white image from the Library Grid or Filmstrip and open it in the Develop module.

 Lightroom displays the photo in the Content area of the Develop module.

2. Choose Window, Panels, Basic to display the Basic panel.

Keyboard Shortcuts

Press Cmd+1 (Mac) or Ctrl+1 (Win) to show or hide the Basic panel quickly.

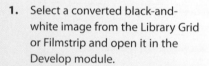

3. Drag the Basic panel Temp slider to the right to make the image appear warmer, or drag it to the left to make it appear cooler.

4. Enhance the green or magenta tones in the converted image by dragging the Basic panel Tint slider.

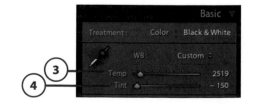

5. Choose Window, Panels, HSL/Color/B&W to display the HSL/Color/B&W panel.

Keyboard Shortcuts

Press Cmd+3 (Mac) or Ctrl+3 (Win) to show or hide the HSL/Color/B&W panel quickly.

6. The HSL/Color/B&W panel displays the last set of controls used. If the black-and-white controls are not visible, click the B&W button at the top of the HSL/Color/B&W panel.

7. Click the Auto button in the Black & White panel.

Lightroom applies the Auto adjustment based on the current White Balance Temperature and Tint settings.

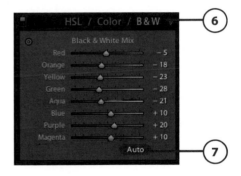

Lightroom applies the auto adjustment.

Applying Custom Black & White Adjustments

The Black & White panel enables you to control how light or dark certain colors appear in a converted black-and-white image. By dragging the eight color sliders in the Black & White panel, you can customize the black-and-white blend used in the conversion. You can also customize images that you desaturated manually (see "Converting Images to Black and White" earlier in this chapter) by dragging the Luminance sliders in the HSL panel. You can further enhance the Luminance settings by dragging the Saturation and Vibrance sliders in the Basic panel.

Create a Custom Black-and-White Mix

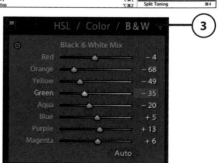

1. Select a converted black-and-white image from the Library Grid or Filmstrip and open it in the Develop module.

 Lightroom displays the photo in the Content area of the Develop module.

2. Choose Window, Panels, HSL/Color/B&W to display the HSL/Color/B&W panel.

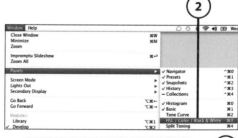

Keyboard Shortcuts

Press Cmd+3 (Mac) or Ctrl+3 (Win) to show or hide the HSL/Color/B&W panel quickly.

3. The HSL/Color/B&W panel displays the last set of controls used. If the Grayscale controls are not visible, click the B&W button at the top of the HSL/Color/B&W panel.

4. In the Black & White panel, drag the sliders for the colors you'd like to brighten or darken in the image.

Lightroom applies the adjustment to the respective colors.

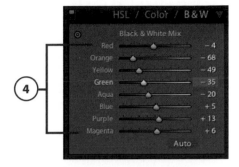

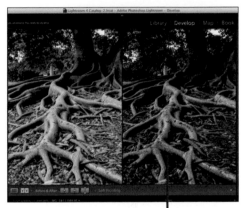

Lightroom applies the adjustment.

USE THE TARGET ADJUSTMENT TOOL TO CREATE A CUSTOM BLACK & WHITE MIX

Lightroom also enables you to use the Black & White Target Adjustment tool to create a custom black-and-white mix. To access the tool, click the Target Adjustment icon in the Black & White panel or choose Tools, Target Adjustment, Black & White Mix. Click in an area of the image that you'd like to lighten and drag up with the tool; drag down to darken.

Creating a Split Tone Image

The Split Toning panel enables you to apply a color tint to the highlight and shadow areas of a monochrome image. You can select which colors to apply using the Color Picker. The Hue and Saturation sliders in the Split Toning panel enable you to adjust the tint and vividness of each color. The Balance slider helps you fine-tune the blend between shadow and highlight colors.

Apply a Color Tint to Highlight and Shadow Areas

1. Select a converted black-and-white image from the Library Grid or Filmstrip and open it in the Develop module.

 Lightroom displays the photo in the Content area of the Develop module.

2. Choose Window, Panels, Split Toning to display the Split Toning panel.

Keyboard Shortcuts

Press Cmd+4 (Mac) or Ctrl+4 (Win) to show or hide the Split Toning panel quickly.

3. To access the Color Picker, click the Highlights color swatch in the Split Toning panel.

4. Select a color by clicking inside the color ramp, or by clicking one of the color preset swatches located at the top of the Color Picker window.

5. Click the Close button in the upper-left corner of the Color Picker window.

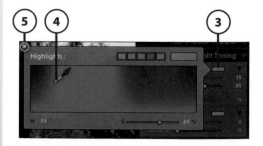

6. If necessary, adjust the hue for the chosen highlights color by dragging the Hue slider in the Highlights portion of the Split Toning panel.

7. Adjust the vividness of the chosen highlights color by dragging the Saturation slider in the Highlights portion of the Split Toning panel.

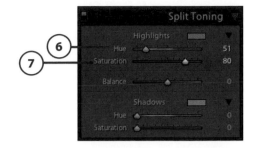

8. To access the Color Picker, click the Shadows color swatch in the Split Toning panel.

9. Select a color by clicking inside the color ramp, or by clicking one of the color preset swatches located at the top of the Color Picker window.

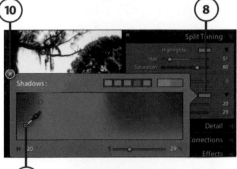

10. Click the Close button in the upper-left corner of the Color Picker window.

11. If necessary, adjust the hue for the chosen shadows color by dragging the Hue slider in the Highlights portion of the Split Toning panel.

12. Adjust the vividness of the chosen shadows color by dragging the Saturation slider in the Highlights portion of the Split Toning panel.

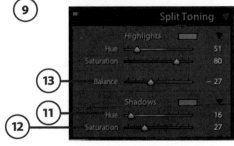

13. Fine-tune the balance between the highlight and shadow color toning by dragging the Balance slider in the Split Toning panel.

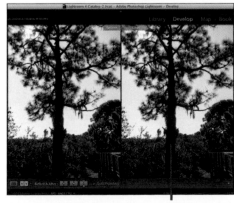

Lightroom applies the split tone adjustments.

Learn to view images at proper magnification when sharpening and reducing noise.

Learn to reduce luminance noise.

Learn to utilize the Detail panel preview image.

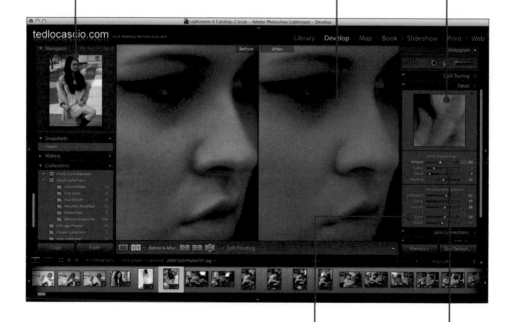

Learn to reduce color noise.

Learn to sharpen images properly.

In this chapter, you learn to utilize Lightroom's noise reduction and sharpening tools.

→ Applying the Sharpen Wide Edges Preset
→ Applying the Sharpen Narrow Edges Preset
→ Sharpening in Luminance Mode
→ Reducing Noise

Reducing Noise and Sharpening

Sharpening enables you to enhance edge contrast in your images, whereas noise reduction enables you to remove unwanted dot patterns that are apparent in your photos. The Detail panel contains sliders that help you perform both of these tasks.

It's important to note that images shot in raw file format are untreated and can always use some sharpening and noise reduction. However, jpeg images already have some sharpening and noise processing applied by the camera. The Detail panel controls are intended for use with raw originals.

In this chapter, you learn how to use the sharpening sliders to enhance fine-edge contrast while suppressing edge halos in smooth tone areas. You also learn how to utilize the Sharpen Wide Edges and Sharpen Narrow Edges presets, as well as how to work with the sharpening sliders in Luminance mode. The last section teaches you how to use the noise reduction sliders to remove luminance noise and color noise from your images.

Applying the Sharpen Faces Preset

Lightroom comes equipped with a Sharpen Faces preset, which you can use to sharpen portraits with a single click of a button. This combination of settings works best for sharpening areas of soft-edge detail, such as eyes and lips, and protecting smooth tone areas, such as skin, from being over-sharpened. In some cases, you may find this preset to be a bit too subtle. If so, you can increase the sharpening effect by dragging the Amount slider to the right, and soften the effect in the smooth tone areas by increasing the Masking value.

Choose the Sharpen Faces Preset

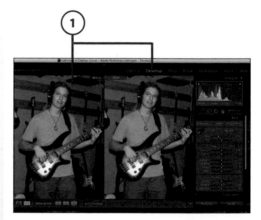

1. Select an image from the Library Grid or Filmstrip and open it in the Develop module.

 Lightroom displays the photo in the Content area of the Develop module.

2. Choose Window, Panels, Navigator to display the Navigator panel.

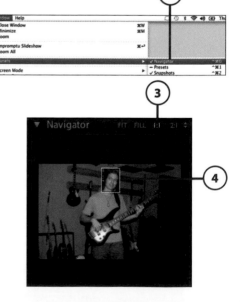

Keyboard Shortcuts

Press Control+Cmd+0 (Mac) or Ctrl+Shift+0 (Win) to show or hide the Navigator panel quickly.

3. Click the 1:1 button in the Navigator panel to view the image at 100% of its size in the Content area.

4. To change the image area displayed in the Content area, click and drag the Navigator target icon, or click and drag in the image itself.

5. Choose Window, Panels, Presets to display the Presets panel.

Keyboard Shortcuts

Press Control+Cmd+1 (Mac) or Ctrl+Shift+1 (Win) to show or hide the Presets panel quickly.

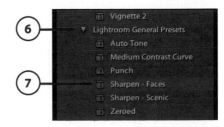

6. In the Presets panel, click the Lightroom General Presets fold-out triangle to reveal the available presets.

7. Click the Sharpen - Faces preset to apply the sharpen settings.

Lightroom applies the Sharpen Faces preset.

8. Choose Window, Panels, Detail to display the Detail panel.

Keyboard Shortcuts

Press Cmd+5 (Mac) or Ctrl+5 (Win) to show or hide the Detail panel quickly.

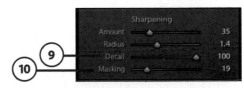

9. If necessary, increase the sharpening effect by dragging the Detail panel Amount slider to the right.

10. If necessary, you can preserve smooth tone areas (such as skin) by dragging the Masking slider to the right.

Lightroom applies the sharpening settings.

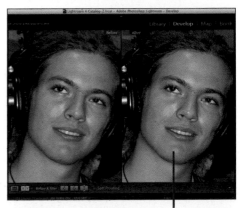

Lightroom applies the sharpening preset.

>>>Go Further

DEVELOP MODULE DETAIL PANEL SETTINGS: RAW VERSUS JPEG

The default settings in the Detail panel are different for raw and jpeg images. Jpeg images already have some level of sharpening and noise reduction applied by the camera, whereas raw images do not. To prevent oversharpening, the default Detail panel settings are set to zero for jpeg images. Raw images, however, are unprocessed and always require a certain amount of sharpening. Therefore, the default Detail panel settings for raw images are not set to zero.

Applying the Sharpen Scenic Preset

Lightroom also comes equipped with a Sharpen Narrow Edges preset, which you can use to sharpen landscapes with a single click of a button. This combination of settings works best for sharpening areas of fine-edge detail, such as the trees in this example photo. This preset applies considerably less edge halo suppression than the Sharpen Faces preset and applies no masking.

Choose the Sharpen Scenic Preset

1. Select an image from the Library Grid or Filmstrip and open it in the Develop module.

 Lightroom displays the photo in the Content area of the Develop module.

2. Choose Window, Panels, Navigator to display the Navigator panel.

Keyboard Shortcuts

Press Control+Cmd+0 (Mac) or Ctrl+Shift+0 (Win) to show or hide the Navigator panel quickly.

3. Click the 1:1 button in the Navigator panel to view the image at 100% of its size in the Content area.

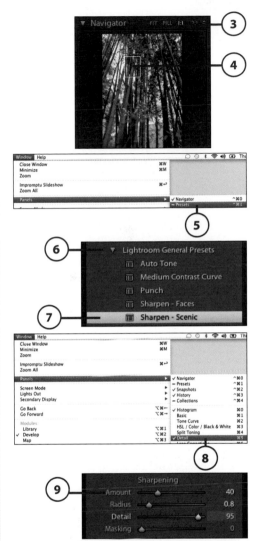

4. To change the image area displayed in the Content area, click and drag the Navigator target icon, or click and drag in the image itself.

5. Choose Window, Panels, Presets to display the Presets panel.

Keyboard Shortcuts

Press Control+Cmd+1 (Mac) or Ctrl+Shift+1 (Win) to show or hide the Presets panel quickly.

6. In the Presets panel, click the Lightroom General Presets fold-out triangle to reveal the available presets.

7. Click the Sharpen - Scenic preset to apply the sharpen settings.

Lightroom applies the Sharpen Scenic preset.

8. Choose Window, Panels, Detail to display the Detail panel.

Keyboard Shortcuts

Press Cmd+5 (Mac) or Ctrl+5 (Win) to show or hide the Detail panel quickly.

9. If necessary, increase the sharpening effect by dragging the Detail panel Amount slider to the right.

Lightroom applies the sharpening preset.

Sharpening in Luminance Mode

Lightroom applies sharpening only to the luminance information in a photograph, and not to any of the color information. This is beneficial because it prevents you from enhancing any color artifacts in the image. By holding down Option (Mac) or Alt (Win) as you drag the Detail panel sliders, you can view an isolated preview of the sharpening effect in grayscale Luminance mode. Doing so gives you a clearer preview of what is happening to the image edges as you adjust the Detail panel sliders.

Inspect in Luminance Mode as You Sharpen

1. Select an image from the Library Grid or Filmstrip and open it in the Develop module.

 Lightroom displays the photo in the Content area of the Develop module.

2. Choose Window, Panels, Navigator to display the Navigator panel.

Keyboard Shortcuts

Press Control+Cmd+0 (Mac) or Ctrl+Shift+0 (Win) to show or hide the Navigator panel quickly.

3. Click the 1:1 button in the Navigator panel to view the image at 100% of its size in the Content area.

4. To change the image area displayed in the Content area, click and drag the Navigator target icon, or click and drag in the image itself.

5. Choose Window, Panels, Detail to display the Detail panel.

Keyboard Shortcuts

Press Cmd+5 (Mac) or Ctrl+5 (Win) to show or hide the Detail panel quickly.

6. Hold down Option (Mac) or Alt (Win) and click and drag the Amount slider in the Sharpening portion of the Detail panel.

 Lightroom displays a grayscale preview of the image in the Content area and in the Detail panel preview window.

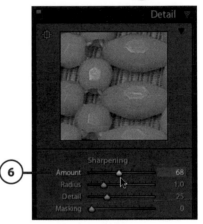

Edge Halos and Oversharpening

If edge halos begin to appear in the image as you increase the sharpening amount, then you are oversharpening the image.

7. Hold down Option (Mac) or Alt (Win) and click and drag the Radius slider in the Sharpening portion of the Detail panel.

 Lightroom displays an isolated preview of the effect in the Content area and in the Detail panel preview window.

Soft Edge Radius Settings

Images containing a lot of soft-edged detail, such as portrait photos, can benefit from a Radius setting that is no lower than 1.0 and no higher than 2.0.

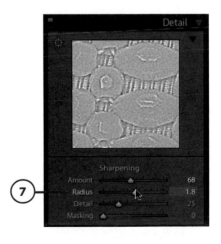

8. Hold down Option (Mac) or Alt (Win) and click and drag the Detail slider in the Sharpening portion of the Detail panel.

Lightroom displays an isolated preview of the effect in the Content area and in the Detail panel preview window.

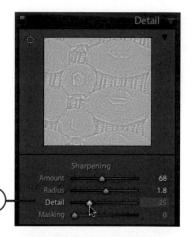

Edge Halo Suppression

A Detail setting of zero applies the most edge halo suppression; a Detail setting of 100 applies no halo suppression at all.

9. Hold down Option (Mac) or Alt (Win) and click and drag the Masking slider in the Sharpening portion of the Detail panel.

Lightroom displays an isolated preview of the effect in the Content area and in the Detail panel preview window.

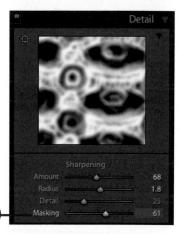

Protect Smooth Tone Areas with Masking

A Masking setting of zero applies no mask at all. As you increase the setting, more smooth tone areas are protected from the sharpening effect.

Lightroom applies the sharpening adjustments.

Lightroom applies the sharpening.

Reducing Noise

In general, when you shoot digital photos at higher ISO settings, the resulting images contain noise. Luminance noise is a visible grain in the image that looks like a white, fine-speckled pattern. By increasing the Luminance slider value, you can remove luminance noise, especially in the shadow areas where it is most apparent. Images containing color noise include a visible colored dot pattern, which is even more apparent (and ugly) than luminance noise. By increasing the color slider value, you can blur the color channels in the image to remove the noise. Note that by doing so, you are also softening the image and may lose some color detail.

Reduce Luminance Noise

1. Select an image from the Library Grid or Filmstrip and open it in the Develop module.

 Lightroom displays the photo in the Content area of the Develop module.

2. Choose Window, Panels, Navigator to display the Navigator panel.

Keyboard Shortcuts

Press Control+Cmd+0 (Mac) or Ctrl+Shift+0 (Win) to show or hide the Navigator panel quickly.

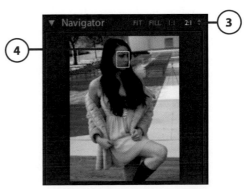

3. Choose 2:1 from the Navigator panel Custom View flyout menu.

4. To change the image area displayed in the Content area, click and drag the Navigator target icon, or click and drag in the image itself.

5. Choose Window, Panels, Detail to display the Detail panel.

Keyboard Shortcuts

Press Cmd+5 (Mac) or Ctrl+5 (Win) to show or hide the Detail panel quickly.

6. In the Noise Reduction section of the Detail panel, drag the Luminance slider to the right.

Lightroom removes the luminance noise from the image.

7. Drag the Detail slider to determine the amount of detail to preserve in the hard contrast edges and textured areas of the image.

Hard Edge Contrast

A Detail setting of zero suppresses hard edge contrast; a Detail setting of 100 retains the most hard edge contrast.

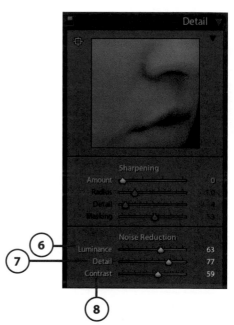

8. Drag the Contrast slider to determine the amount of detail to preserve in the smooth areas of the image.

Protect Smooth Tone Areas with Contrast

A Contrast setting of zero applies no contrast at all. As you increase the setting, more smooth tone areas are protected from the blur effect.

Lightroom applies the luminance noise reduction adjustments.

Lightroom applies the noise reduction.

>Go Further

CHANGE THE DETAIL PANEL PREVIEW WINDOW DISPLAY

You can change the image area displayed in the Detail panel preview window. To do so, click the Target icon in the upper-left corner of the Detail panel, and then click the image area that you would like to display in the preview window. You can also click and drag the preview window to scroll through the image with the Hand tool.

Reduce Color Noise

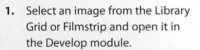

1. Select an image from the Library Grid or Filmstrip and open it in the Develop module.

 Lightroom displays the photo in the Content area of the Develop module.

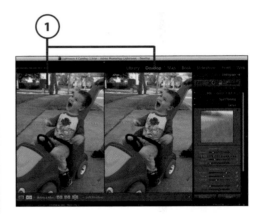

2. Choose Window, Panels, Navigator to display the Navigator panel.

Keyboard Shortcuts

Press Control+Cmd+0 (Mac) or Ctrl+Shift+0 (Win) to show or hide the Navigator panel quickly.

3. Choose 2:1 from the Navigator panel Custom View flyout menu.

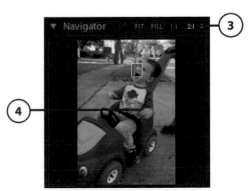

4. To change the image area displayed in the Content area, click and drag the Navigator target icon, or click and drag in the image itself.

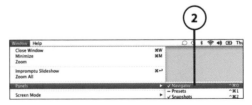

5. Choose Window, Panels, Detail to display the Detail panel.

Keyboard Shortcuts

Press Cmd+5 (Mac) or Ctrl+5 (Win) to show or hide the Detail panel quickly.

6. In the Noise Reduction section of the Detail panel, drag the Color slider to the right.

 Lightroom removes the color noise from the image.

7. Drag the Detail slider to determine the amount of detail to preserve in the hard contrast edges and textured areas of the image.

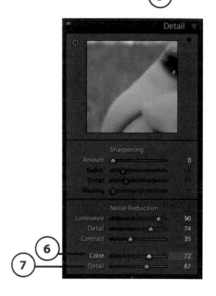

SAVE NOISE REDUCTION SETTINGS AS PART OF A DEFAULT DEVELOP PRESET

>>>Go Further

To save noise reduction settings as part of a camera and ISO-specific default develop preset, you must first enable the Make Defaults Specific to Camera Serial Number and Make Defaults Specific to ISO Settings preferences in the Presets panel of the Preferences dialog box. Select an image that contains the noise reduction setting that you would like to save as a preset; then click the Create New Preset button in the upper-right corner of the Presets panel. In the New Develop Preset dialog box that appears, select Noise Reduction. Name the preset and click Create. Choose Develop, Set Default Settings to apply the settings as the default. For any newly imported images that match the camera serial and ISO setting, Lightroom applies these settings as the default.

Hard Edge Contrast

A Detail setting of zero suppresses hard edge contrast; a Detail setting of 100 retains the most hard edge contrast.

Lightroom applies the color noise reduction adjustment.

Lightroom applies the noise reduction.

Learn to display location markers on the map.

Learn to add GPS coordinates to a selected image's metadata.

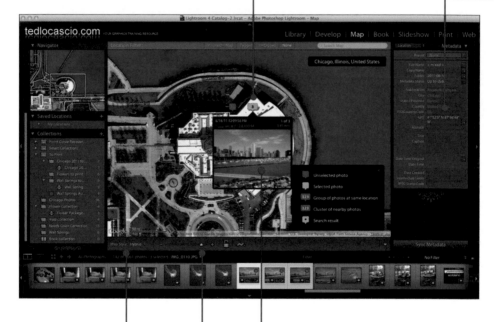

Learn to choose a map style.

Learn to access thumbnail previews from the location markers.

Learn to use the map navigational controls.

In this chapter, you learn to use the mapping features available in Lightroom's Map module.

→ Changing the Map Style
→ Changing Map Magnification and Crop
→ Viewing Geotagged Image Locations
→ Adding GPS Locations

12

Mapping Photos

The Map module in Lightroom enables you to identify where your catalog images were captured. Any photos automatically geotagged by a digital camera contain GPS coordinates that are embedded in the image metadata. Lightroom uses this information to place markers on the map that is displayed in the Content area.

In this chapter, you learn how to display location markers for geo-tagged images and access thumbnail previews from the map. You also learn how to use the map navigation controls and add GPS locations to untagged images.

Changing the Map Style

The Map module in Lightroom comes equipped with several map styles. Each style provides a different map view that you can display in the Content area, such as a road map, a terrain map, a satellite view, or a satellite/road map hybrid. You can choose a map style from the Map Style list in the Toolbar, or by choosing a Map Style command from the View menu.

Choose a Map Style View Command

1. To access the Map module, choose Window, Map or click the Map button in the upper-right corner of the interface.

Keyboard Shortcuts

Press Option+Cmd+3 (Mac) or Alt+Ctrl+3 (Win) to access the Map module quickly.

2. If the Toolbar is not already visible, choose View, Show Toolbar.

Keyboard Shortcuts

Press T to show or hide the Toolbar quickly.

3. Choose a map style from the Map Style list in the Toolbar, or choose one from the View menu.

Lightroom displays the map style in the Content area.

Changing Map Magnification and Crop

The Toolbar contains a special set of map navigation controls when working in the Map module. These controls enable you to change the zoom magnification of the map that is displayed. You can scroll the current map view by clicking and dragging anywhere in the Content area. To zoom into a specific map location, hold down Option (Mac) or Alt (Win) and drag a marquee over the area.

Use the Map Navigation Controls

1. To access the Map module, choose Window, Map or click the Map button in the upper-right corner of the interface.

Keyboard Shortcuts

Press Option+Cmd+3 (Mac) or Alt+Ctrl+3 (Win) to access the Map module quickly.

2. If the Toolbar is not already visible, choose View, Show Toolbar.

3. In the Toolbar, click the Zoom In or Zoom Out buttons, or drag the Zoom slider to the right to increase zoom magnification. Drag it to the left to decrease magnification.

Double-Click to Zoom

You can also double-click anywhere in the map to zoom in.

4. Click and drag the map in any direction to reposition it in the Content area.

Viewing Geotagged Image Locations

Some digital cameras, as well as most smartphone cameras, automatically record the map location where an image was captured and store the information in the image's metadata. For any image that contains GPS coordinates, Lightroom displays a pin icon in the lower-right corner of the image's thumbnail in the Filmstrip or Library Grid.

View Geotagged Images on the Map

1. In the Library module, locate images that have GPS coordinates stored in their metadata (see "Filtering by GPS Location" in Chapter 5, "Searching for Images").

2. To access the Map module, choose Window, Map or click the Map button in the upper-right corner of the interface.

Keyboard Shortcuts

Press Option+Cmd+3 (Mac) or Alt+Ctrl+3 (Win) to access the Map module quickly.

3. From the Filmstrip, double-click any image that contains GPS coordinates.

 Lightroom displays a yellow marker on the map where the primary selected image was taken. If multiple images were taken in the same location, Lightroom displays a number in the yellow marker.

4. Hover the cursor over the yellow marker to display the image preview window.

5. If multiple images were taken at this location, click the before or next arrows to preview the other images in the series.

Adding GPS Locations

If your digital camera does not automatically record GPS coordinates with each capture, you can easily add them to your catalog images in Lightroom. By dragging image thumbnails onto the map in the Map module, you can add GPS metadata and place a location marker.

Tag an Image with GPS Coordinates

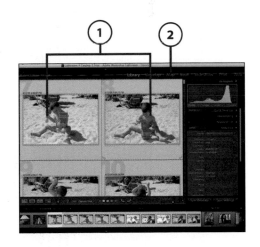

1. In the Library module, locate an image that does not have GPS coordinates stored in its metadata.

2. To access the Map module, choose Window, Map or click the Map button in the upper-right corner of the interface.

Keyboard Shortcuts

Press Option+Cmd+3 (Mac) or Alt+Ctrl+3 (Win) to access the Map module quickly.

3. Using the map in the Content area, find the location where the photo was taken.

4. Drag the image thumbnail from the Filmstrip to the location on the map, or with the thumbnail selected, Cmd-click (Mac) or Ctrl-click (Win) on the map location.

 Lightroom places a marker on the map and also adds the GPS coordinates to the selected image.

Add GPS Coordinates Via the Contextual Menu

You can also add GPS coordinates via the contextual menu. To do so, select an image thumbnail from the Filmstrip. Then Control-click (Mac) or right-click on the map location and choose Add GPS Coordinates to Selected Photos from the contextual menu.

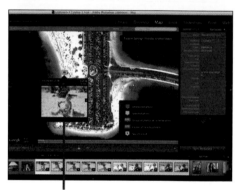

Lightroom places a marker on the map.

Learn to create
a saved print.

Learn to save custom print
layouts as user templates.

Learn to create a Custom
Package print layout.

Learn to display
rulers, grids, and
guides in a print layout.

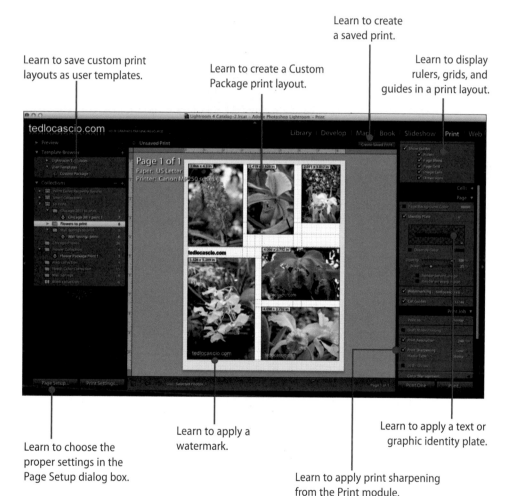

Learn to apply a
watermark.

Learn to apply a text or
graphic identity plate.

Learn to choose the
proper settings in the
Page Setup dialog box.

Learn to apply print sharpening
from the Print module.

In this chapter, you learn to utilize Lightroom's various printing options.

→ Choosing a Print Layout Style
→ Choosing Print Settings and Options
→ Inserting an Identity Plate Overlay
→ Creating a Watermarking Preset
→ Adding Photo Info
→ Utilizing Color Management
→ Utilizing Alternative Printing Options
→ Saving a Custom Print Template
→ Creating a Saved Print

13

Printing

One of the most common ways to share your favorite photos is to create prints of them. In recent years, it has become increasingly popular to print your own photos using a home-based inkjet printer rather than sending them off to a professional printing service. This is partly because it is now affordable to purchase inkjet printers capable of producing high-quality photographic prints. The downside to taking on this task yourself is that you might find it overwhelming to try to demystify the complexities of the operating system print dialog boxes. You might also find it difficult to make the colors in your photographic prints match what you see onscreen.

Thankfully, Lightroom makes the home-based inkjet printing process much easier. In this chapter, you learn how to set up a print layout using Single Image/Contact Sheet mode or the Picture Package style. You also learn how to print additional photo info, such as filename, shot date, or exposure setting; page options, such as crop marks; and an identity plate overlay, such as a custom watermark or a graphic border.

Choosing a Print Layout Style

Lightroom comes equipped with three different layout styles for you to choose from: Single Image/Contact Sheet, Picture Package, and Custom Package. Each layout style provides you with different options for creating a multi-photo print layout. Several options, including watermarking, identity plates overlays, background colors, rulers, and guides, are available with every layout style.

Create a Single Image/ Contact Sheet Layout

The Single Image/Contact Sheet style enables you to choose how an image (or multiple selected images) are positioned in a print layout. You accomplish this by entering specific settings in the Layout panel.

1. From the Library module Grid or the Filmstrip, select the photo(s) to print.

2. Choose File, Print or click the Print button in the upper-right corner of the interface.

Keyboard Shortcuts

Press Cmd+P (Mac) or Ctrl+P (Win) to apply the Print command quickly.

Lightroom displays the photo in the Content area of the Print module.

3. Choose Window, Panels, Layout Style to display the Layout Style panel.

Keyboard Shortcuts

Press Cmd+1 (Mac) or Ctrl+1 (Win) to show or hide the Layout Style panel quickly.

4. Select Single Image/Contact Sheet from the Layout Style panel.

5. Choose Window, Panels, Layout to display the Layout panel.

Keyboard Shortcuts

Press Cmd+3 (Mac) or Ctrl+3 (Win) to show or hide the Layout panel quickly.

6. At the top of the Layout panel, choose a measurement option from the Ruler Units drop-down list. The default Ruler Units option is inches.

7. To determine the margin widths for the contact sheet, adjust the Left, Right, Top, and Bottom sliders in the Margins section of the Layout panel. As you adjust the margin settings, Lightroom automatically adapts the Cell Spacing and Cell Size settings to fit within the margins.

8. To determine the number of rows and columns to include, adjust the Rows and Columns sliders in the Page Grid section of the Layout panel.

9. To determine the amount of cell spacing to include, adjust the Vertical and Horizontal sliders in the Cell Spacing section of the Layout panel.

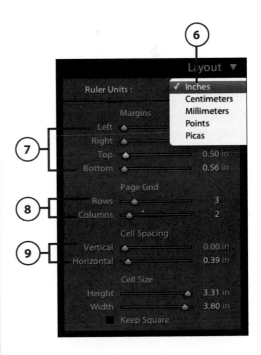

10. To determine the size of the cells, adjust the Height and Width sliders in the Cell Size section of the Layout panel.

11. If you'd like to constrict the cell size proportions to a perfect square, enable the Keep Square option.

Adjust a Single Image/ Contact Sheet Manually

You can also adjust the Single Image/Contact Sheet layout by clicking and dragging any of the page guidelines in the Content area.

The Single/Image Contact Sheet layout.

Create a Picture Package Layout

Picture Package enables you to include photos of all different sizes on a single page. You can use this style to print multiple variations of a portrait image on a single sheet of paper and then trim them to size.

1. From the Library module Grid or the Filmstrip, select the photo(s) to print.

2. Choose File, Print or click the Print button in the upper-right corner of the interface.

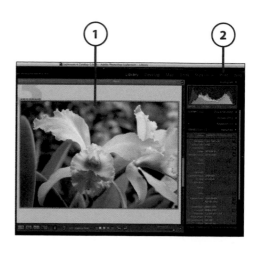

Keyboard Shortcuts

Press Cmd+P (Mac) or Ctrl+P (Win) to apply the Print command quickly.

Lightroom displays the photo in the Content area of the Print module.

3. Choose Window, Panels, Layout Style to display the Layout Style panel.

Keyboard Shortcuts

Press Cmd+1 (Mac) or Ctrl+1 (Win) to show or hide the Layout Style panel quickly.

4. Select Picture Package from the Layout Style panel.

5. Choose Window, Panels, Rulers, Grids & Guides to display the Rulers, Grids & Guides panel.

Keyboard Shortcuts

Press Cmd+3 (Mac) or Ctrl+3 (Win) to show or hide the Cells panel quickly.

6. In the Rulers section of the Rulers, Grids & Guides panel, choose a measurement option from the Units drop-down list. The default Units option is inches.

7. Choose Window, Panels, Cells to display the Cells panel.

Keyboard Shortcuts

Press Cmd+4 (Mac) or Ctrl+4 (Win) to show or hide the Cells panel quickly.

8. Click the Clear Layout button in the Cells panel.

9. Add cells to the blank Picture Package layout by clicking the Cell Size buttons in the Cells panel. The cell sizes range from 2 x 2.5 inches to 8 x 10 inches.

10. To assign a new cell size to a button, click the down-facing arrow and choose one from the drop-down list. To assign a custom size, choose Edit from the drop-down list; then enter the dimensions in the New Custom Size dialog box and click Add. If the cells that you add do not fit on a single page, Lightroom automatically adds a page to the layout.

11. If necessary, adjust the size of a cell by selecting it in the Content area and dragging the Height and Width sliders in the Adjust Selected Cell section of the Cells panel.

12. If necessary, click the Auto Layout button to automatically rearrange the cells to fit best on the page.

Adjust Picture Package Cells Manually

You can also resize and reposition Picture Package cells by clicking and dragging them in the Content area. To resize them, click and drag any side or corner bounding box node.

The Picture Package layout.

Create a Custom Package Layout

Custom Package is similar to Picture Package in that it also enables you to include photos of all different sizes on a single page. The difference is that with Custom Package, you can drag and drop thumbnails directly from the Filmstrip and position them in the Content area however you like.

1. From the Library module Grid or the Filmstrip, select the photo(s) to print.

2. Choose File, Print or click the Print button in the upper-right corner of the interface.

Keyboard Shortcuts

Press Cmd+P (Mac) or Ctrl+P (Win) to apply the Print command quickly.

Lightroom displays the photo in the Content area of the Print module.

3. Choose Window, Panels, Layout Style to display the Layout Style panel.

Keyboard Shortcuts

Press Cmd+1 (Mac) or Ctrl+1 (Win) to show or hide the Layout Style panel quickly.

4. Select Custom Package from the Layout Style panel.

5. Choose Window, Panels, Rulers, Grids & Guides to display the Rulers, Grids & Guides panel.

Keyboard Shortcuts

Press Cmd+3 (Mac) or Ctrl+3 (Win) to show or hide the Cells panel quickly.

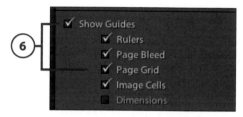

6. In the Rulers, Grids & Guides panel, enable the Show Guides and Page Grid options.

7. Add cells to the blank Custom Package by dragging thumbnails from the Filmstrip. Note that you can drag multiple selected thumbnails at once.

8. Reposition the cells on the page by clicking and dragging each one in the Content area. Use the Page Grid to help align the cells on the page.

9. Choose Window, Panels, Cells to display the Cells panel.

Keyboard Shortcuts

Press Cmd+4 (Mac) or Ctrl+4 (Win) to show or hide the Cells panel quickly.

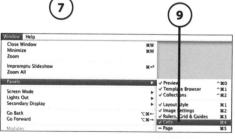

10. If necessary, adjust the size of a cell by selecting it in the Content area and dragging the Height and Width sliders in the Adjust Selected Cell section of the Cells panel.

11. To maintain the photo aspect ratio as you resize the cells, enable the Lock to Photo Aspect Ratio option in the Cells panel.

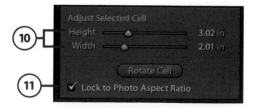

Choosing Print Settings and Options

The Print module includes a multitude of options for you to choose from when creating a print layout. For example, you can choose to display rulers, grids, and guides as well as select the desired image settings. You can also choose to display page options, such as page numbers, page info, and crop marks. The Photo Info option enables you to display image metadata below each photo in the print. You can also apply extra print sharpening and a tone curve adjustment to enhance colors and clarity in your final print.

Choose Image Settings ▶

The options in the Image Settings panel enable you to control how selected images fill the cell areas in a print layout. The border options in the Image Settings panel differ depending on which layout style you use.

1. From the Library module Grid or the Filmstrip, select the photo(s) to print.

2. Choose File, Print or click the Print button in the upper-right corner of the interface.

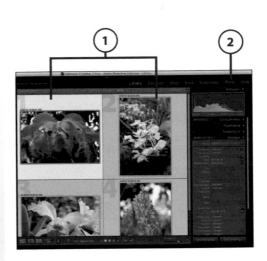

Keyboard Shortcuts
Press Cmd+P (Mac) or Ctrl+P (Win) to apply the Print command quickly.

Lightroom displays the photo(s) in the Content area of the Print module.

3. Choose Window, Panels, Image Settings to display the Image Settings panel.

4. Enable any of the following image settings:

Zoom to Fill fills the entire cell area with the image.

Rotate to Fit automatically rotates the image to fill the cell area.

Repeat One Photo per Page assigns a single page to every photo in the selection. Lightroom places as many copies of the photo as it can fit on the page.

Stroke Border places an outer border around the image. To determine the stroke width, adjust the Width slider. As you increase the width of the stroke border, Lightroom automatically resizes the image inside the cell. To determine the stroke color, click the neighboring color swatch icon and choose one from the Color Picker.

Photo Border places a white border around the image. To determine the border width, adjust the Width slider. As you increase the width of the photo border, Lightroom automatically resizes the image inside the cell, with or without an inner stroke applied.

Inner Stroke places an inner stroke around the image. To determine the stroke width, adjust the Width slider. As you increase the width of the inner stroke, Lightroom automatically resizes the image inside the cell. To determine the stroke color, click the neighboring color swatch icon and choose one from the Color Picker.

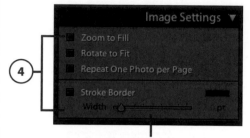

The Image Settings dialog box in Single Image/Contact Sheet mode.

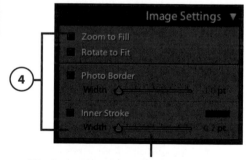

The Image Settings dialog box in Picture Package mode.

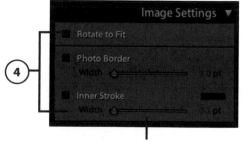

The Image Settings dialog box in Custom Package mode.

Display Rulers, Grids, and Guides in Single Image/Contact Sheet Mode

When creating a print layout in Single Image/Contact Sheet mode, you can display rulers, grids, and guides by enabling the options available in the Guides panel.

1. With a Single Image/Contact Sheet layout already set up in the Print module, choose Window, Panels, Guides to display the Guides panel.

Keyboard Shortcuts

Press Cmd+4 (Mac) or Ctrl+4 (Win) to show or hide the Guides panel quickly.

2. Enable the Show Guides option at the top of the Guides panel.

3. Enable the items in the Guides panel that you would like to display in the layout. Options include: Rulers, Page Bleed, Margins and Gutters, Image Cells, and Dimensions.

The print layout with guides visible.

>Go Further

CHOOSE A RULER UNITS OPTION FROM THE LAYOUT PANEL

You can choose a measurement option from the Ruler Units drop-down list, which is located at the top of the Layout panel. The default Ruler Units option is inches. Other options include centimeters, millimeters, points, and picas.

Display Rulers, Grids, and Guides in Picture Package and Custom Package Mode

To display guides in Picture Package mode, you must enable the options in the Rulers, Grid & Guides panel.

1. With a Picture Package layout already set up in the Print module, choose Window, Panels, Rulers, Grids & Guides to display the Rulers, Grids & Guides panel.

2. Enable the Show Guides option in the Rulers, Grids & Guides panel.

3. To display rulers, enable the Rulers option.

4. Choose a measurement option from the Ruler Units drop-down list in the Rulers, Grids & Guides panel. The default Ruler Units option is inches.

5. To display bleed guides, enable the Page Bleed option.

6. To display grids, enable the Page Grid option.

7. Choose a snapping option from the Grid Snap drop-down list in the Rulers, Grids & Guides panel. You can choose to snap images to the cells or the grid, or turn snapping off entirely.

8. To display image cells, enable the Image Cells option.

9. To display image dimensions in the upper-left corner of each cell, enable the Dimensions option.

The print layout with guides visible.

Insert Page Options

When creating a print layout using the Single Image/Contact Sheet style, page options enable you to include useful extras. The Crop Marks option is especially useful for trimming photos after they have been printed. The Page Info option inserts information relating to the print output method. The Page Numbers option enables you to apply a specific page order to your contact sheets.

1. With a Single Image/Contact Sheet layout already set up in the Print module, choose Window, Panels, Page to display the Page panel.

Keyboard Shortcuts

Press Cmd+5 (Mac) or Ctrl+5 (Win) to show or hide the Page panel quickly.

2. Enable Page Options in the Page panel.

3. Enable any of the following page options:

Page Numbers inserts a page number in the bottom-right corner of each page.

Page Info inserts the chosen Sharpening and Color Management settings, as well as the name of the chosen printer, in the lower-left corner of each page.

Crop Marks inserts crop marks around each image cell.

4. At the bottom of the Page panel, choose a font size for the page number and page info text from the Font Size drop-down list.

Add Photo Info

The Photo Info section of the Page panel enables you to display specific information about the photos at the bottom of each image cell.

1. With a Single Image/Contact Sheet layout already set up in the Print module, choose Window, Panels, Page to display the Page panel.

Keyboard Shortcuts

Press Cmd+5 (Mac) or Ctrl+5 (Win) to show or hide the Page panel quickly.

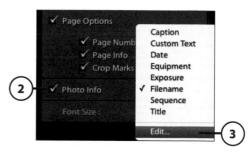

2. Enable Photo Info in the Page panel.

3. Choose a photo info preset option from the Photo Info drop-down list, or to create a custom setting, choose Edit.

4. For custom info settings, choose the items to include from the drop-down lists in the Text Template Editor dialog box. Click the neighboring Insert buttons to add the text items.

5. If you've chosen to apply a custom setting, click the Done button in the bottom-right corner of the Text Template Editor dialog box.

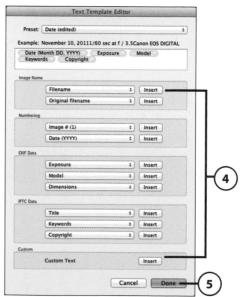

6. At the bottom of the Page panel, choose a font size for the text from the Font Size drop-down list.

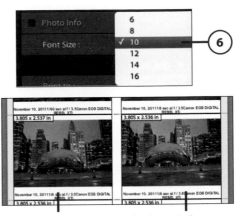

The print layout with photo info.

ADD CUSTOM PHOTO INFO MANUALLY WITH THE TEXT TEMPLATE EDITOR

>Go Further

You can also manually enter custom text in the Text Template Editor. To add spaces between photo info or to add characters and custom text, simply place the cursor in the text field above and type. Note that you cannot enter paragraph breaks or forced line breaks.

Enable Print Sharpening

Print Sharpening enables you to compensate for the natural softening process that occurs when printing an image. You cannot preview Print Sharpening prior to printing, but rest assured that the Standard setting applies enough extra sharpening to ensure that your printed photo will appear as sharp as it does onscreen.

1. With a print layout already set up in the Print module, choose Window, Panels, Print Job to display the Print Job panel.

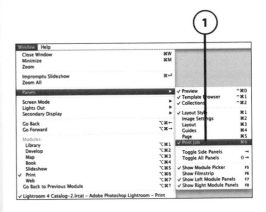

Keyboard Shortcuts

Press Cmd+6 (Mac) or Ctrl+6 (Win) to show or hide the Print Job panel quickly.

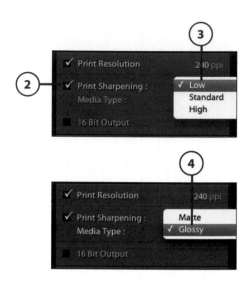

2. Enable the Print Sharpening option in the Print Job panel.

3. Choose the sharpening quality from the Print Sharpening drop-down list.

4. Select the type of paper you are printing on from the Media Type drop-down list.

Enable Print Adjustment

Print Adjustment applies a tone curve adjustment that helps you achieve print colors that appear closer to the bright and saturated colors you see onscreen in Lightroom. You are unable to preview this adjustment prior to printing; therefore, utilizing this feature requires some experimentation.

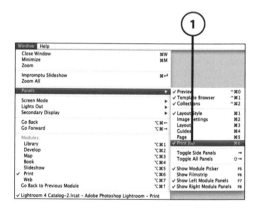

1. With a print layout already set up in the Print module, choose Window, Panels, Print Job to display the Print Job panel.

2. Enable the Print Adjustment option in the Print Job panel.

3. Drag the Brightness and Contrast sliders to the right to increase both items in your print.

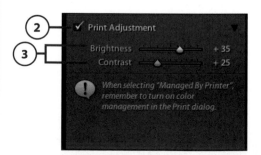

Configure the Page Setup Dialog Box in Mac OS X

The Page Setup dialog box is native to your operating system (Mac OS X or Windows) and enables you to specify which printer to send the file to and what paper size to use. Paper size options may vary depending on which printer you've chosen.

1. Choose File, Page Setup or click the Page Setup button located in the lower-left corner of the Print module interface.

Keyboard Shortcuts

Press Cmd+P (Mac) or Ctrl+P (Win) to apply the Print command quickly.

2. In the Page Setup dialog box, choose the printer that you'd like to use from the Format For drop-down list.

3. Choose the paper size that you are using from the Paper Size drop-down list.

4. Choose the paper orientation by clicking the portrait or landscape Orientation button.

5. Click OK to close the Page Setup dialog box.

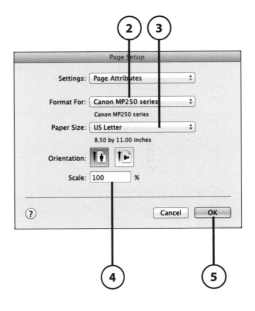

Configure the Page Setup Dialog Box in Windows

1. Choose File, Page Setup or click the Page Setup button located in the lower-left corner of the Print module interface.

Keyboard Shortcuts
Press Cmd+P (Mac) or Ctrl+P (Win) to apply the Print command quickly.

2. In the Print Setup dialog box, choose the printer that you'd like to use from the Name drop-down list.

3. Choose the paper size that you are using from the Size drop-down list.

4. Choose the paper orientation by clicking the portrait or landscape Orientation button.

5. Click OK to close the Print Setup dialog box.

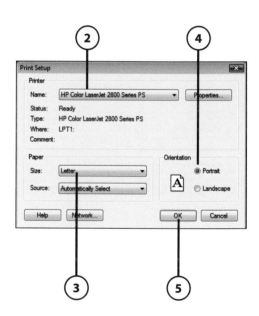

Inserting an Identity Plate Overlay

Just as you can choose to display an identity plate in the Lightroom Module Picker, you can also choose to display one in your photo prints. By enabling this feature, you can add contact info or captions by inserting a styled text identity plate. By inserting a graphical identity plate, you can apply a graphic border to your print images.

Insert a Styled Text Identity Plate

1. With a print layout already set up in the Print module, choose Window, Panels, Page to display the Page panel.

Keyboard Shortcuts

Press Cmd+5 (Mac) or Ctrl+5 (Win) to show or hide the Page panel quickly.

2. Enable the Identity Plate option.

 Lightroom applies the identity plate currently displayed in the Module Picker.

3. To edit the Identity Plate settings, click the Identity Plate preview in the Page panel and choose Edit from the drop-down list.

4. In the Identity Plate Editor dialog box, enable the Use a Styled Text Identity Plate option and enter some text in the field below.

5. Highlight the preview text with the cursor. From the drop-down lists positioned below the text preview, choose a font, style, and point size.

6. Click the color swatch icon to launch the system Color Picker and choose a different color for the identity plate.

7. Click OK to apply the identity plate as an image overlay.

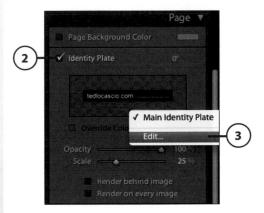

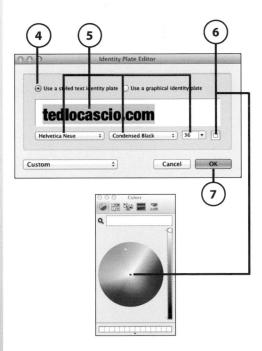

8. To apply a background color to the page, enable Page Background Color in the Page panel. Click the neighboring swatch icon to access the Lightroom Color Picker and choose a different color.

9. Choose a rotation option from the Rotate Identity Plate drop-down list, located in the upper-right corner of the Page panel.

10. If necessary, enable the Override Color option and click the neighboring swatch icon to access the Lightroom Color Picker and choose a different color for the identity plate text.

11. To adjust the opacity level of the identity plate, drag the Opacity slider.

12. To adjust the size of the identity plate, drag the Scale slider.

13. Choose one of the following Rendering options:

 Render Behind Image positions the identity plate behind the image in the layout.

 Render on Every Image repeats the identity plate in a multiple grid cell layout.

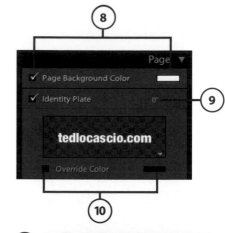

The print layout with the text ID plate.

Insert a Graphical Identity Plate

1. With a print layout already set up in the Print module, choose Window, Panels, Page to display the Page panel.

Keyboard Shortcuts

Press Cmd+5 (Mac) or Ctrl+5 (Win) to show or hide the Page panel quickly.

2. Enable the Identity Plate option in the Page panel.

 Lightroom applies the identity plate currently displayed in the Module Picker, or the last created identity plate.

3. To edit the identity plate settings, click the identity plate preview in the Page panel, and choose Edit from the drop-down list.

4. In the Identity Plate Editor dialog box, enable the Use a Graphical Identity Plate option.

5. Click the Locate File button located under the preview area.

6. In the Locate File dialog box, browse to the file on your system and click Choose. You can also drag and drop, or copy and paste the image into the preview area.

7. Click OK to apply the identity plate.

8. To apply a background color to the page, enable Page Background Color in the Page panel. Click the neighboring swatch icon to access the Lightroom Color Picker and choose a different color.

9. Choose a rotation option from the Rotate Identity Plate drop-down list, located in the upper-right corner of the Page panel.

10. To adjust the opacity level of the identity plate, drag the Opacity slider in the Page panel.

11. To adjust the size of the identity plate, drag the Scale slider in the Page panel.

12. Choose one of the following Rendering options:

 Render Behind Image positions the identity plate behind the image in the layout.

 Render on Every Image repeats the identity plate in a multiple grid cell layout.

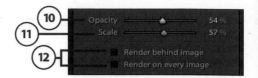

The print layout with the graphical ID plate.

Creating a Watermarking Preset

Lightroom enables you to save your favorite settings for applying custom text and graphic style watermarkings. By saving a watermarking preset, you can apply these settings to all images in your print layout by simply choosing the preset from the Watermarking list in the Pages panel.

Save a Text Watermarking Preset

1. With a print layout already set up in the Print module, choose Window, Panels, Page to display the Page panel.

Keyboard Shortcuts

Press Cmd+5 (Mac) or Ctrl+5 (Win) to show or hide the Page panel quickly.

2. Enable the Watermarking option in the Page panel.

3. To edit the watermark settings, choose Edit Watermarks from the neighboring drop-down list.

4. In the Watermark Editor dialog box, choose Text as the Watermark Style.

5. Enter the custom watermark text in the field below the preview image.

6. Choose a font and style from the Text Options Font and Style drop-down lists.

7. Click one of the Align buttons to specify a text alignment option (left, center, or right).

8. Click the color swatch icon to launch the system Color Picker and choose a different color for the watermark text.

9. To apply a shadow to the watermark, enable the Shadow option and specify the following settings using the respective sliders:

 Opacity enables you to specify an opacity value for the drop shadow.

 Offset enables you to specify an offset distance for the shadow.

 Radius enables you to specify a softness value for the shadow.

 Angle enables you to specify where to position the drop shadow in relation to the text.

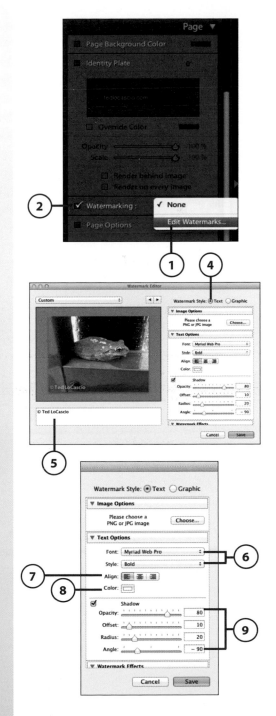

10. In the Watermark Effects section of the dialog box, use the Opacity slider to specify an opacity value for the watermark. You can also enter a value in the Opacity field.

11. Choose an anchor option by clicking one of the Anchor radio buttons.

12. Specify a size for the watermark by selecting one of the following Size options:

Click Proportional to size the watermark proportionally. Drag the slider or enter a size value in the neighboring field.

Click Fit to force the entire watermark in the image area.

Click Fill to cover the image area with the watermark.

13. If necessary, specify an inset value by dragging the Horizontal and Vertical Inset sliders. You can also enter inset values in the respective fields.

14. If necessary, rotate the watermark by clicking the Rotate buttons.

15. Click Save.

16. In the New Preset dialog box, enter a name in the Preset Name field.

17. Click Create.

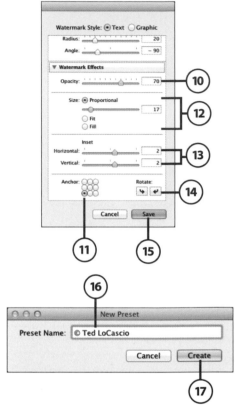

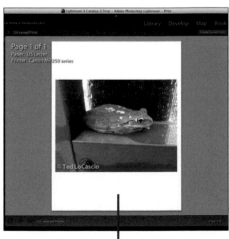

The print layout with the text watermark.

Save a Graphic Watermarking Preset

1. With a print layout already set up in the Print module, choose Window, Panels, Page to display the Page panel.

2. Enable the Watermarking option in the Page panel.

3. To edit the watermark settings, choose Edit Watermarks from the neighboring drop-down list.

4. In the Watermark Editor dialog box, choose Graphic as the Watermark Style.

5. In the Choose a File dialog box, browse to the file on your system and click Choose.

6. In the Watermark Effects section of the dialog box, use the Opacity slider to specify an opacity value for the watermark. You can also enter a value in the Opacity field.

7. Select an anchor option by clicking an Anchor radio button.

8. Specify a size for the watermark by selecting one of the following Size options:

 Click Proportional to size the watermark proportionally. Drag the slider or enter a size value in the neighboring field.

 Click Fit to force the entire watermark in the image area.

 Click Fill to fill the image area with the watermark.

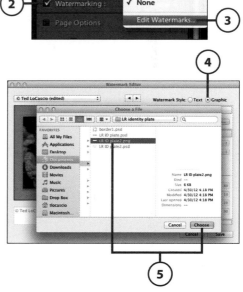

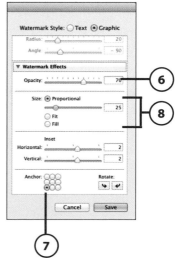

9. If necessary, specify an inset value by dragging the Horizontal and Vertical Inset sliders. You can also enter inset values in the respective fields.

10. If necessary, rotate the watermark by clicking the Rotate Clockwise or Rotate Counterclockwise buttons.

11. Click Save.

12. In the New Preset dialog box, enter a name in the Preset Name field.

13. Click Create.

Watermarking Presets and Other Modules

You can also create and apply watermarking presets in the Slideshow and Web modules. Access the watermarking preset options from the Watermarking list in the Slideshow module Overlays panel.

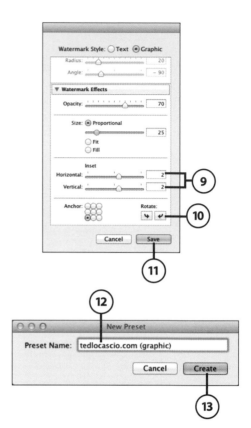

The print layout with the graphic watermark.

Utilizing Color Management

There are two ways you can manage color during output: via the printer driver or via Lightroom. To achieve the highest-quality prints, you should allow Lightroom to manage your color and choose the printer's custom profile from the Profile drop-down list in the Color Management section of the Print Job panel. Note that the Managed by Printer options vary depending on what printer you are using and what options are available through the printer driver.

Use Managed By Printer Settings

1. With a print layout already set up in the Print module, choose Window, Panels, Print Job to display the Print Job panel.

Keyboard Shortcuts
Press Cmd+6 (Mac) or Ctrl+6 (Win) to show or hide the Print Job panel quickly.

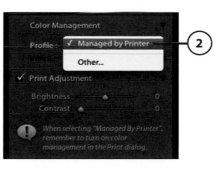

2. In the Color Management section of the Print Job panel, choose Managed by Printer from the Profile drop-down list.

3. Choose File, Print or click the Print button located in the lower-right corner of the interface.

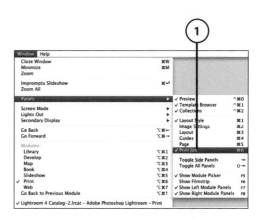

Save Printer Color Management Settings
You can save printer color management settings by choosing File, Print Settings or by clicking the Print Settings button in the lower-left corner of the interface. Doing so enables you to save the settings without actually printing the file.

4. In the Print dialog box for Mac OS X, enable the color management option available through your printer driver. In Windows, click the Properties button and enable the option from the Properties dialog box.

5. Click Print (Mac) or OK (Windows).

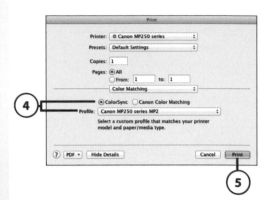

Use Managed By Lightroom Settings

1. With a print layout already set up in the Print module, choose Window, Panels, Print Job to display the Print Job panel.

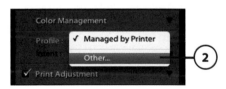

Keyboard Shortcuts
Press Cmd+6 (Mac) or Ctrl+6 (Win) to show or hide the Print Job panel quickly.

2. In the Color Management section of the Print Job panel, choose Other from the Profile drop-down list.

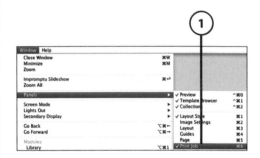

3. In the Choose Profiles dialog box, select the color profiles to display in the Profile drop-down list. Enable the Include Display Profiles option to choose a custom monitor profile.

4. Click OK to close the Choose Profiles dialog box.

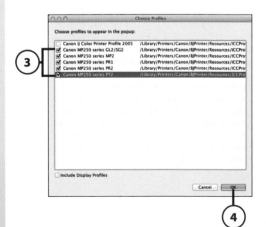

5. Select the custom profile from the Profile drop-down list.

6. Click one of the following Rendering Intent buttons:

 Perceptual maps all the colors in the image to fit smoothly using the selected print profile. All color differentiations are preserved.

 Relative maps all the colors in the image to the nearest equivalent in-gamut color using the selected print profile. Colors that fall outside the print space gamut are clipped.

7. Choose File, Print or click the Print button located in the lower-right corner of the interface.

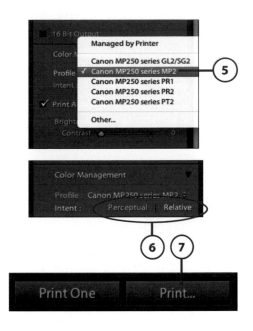

Saving a Custom Print Template

Lightroom enables you to save your favorite print layouts as templates, which enables you to reinstate your most commonly used layouts with a simple click of a button. You can save templates in the User Templates folder or create new folders within the Templates Browser panel. In addition, the Templates Browser panel also contains a Lightroom Templates folder that contains all the templates (Single Image/Contact Sheet and Picture Package) that ship with Lightroom.

Save Print Layout Settings as a Template

1. With a print layout already set up in the Print module, and the Page Setup and Print Settings dialog box options already configured, choose Window, Panels, Template Browser to display the Template Browser panel.

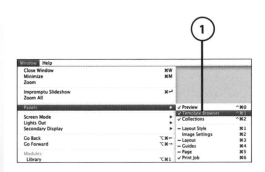

Keyboard Shortcuts

Press Control+Cmd+1 (Mac) or Ctrl+Shift+1 (Win) to show or hide the Template Browser panel quickly.

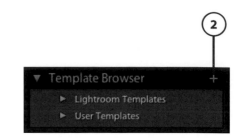

2. Choose Print, New Template, or click the Create New Preset button (the + symbol) in the upper-right corner of the Template Browser panel.

Keyboard Shortcuts

Press Cmd+N (Mac) or Ctrl+N (Win) to apply the New Template command.

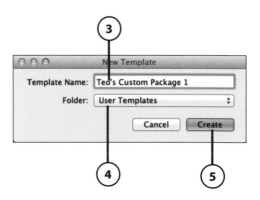

3. In the New Template dialog box, enter a name in the Template Name field.

4. Choose a folder to save the template in from the Folder drop-down list. The default is User Templates.

5. Click Create.

Lightroom adds the new template to the Template Browser list.

Creating a Saved Print

Creating a print layout for a group of photos can be a very time-consuming process. Although creating print layout presets can help save you time in print setup, the presets do not recall any photos. By creating a saved print in the Collections panel, you can recall a print layout with the photos placed in position. This enables you to print multiple copies of the same print layout at any time, without having to set anything up again.

Save a Print Layout in the Collections Panel

1. With a print layout already set up in the Print module, and the Page Setup and Print Settings dialog box options already configured, choose Print, Create Saved Print or click the Create Saved Print button in the upper-right corner of the Content area.

2. In the Create Print dialog box, enter a name for the print in the Name field.

3. Choose to place the saved print in either the top level of the Collections panel or inside an existing collection set. If you currently have a collection selected in the Collections panel, Lightroom replaces the top level option with the option to place the saved print next to the selected collection.

4. Under the Print Options section of the Create Print dialog box, choose to enable either of the following options:

 Include Only Used Photos includes only the currently selected photos for the saved print.

 Make New Virtual Copies creates virtual copies of the photos used in the print layout.

5. Click Create.

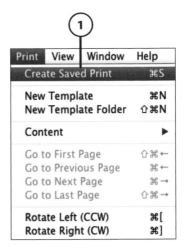

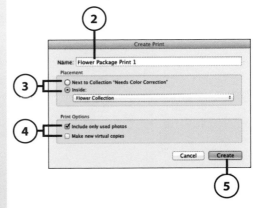

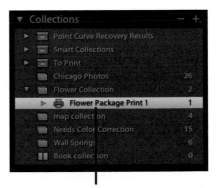

Lightroom adds the saved print to the Collections panel.

Learn to add page captions.

Learn to choose a book format.

Learn to save a book project in the Collections panel.

Learn to add photo captions.

Learn to apply cell padding to photo cells.

Learn to create an auto layout.

In this chapter, you learn to utilize Lightroom's book options.

14

Creating Books

The Book module enables you to create printable photo books of your favorite image collections. In this chapter, you learn how to choose book setup options, such as choosing an output format, displaying guides, and inserting page backgrounds. You also learn how to create an auto layout using layout presets.

This chapter also shows you how to view book pages in three different view modes, and explains how to edit the layout as well as the page contents. You learn how to create and stylize photo and page captions and utilize text style presets.

Choosing Book Setup Options

The Book module contains setup options that you can access from the Book Settings panel. From this panel, you can choose to create a book layout in the PDF or JPEG formats, or in the Blurb format, which you can send to the Blurb.com printing service. You can also choose to display guides, adjust photo cell padding, and include page backgrounds.

Choose Book Settings

1. From the Library module Grid or the Filmstrip, select the photo(s) to include in the book.

2. Choose Window, Book or click the Book button in the upper-right corner of the interface.

Keyboard Shortcuts
Press Cmd+Option+4 (Mac) or Ctrl+Alt+4 (Win) to enter the Book module quickly.

By default, the Autofill book preference is enabled. As a result, Lightroom automatically places the selected images on the book pages using the current layout settings.

Lightroom autofills the book pages.

3. Choose Window, Panels, Book Settings to display the Layout panel.

Keyboard Shortcuts

Press Cmd+1 (Mac) or Ctrl+1 (Win) to display the Book Settings panel quickly.

4. From the Book list, choose whether to output the book to PDF, JPEG, or to Blurb.com. When you choose the Blurb option, Lightroom displays the estimated price for the book project at the bottom of the panel.

5. Choose the Size and Cover options from the respective lists.

6. When outputting to Blurb.com, you must choose an option from the Paper Type list. You must also choose whether to include a Blurb.com logo page. Choosing On from the Logo Page list reduces the estimated price of the book.

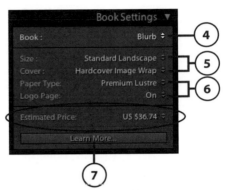

7. When outputting to Blurb.com, click the Learn More button to visit the Blurb.com website.

8. When outputting to PDF or JPEG, determine the JPEG quality by adjusting the Quality slider or by manually entering the value in the field provided.

Click Learn More to visit the Blurb website.

9. When outputting to PDF or JPEG, choose a color profile from the Color Profile list. In general, sRGB is best for onscreen display; Adobe RGB and Pro Photo RGB are best for print output.

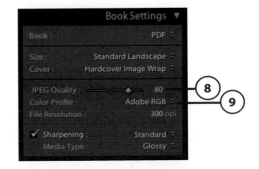

10. When outputting to PDF or JPEG, enter a resolution value in the File Resolution field. 72ppi is the standard for onscreen display; 240ppi or higher is the standard for high-resolution print output.

11. When outputting to PDF or JPEG, enable the Sharpening option and choose the sharpening quality from the drop-down list.

12. When outputting to PDF or JPEG, choose the style of paper you plan to print on from the Media Type list.

Display Guides

1. With a book layout already set up in the Book module, choose Window, Panels, Guides to display the Guides panel.

2. Enable the Show Guides option.

3. When outputting to Blurb.com, enable the Page Bleed option to display bleed guides.

4. Enable the Text Safe Area option. These guides indicate where to position text for print output.

5. Enable the Photo Cells option. These guides indicate where to place photos on the page.

6. To auto fill empty pages and caption fields with placeholder text, enable the Filler Text option.

Filler Text Book Preference

Note that in order for filler text to appear, you must choose the Filler Text option from the Fill Text Boxes list in Book Preferences. Choose Book, Book Preferences to choose this option from the Book Preferences dialog box.

Choose Filler Text in Book Preferences.

Adjust Cell Padding

1. With a book layout already set up in the Book module, choose Window, Panels, Cell to display the Cell panel.

Keyboard Shortcuts

Press Cmd+5 (Mac) or Ctrl+5 (Win) to show and hide the Cell panel quickly.

2. Click to select any page from the Content area. Cmd-click (Mac) or Ctrl-click (Win) to select multiple book pages.

3. To increase white space around the photo cells on the selected pages, drag the Padding Amount slider to the right. To decrease white space, drag to the left.

 Lightroom adjusts the cell padding for the selected pages.

Lightroom adjusts the cell padding.

Apply a Background Graphic and Color

1. With a book layout already set up in the Book module, choose Window, Panels, Background to display the Background panel.

2. To apply a background to every page in the book, enable the Apply Background Globally option. With this option disabled, the background options you choose are only applied to the pages you currently have selected.

3. To apply a graphic background, enable the Graphic option.

4. To access the background graphic list, click the down-facing arrow to the right of the background preview thumbnail.

5. At the top of the Background Graphic list, select from the Travel or Wedding group of pre-set graphics. To apply a custom photo, choose Photos.

6. When choosing a graphic from the Travel or Wedding presets, select a thumbnail from the list.

7. When choosing a graphic from the Travel or Wedding presets, you can change the graphic's color by clicking the color swatch icon to the right of the Graphic option and selecting a color with the Color Picker.

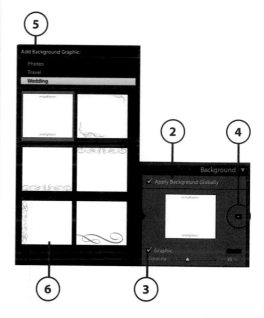

8. When placing a custom background graphic, select a photo from the Filmstrip and drag it into the preview thumbnail in the Background panel.

9. Drag the Opacity slider to the right to increase the opacity of the graphic. Drag it to the left to decrease it.

10. To place a background color on the pages, enable the Background Color option.

11. Change the background color by clicking the color swatch icon to the right of the Graphic option and selecting a different color with the Color Picker.

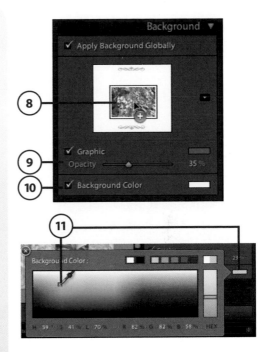

Working with Auto Layout

The Auto Layout panel enables you to automatically place all of the photos in the Filmstrip onto the pages of a preexisting layout template—all with the click of a single button. Lightroom ships with three prebuilt layouts that you can use and edit, but you can also create and save your own custom layout presets.

Create an Auto Layout ▶

1. From the Book module, choose Window, Panels, Collections to display the Collections panel.

2. Select an existing collection from the Collections panel list (for more on creating collections see "Saving Photos to Collections" in Chapter 5, "Searching for Images").

3. Choose Window, Panels, Auto Layout to display the Auto Layout panel.

Keyboard Shortcuts

Press Cmd+2 (Mac) or Ctrl+2 (Win) to display the Auto Layout panel quickly.

4. Choose a book layout preset from the Preset list. You can also choose Edit Auto Layout Preset and create a custom layout using the Auto Layout Preset Editor dialog box.

5. Click the Auto Layout button to place every photo in the collection on the pages automatically.

Create an Auto Layout Preset

1. From the Book module, choose Window, Panels, Auto Layout to display the Auto Layout panel.

Keyboard Shortcuts

Press Cmd+2 (Mac) or Ctrl+2 (Win) to display the Auto Layout panel quickly.

2. From the Preset list, choose Edit Auto Layout Preset.

3. In the Left Pages section of the Auto Layout Preset Editor dialog box, choose a layout option from the list provided.

4. In the Right Pages section of the Auto Layout Preset Editor dialog box, choose a layout option from the list provided.

5. Choose the preferred Zoom, Long Edges, and Caption options for both left and right pages.

6. Click Save.

7. Enter a name for the preset in the Name field of the New Preset dialog box.

8. Click Create.

Viewing Book Pages

The Book module enables you to view book pages in three different ways: Multi-Page view, Spread view, and Single Page view. Multi-Page view enables you to easily select and rearrange pages and swap photos. Spread view is great for editing the page contents of a single spread. Single Page view is excellent for editing captions and repositioning photos. You can click the page view buttons in the Toolbar to switch between these views.

Click the Page View Buttons

1. With a book layout already set up in the Book module, choose View, Show Toolbar.

Keyboard Shortcuts
Press T to show or hide the Toolbar quickly.

2. To view multiple pages in the Content area, click the Multi-Page view button at the far left of the Toolbar.

 Lightroom displays the book in Multi-Page view.

Keyboard Shortcuts
Press Cmd+E (Mac) or Ctrl+E (Win) to apply the Multi-Page View command quickly.

3. When viewing in Multi-Page view, drag the Thumbnails slider to the right to increase the thumbnail size, or drag it to the left to decrease their size.

4. To view a single spread in the Content area, click the Spread View button at the far left of the Toolbar.

Lightroom displays the book in Spread view.

Keyboard Shortcuts
Press Cmd+R (Mac) or Ctrl+R (Win) to apply the Spread View command quickly.

5. To view a single page in the Content area, click the Single Page View button at the far left of the Toolbar.

Lightroom displays the book in Single Page view.

Keyboard Shortcuts
Press Cmd+T (Mac) or Ctrl+T (Win) to apply the Single Page View command quickly.

Editing a Book Project

After you create a basic book layout using the auto layout feature, you can apply changes to both the layout and page contents. You can add, remove, and reposition pages, as well as apply different page layout presets to existing pages. Lightroom also enables you to change the zoom magnification for placed photos so that they fill the photo cells, and you can swap images from page to page.

Rearrange Pages

1. With a book layout already set up in the Book module, choose View, Show Toolbar.

Keyboard Shortcuts

Press T to show or hide the Toolbar quickly.

2. To view multiple pages in the Content area, click the Multi-Page View button at the far left of the Toolbar.

 Lightroom displays the book in Multi-Page view.

3. Click any page edge (not the placed photos or captions) and drag it to a new position in the layout.

Edit Page Layouts

1. With a book layout already set up in the Book module, click to select any page from the Content area. Cmd-click (Mac) or Ctrl-click (Win) to select multiple book pages.

2. Choose Window, Panels, Page to display the Page panel.

Keyboard Shortcuts

Press Cmd+3 (Mac) or Ctrl+3 (Win) to show and hide the Page panel quickly.

3. To access the Page Layout list, click the down-facing arrow to the right of the page preview thumbnail.

4. At the top of the Page Layout list, select a preset layout group.

5. Choose a layout from the selected preset group by clicking on a thumbnail in the bottom half of the panel.

 Lightroom applies the chosen page layout preset to the selected page.

Add and Remove Pages ▶

1. With a book layout already set up in the Book module, click to select any page from the Content area.

Select Multiple Nonconsecutive Pages
Cmd-click (Mac) or Ctrl-click (Win) page thumbnails to select multiple book pages.

2. Choose Window, Panels, Page to display the Page panel.

Keyboard Shortcuts
Press Cmd+3 (Mac) or Ctrl+3 (Win) to show and hide the Page panel quickly.

3. Click the Add Page button to insert a single page immediately after the furthest selected page in the book.

The new page inherits the same page layout style as the selected page.

4. To add a page immediately before a selected page in the book, Control-click (Mac) or right-click on the page thumbnail and choose Add Page from the contextual menu.

5. Click the Add Blank button to insert a single blank page (with no page layout applied) immediately after the furthest selected page in the book.

6. To add a blank page immediately before a selected page in the book, Control-click (Mac) or right-click on the page thumbnail and choose Add Blank Page from the contextual menu.

7. To delete selected pages from the book, choose Edit, Remove Pages, or Control-click (Mac) or right-click on the page thumbnail and choose Remove Pages from the contextual menu.

Lightroom removes the pages form the book.

Zoom Photos to Fill Cells

1. With a book layout already set up in the Book module, click to select any photo cell from a page. Cmd-click (Mac) or Ctrl-click (Win) to select multiple photo cells.

Select All Photo Cells

To select every photo cell in the book, choose Edit, Select All Photo Cells or press Option+Shift+Cmd+A (Mac) or Alt+Shift+Ctrl+A (Win).

2. Control-click (Mac) or right-click on any selected photo cell and choose Zoom Photo to Fill Cell from the contextual menu.

 Lightroom zooms the photos to fill the selected photo cells.

3. To adjust the zoom percentage of a photo, select the photo cell and drag the pop-up zoom slider.

 Lightroom adjusts the zoom percentage for the selected photo.

4. Click and drag the photo to reposition it inside the photo cell.

Print Size Warning

When you scale an image larger than its actual dimensions (100% or 1:1), it reduces print quality. Lightroom displays a warning icon in the upper right of the page thumbnail for any image that is scaled too large.

Swap Photos

1. With a book layout already set up in the Book module, click to select any photo from a page.

2. To swap photos, drag the selected photo over any other placed photo in the book layout.

 Lightroom swaps the two photos.

Lightroom swaps the photos.

Working with Captions

In the Book module, you can choose to add captions at the tops or bottoms of the pages. You can also insert captions above, below, or over the photos. For each caption you create, you can choose to apply a preset text style, or apply your own preferred text attributes. You can also save your favorite text attributes as a custom text style.

Add Photo Captions

1. With a book layout already set up in the Book module, click to select any photo from a page.

2. If it's not already visible, choose View, Show Toolbar.

Keyboard Shortcuts
Press T to show or hide the Toolbar quickly.

3. Click the Single Page View button at the far left of the Toolbar.

 Lightroom displays the page in Single Page view.

4. Choose Window, Panels, Caption to display the Caption panel.

Keyboard Shortcuts
Press Cmd+6 (Mac) or Ctrl+6 (Win) to show and hide the Caption panel quickly.

5. Enable the Photo Caption option.

6. Drag the Offset slider to specify the amount of space to leave between the photo and the caption.

7. Enable the Align with Photo option to align the caption.

8. Determine where to position the caption relative to the photo by clicking the Above, Over, or Below buttons.

9. Choose Window, Panels, Type to display the Type panel.

10. Choose a font and font style from the lists provided.

11. Choose the character color by clicking the color swatch icon and selecting one with the Color Picker.

12. Specify the character size by dragging the Size slider or by entering a point value in the Size field.

13. Specify the Opacity level of the caption by dragging the Opacity slider, or by entering a percentage in the Opacity field.

14. For captions containing two or more lines of text, click the left-facing arrow to reveal additional paragraph options. Choose the preferred Tracking, Baseline, Leading, and Kerning settings. To apply auto leading and kerning, click the Auto Leading and Auto Kerning buttons. Specify the number columns to use by dragging the Columns slider. Specify the amount of space to insert between the columns by dragging the Gutter slider.

15. Specify the paragraph alignment and vertical alignment by clicking the alignment buttons at the bottom of the Type panel.

16. In the Content area, enter the text into the caption field.

Add Page Captions

1. With a book layout already set up in the Book module, click any page edge to select that page.

2. If it's not already visible, choose View, Show Toolbar.

Keyboard Shortcuts

Press T to show or hide the Toolbar quickly.

3. Click the Single Page View button at the far left of the Toolbar.

 Lightroom displays the page in Single Page view.

4. Choose Window, Panels, Caption to display the Caption panel.

Keyboard Shortcuts

Press Cmd+6 (Mac) or Ctrl+6 (Win) to show and hide the Caption panel quickly.

5. Enable the Page Caption option.

6. Drag the Offset slider to specify the amount of space to leave between the photo and the page caption.

7. Determine where to position the caption relative to the photo by clicking the Top or Bottom buttons.

8. Choose Window, Panels, Type to display the Type panel.

9. Choose a font and font style from the lists provided.

10. Choose the character color by clicking the color swatch icon and selecting one with the Color Picker.

11. Specify the character size by dragging the Size slider or by entering a point value in the Size field.

12. Specify the Opacity level of the caption by dragging the Opacity slider, or by entering a percentage in the Opacity field.

13. For captions containing two or more lines of text, click the left-facing arrow to reveal additional paragraph options. Choose the preferred Tracking, Baseline, Leading, and Kerning settings. To apply auto leading and kerning, click the Auto Leading and Auto Kerning buttons. Specify the number columns to use by dragging the Columns slider. Specify the amount of space to insert between the columns by dragging the Gutter slider.

14. Specify the paragraph alignment and vertical alignment by clicking the alignment buttons at the bottom of the Type panel.

15. In the Content area, enter the text into the caption field.

Save a Text Style Preset

1. With a book layout already set up in the Book module, select any page or photo caption field.

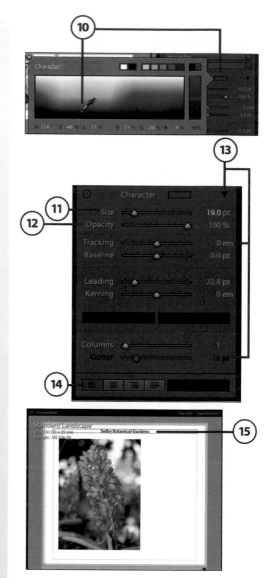

2. Choose Window, Panels, Type to display the Type panel.

Keyboard Shortcuts

Press Cmd+7 (Mac) or Ctrl+7 (Win) to show and hide the Type panel quickly.

3. To save the applied character and paragraph attributes as a text style preset, choose Save Current Settings as New Preset from the Text Style Preset list.

4. Enter a name in the Preset Name field and click Create.

 Lightroom adds the preset to the Text Style Preset list.

Saving a Book Project

Creating a photo book can be a very time-consuming process. Although creating Auto Layout presets can help save setup time, the presets do not recall any photos. By creating a saved book in the Collections panel, you can recall a book layout with the photos and captions in place.

Create a Saved Book

1. With a book layout already set up in the Book module, choose Book, Create Saved Book, or click the Create Saved Book button in the upper-right corner of the Content area.

Keyboard Shortcuts

Press Cmd+S (Mac) or Ctrl+S (Win) to apply the Create Saved Book command quickly.

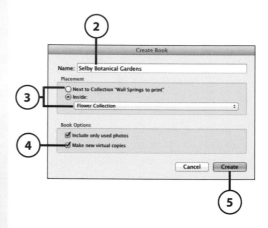

2. In the Create Book dialog box, enter a name for the book in the Name field.

3. Choose to place the saved book in either the Top level of the Collections panel or inside an existing collection set. If you currently have a collection selected in the Collections panel, Lightroom replaces the Top level option with the option to place the saved book next to the selected collection.

4. If you prefer, enable the Make New Virtual Copies option to create virtual copies of the photos used in the book.

5. Click Create.

Learn to create
a saved slideshow
project.

Learn to save slideshow settings
as user templates.

Learn to insert intro
and ending screen
identity plates.

Learn to preview a
slideshow in Lightroom.

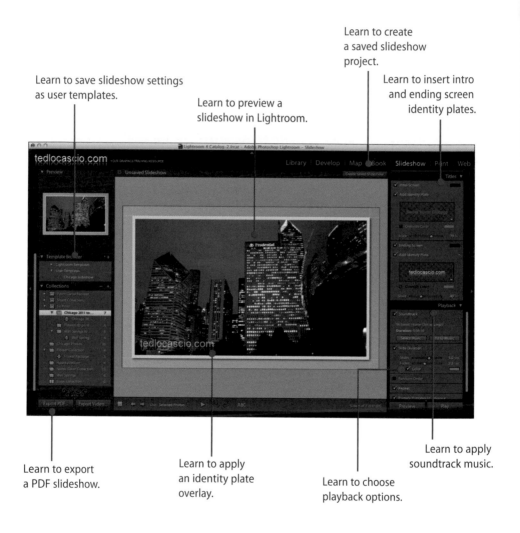

Learn to export
a PDF slideshow.

Learn to apply
an identity plate
overlay.

Learn to choose
playback options.

Learn to apply
soundtrack music.

In this chapter, you learn to create slideshows in Lightroom.

- → Viewing Images in the Slide Editor
- → Choosing Slideshow Settings and Options
- → Inserting Slideshow Overlays
- → Creating a Backdrop
- → Adding Intro and Ending Screens
- → Adding Soundtrack Music
- → Previewing and Playing a Slideshow
- → Exporting a Slideshow
- → Saving a Slideshow Template
- → Saving a Slideshow Project

Creating Slideshows

One great way to share your favorite photos is to present them in a slideshow. You can create a slideshow to be displayed in Lightroom, or export a slideshow in PDF format to be viewed in a separate application, such as Adobe Acrobat. You can also export your slides as individual JPEG images to be used in other applications, such as Microsoft PowerPoint or Apple Keynote.

In this chapter, you learn how to view the images you have selected from the Filmstrip in the Slide Editor. You also learn how to specify slideshow margin width settings, choose image display options, and insert slide overlays, such as styled text and graphical identity plates, star ratings, and custom text.

This chapter also teaches you how to create a custom backdrop appearance for your slides and include slideshow intro and ending screens. In addition, you learn how to specify slide duration and order and include soundtrack music.

Viewing Images in the Slide Editor

The Content area in the Slideshow module is referred to as the Slide Editor. You can view the primary selected photo from the Filmstrip in the Slide Editor. To change the image that is currently displayed, click the arrow buttons in the Toolbar or press the left and right arrow keys on the keyboard. The Use menu in the Toolbar also enables you to choose whether to display all photos in the Filmstrip, just the selected photos, or only photos that have been flagged.

Open Images in the Slideshow Module

1. From the Library module Grid or the Filmstrip, select the photo(s) to include in the slideshow.

2. Click the Slideshow button in the upper-right corner of the interface.

Keyboard Shortcuts
Press Cmd+Option+3 (Mac) or Ctrl+Alt+3 (Win) to enter the Slideshow module quickly.

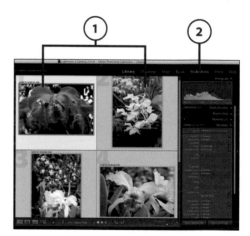

Lightroom displays the primary selected photo in the Content area of the Slideshow module.

3. If the Toolbar is not already visible, choose View, Show Toolbar.

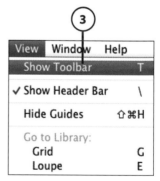

Keyboard Shortcuts
Press T to show or hide the Toolbar quickly.

4. Choose Selected Photos from the Use menu in the Toolbar.

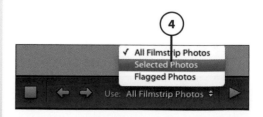

5. Click the left or right arrow buttons in the Toolbar, or the left or right arrow keys on the keyboard, to display the previous or next selected photo in the Content area.

6. To display the first slideshow image in the Content area, click the Go to first slide button (the square icon) in the Toolbar.

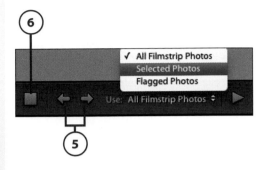

Choosing Slideshow Settings and Options

To create a custom slideshow in Lightroom, you must specify the image margin widths, and choose the desired display options, such as whether to include a stroke border, or a cast shadow. You must also specify the slide order and playback duration time. Lightroom enables you to choose all of these settings from the Layout, Options, and Playback panels in the Slideshow module.

Specify Margin Widths

The Layout panel enables you to specify the amount of pixels to apply to the slideshow margins. Note that the margin widths are always relative to and dictated by the proportions of the monitor that you are using to display the slideshow.

1. In the Slideshow module (with or without slideshow images selected in the Filmstrip), choose Window, Panels, Layout to display the Layout panel.

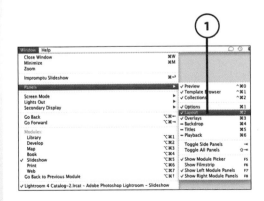

Keyboard Shortcuts

Press Cmd+2 (Mac) or Ctrl+2 (Win) to show or hide the Layout panel quickly.

2. At the top of the Layout panel, enable the Show Guides option.

3. In the Layout panel, adjust the margins by dragging the Left, Right, Top, and Bottom sliders, or by entering new pixel values in the respective fields. You can also adjust the margins by hovering the cursor over the pixel values and dragging with the scrubby slider.

4. To adjust multiple margins simultaneously, enable the Link All option located at the bottom of the Layout panel.

Adjust Margins Manually

You can also adjust the slideshow margins manually. To do so, click and drag any of the guidelines in the Content area.

Lightroom adjusts the slideshow margins.

Choose Image Display Options

The Options panel enables you to apply stroke borders, cast shadows, and a Zoom to Fill Frame option.

1. In the Slideshow module (with slideshow images already selected in the Filmstrip), choose Window, Panels, Options to display the Options panel.

Keyboard Shortcuts

Press Cmd+1 (Mac) or Ctrl+1 (Win) to show or hide the Options panel quickly.

2. Enable any of the following image display options:

Zoom to Fill Frame enlarges and crops the image to fill the entire frame.

Stroke Border places an outer border around the image. To determine the stroke width, adjust the Width slider. To determine the stroke color, click the neighboring color swatch icon and choose one from the Color Picker.

Cast Shadow places a drop shadow under each image. To control the opacity of the shadow, adjust the Opacity slider, or enter a value in the percentage field. Drag the Offset slider to control the distance between the image and the shadow. Drag the Radius slider to control the hardness or softness of the shadow. To control the position of the shadow underneath the image, drag the Angle slider or the Angle wheel.

Lightroom applies the display options.

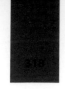

Specify Slide Duration and Order ▶

The Playback panel enables you to specify the length of time the photos display in the slideshow. It also enables you to specify the length of time to use for fade transitions during playback.

1. In the Slideshow module (with slideshow images already selected in the Filmstrip), choose Window, Panels, Playback to display the Playback panel.

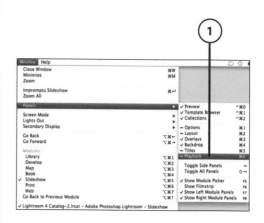

Keyboard Shortcuts

Press Cmd+6 (Mac) or Ctrl+6 (Win) to show or hide the Playback panel quickly.

2. Enable the Slide Duration option in the Playback panel.

3. Determine the amount of time each slide is displayed in the slideshow by adjusting the Slides slider.

4. Determine the amount of time each slide transition is displayed in the slideshow by adjusting the Fades slider.

5. If during each slide transition, you'd like to display a different background color, enable the Color option and click the color swatch icon to select a color with the Color Picker.

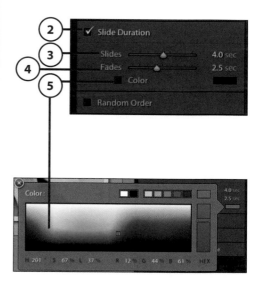

6. To shuffle the slideshow images randomly during playback, enable the Random Order.

7. Enable the Repeat option to allow the slideshow to play continuously.

8. Enable the Prepare Previews in Advance option to ensure that the slideshow is not interrupted waiting for image information to render on the display.

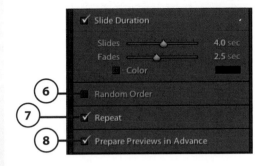

Inserting Slideshow Overlays

When you create a slideshow in Lightroom, you also have the option to display styled text and graphical identity plates, star ratings, and custom text as image overlays. The options available in the Overlays panel enable you to control the size, color, and opacity of the inserted overlay objects. You can also manually control the position of each object by clicking and dragging it in the Content area of the Slide Editor.

Include a Star Rating

Lightroom enables you to display star ratings as image overlays in a slideshow. You can choose a specific display color and adjust the opacity and size of the star ratings using the controls available in the Overlays panel.

1. In the Slideshow module (with slideshow images already selected in the Filmstrip), choose Window, Panels, Overlays to display the Overlays panel.

Keyboard Shortcuts

Press Cmd+5 (Mac) or Ctrl+5 (Win) to show or hide the Overlays panel quickly.

2. Enable the Rating Stars option in the Overlays panel.

 Lightroom displays the current star rating in the upper-left corner of the image.

3. To change the color of the star rating, click the neighboring color swatch icon in the Rating Stars portion of the Overlays panel and select one using the Color Picker.

4. To adjust the opacity level of the star rating overlay, drag the Opacity slider in the Rating Stars portion of the Overlays panel.

5. To adjust the size of the star rating overlay, drag the Scale slider in the Rating Stars portion of the Overlays panel.

Resize Slideshow Star Ratings Manually

To resize the star rating manually, click to select it in the Content area, and then drag any corner or side bounding box node.

6. To reposition the star rating overlay, click and drag it in the Content area. As you move the star rating around the screen, an anchor point automatically appears and snaps to the nearest Slide Editor side or corner point.

7. Click the anchor point to lock the repositioned star rating into place. This locks it to the anchor point should you continue to move or rotate it in the image.

8. To apply a drop shadow to the star rating overlay, select it from the Content area and enable the Shadow option. To control the opacity of the shadow, adjust the Opacity slider, or enter a value in the percentage field. Drag the Offset slider to control the distance between the rating and the shadow. Drag the Radius slider to control the hardness or softness of the shadow. To control the position of the shadow underneath the rating, drag the Angle slider or the Angle wheel.

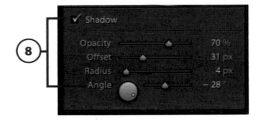

Rotate Star Rating Overlays

You can also rotate the star rating. To do so, click the Rotate adornment right (clockwise) or Rotate adornment left (counterclockwise) buttons in the Toolbar.

Insert a Styled Text Identity Plate Overlay

The Overlays panel also enables you to apply a styled text or graphical Identity Plate overlay to your slideshows.

1. In the Slideshow module (with slideshow images already selected in the Filmstrip), choose Window, Panels, Overlays to display the Overlays panel.

Keyboard Shortcuts

Press Cmd+5 (Mac) or Ctrl+5 (Win) to show or hide the Overlays panel quickly.

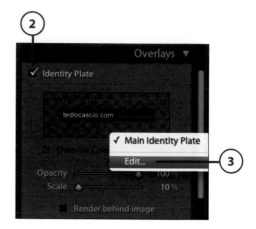

2. Enable the Identity Plate option in the Overlays panel.

 Lightroom applies the identity plate that is currently displayed in the Module Picker.

3. To edit the identity plate settings, click the identity plate preview in the Overlays panel and choose Edit from the drop-down list.

4. In the Identity Plate Editor dialog box, enable the Use a Styled Text Identity Plate option and enter some text in the field below.

5. Highlight the preview text with the cursor. From the drop-down lists positioned below the text preview, choose a font, style, and point size.

6. Click the color swatch icon to launch the system Color Picker and choose a different color for the identity plate text.

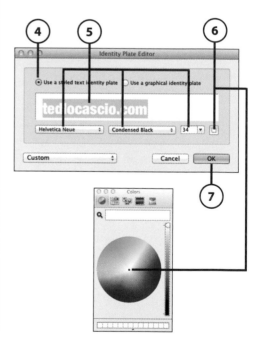

7. Click OK to apply the identity plate as an image overlay.

8. If necessary, enable the Override Color option and click the neighboring swatch icon to access the Color Picker, and choose a different color for the identity plate text.

9. To adjust the opacity level of the identity plate, drag the Opacity slider.

10. To adjust the size of the identity plate, drag the Scale slider, or click and drag any side or corner bounding box node positioned around the styled text identity plate in the Slide Editor.

11. If you prefer, enable the Render Behind Image option in the Overlays panel to position the identity plate behind the image in the slideshow.

12. To apply a drop shadow to the identity plate, select it from the Content area and enable the Shadow option. To control the opacity of the shadow, adjust the Opacity slider, or enter a value in the percentage field. Drag the Offset slider to control the distance between the image and the shadow. Drag the Radius slider to control the hardness or softness of the shadow. To control the position of the shadow underneath the image, drag the Angle slider or the Angle wheel.

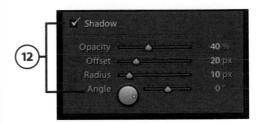

13. To reposition the identity plate, click and drag it in the Content area. As you move it around the screen, an anchor point automatically appears and snaps to the nearest Slide Editor side or corner point.

Insert a Graphical Identity Plate

1. In the Slideshow module (with slideshow images already selected in the Filmstrip), choose Window, Panels, Overlays to display the Overlays panel.

Keyboard Shortcuts

Press Cmd+5 (Mac) or Ctrl+5 (Win) to show or hide the Overlays panel quickly.

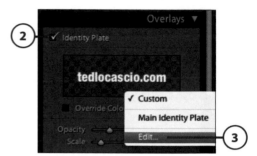

2. Enable the Identity Plate option in the Overlays panel.

 Lightroom applies the identity plate that is currently displayed in the Module Picker.

3. To edit the identity plate settings, click the identity plate preview and choose Edit from the drop-down list.

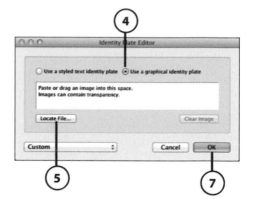

4. In the Identity Plate Editor dialog box, enable the Use a Graphical Identity Plate option.

5. Click the Locate File button located under the preview area.

6. In the Locate File dialog box, browse to the file on your system and click Choose. You can also drag and drop or copy and paste the image into the preview area.

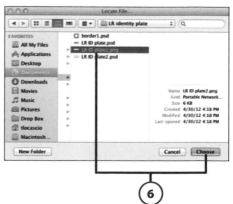

7. Click OK to apply the identity plate.

8. To adjust the opacity level of the identity plate, drag the Opacity slider.

9. To adjust the size of the identity plate, drag the Scale slider, or click and drag any side or corner bounding box node positioned around the styled text identity plate in the Slide Editor.

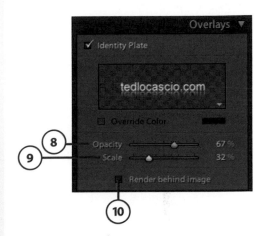

10. If you prefer, enable the Render Behind Image option in the Overlays panel to position the identity plate behind the image in the slideshow.

11. If you'd like to apply a drop shadow to the identity plate, select it from the Content area and enable the Shadow option. To control the opacity of the shadow, adjust the Opacity slider, or enter a value in the percentage field. Drag the Offset slider to control the distance between the identity plate and the shadow. Drag the Radius slider to control the hardness or softness of the shadow. To control the position of the shadow underneath the identity plate, drag the Angle slider or the Angle wheel.

12. To reposition the identity plate, click and drag it in the Content area. As you move it around the screen, an anchor point automatically appears and snaps to the nearest Slide Editor side or corner point.

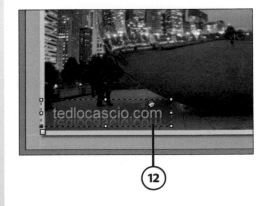

Add a Custom Text Overlay

Lightroom also enables you to insert text as a slideshow overlay. You can choose a preset text overlay option, such as Date or Filename, from the drop-down list in the Toolbar, or else choose Custom Text and type in the text in the Toolbar field provided.

1. In the Slideshow module (with slideshow images already selected in the Filmstrip), choose Window, Panels, Overlays to display the Overlays panel.

2. If the Toolbar is not already visible, choose View, Show Toolbar.

Keyboard Shortcuts
Press T to show or hide the Toolbar quickly.

3. Click the Add text to slide button in the Toolbar. Lightroom displays the Custom Text field in the Toolbar.

4. Insert some text into the Custom Text field. When you finish typing, press Return (Mac) or Enter (Win).

 Lightroom automatically enables the Text Overlays option in the Overlays panel.

5. To reposition the text overlay, click and drag the text in the Content area. As you move the text around the screen, an anchor point automatically appears and snaps to the nearest Slide Editor side or corner point.

6. Click the anchor point to lock the repositioned text overlay into place. This locks it to the anchor point should you continue to move or rotate it in the image.

7. To rotate the text overlay, click the Rotate adornment right (clockwise) or Rotate adornment left (counter-clockwise) buttons in the Toolbar.

8. To resize the text overlay, click and drag any corner or side bounding box node.

9. To choose a different color for the text overlay, click the color swatch icon and select one using the Color Picker.

10. To adjust the opacity level of the text overlay, drag the Opacity slider.

11. To choose a different font for the text overlay, choose one from the Font menu.

12. To choose a different font style for the text overlay, choose one from the Face menu.

13. If you'd like to apply a drop shadow to the custom text overlay, select it from the Content area and enable the Shadow option. To control the opacity of the shadow, adjust the Opacity slider, or enter a value in the percentage field. Drag the Offset slider to control the distance between the text and the shadow. Drag the Radius slider to control the hardness or softness of the shadow. To control the position of the shadow underneath the text, drag the Angle slider or the Angle wheel.

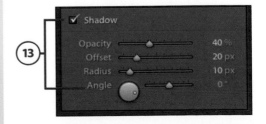

Creating a Backdrop

The Backdrop panel enables you to modify the background appearance in your slideshow. The controls in the panel enable you to choose a different background color, as well as insert a gradient color wash. You can also insert a background image and adjust its opacity level. Note that you can combine these backdrop options or apply them independently of each other.

Insert a Slideshow Background

1. In the Slideshow module (with slideshow images already selected in the Filmstrip), choose Window, Panels, Backdrop to display the Backdrop panel.

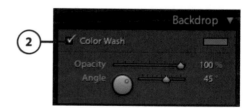

Keyboard Shortcuts

Press Cmd+4 (Mac) or Ctrl+4 (Win) to show or hide the Overlays panel quickly.

2. Enable the Color Wash option in the Backdrop panel.

3. To choose a different color for the color wash, click the color swatch icon in the Color Wash portion of the Backdrop panel and select one using the Color Picker.

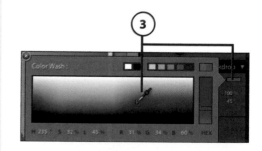

4. To adjust the opacity level of the color wash, drag the Opacity slider.

5. To control the angle of the color wash gradient, drag the Angle slider or click and drag the Angle wheel.

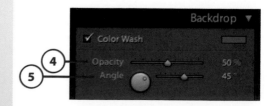

6. To add a background image, enable the Background Image option.

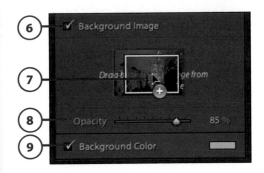

7. Drag a catalog image from the Filmstrip to the Background Image preview area in the Backdrop panel.

 Lightroom adds the image to the backdrop.

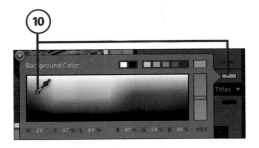

8. To adjust the opacity level of the background image, drag the Opacity slider.

9. To add a background color, enable the Background Color option.

10. To choose a different color for the background, click the color swatch icon and select one using the Color Picker.

Lightroom applies the backdrop options.

Adding Intro and Ending Screens

The Titles panel enables you to apply a styled text or graphical identity plate as the intro and ending screens in your slideshow. As it is when inserting identity plate overlays, you can choose to apply the main identity plate or create/insert a new one. Note that if you plan to include a lot of text in an intro or ending screen, you should set up the text ahead of time using a basic text editor application, such as TextEdit (Mac) or WordPad (Windows).

Insert a Styled Text Intro and End Screen

1. In the Slideshow module (with slideshow images already selected in the Filmstrip), choose Window, Panels, Titles to display the Titles panel.

2. Enable the Intro Screen and Ending Screen options in the Titles panel.

3. To choose a different color for the intro or ending screen, click the color swatch icon in the Intro Screen or Ending Screen portion of the Titles panel and select one using the Color Picker.

4. Enable the Identity Plate option in the Intro Screen or Ending Screen portion of the Titles panel.

 Lightroom applies the identity plate that is currently displayed in the Module Picker.

5. To edit the identity plate settings, click the identity plate preview and choose Edit from the drop-down list.

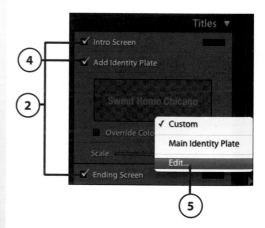

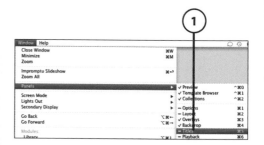

6. In the Identity Plate Editor dialog box, enable the Use a Styled Text Identity Plate option and enter some text in the field below.

7. Highlight the preview text with the cursor. From the drop-down lists positioned below the text preview, choose a font, style, and point size.

8. Click the color swatch icon to launch the system Color Picker and choose a different color for the identity plate text.

9. Click OK to apply the identity plate as an intro or end screen.

10. If necessary, enable the Override Color option and click the neighboring swatch icon to access the Color Picker and choose a different color for the identity plate text.

11. To adjust the size of the identity plate, drag the Scale slider in the Intro Screen or Ending Screen portion of the Titles panel.

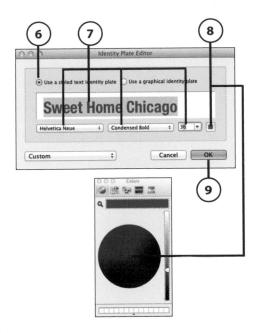

Lightroom applies the screen options.

Insert a Graphical Intro and End Screen

1. In the Slideshow module (with slideshow images already selected in the Filmstrip), choose Window, Panels, Titles to display the Titles panel.

Keyboard Shortcuts

Press Cmd+5 (Mac) or Ctrl+5 (Win) to show or hide the Overlays panel quickly.

2. Enable the Intro Screen and/or Ending Screen options in the Titles panel.

3. To choose a different color for the intro or ending screen, click the color swatch icon in the Intro Screen or Ending Screen portion of the Titles panel and select one using the Color Picker.

4. Enable the Identity Plate option in the Intro Screen or Ending Screen portion of the Titles panel.

 Lightroom applies the identity plate that is currently displayed in the Module Picker.

5. To edit the identity plate settings, click the identity plate preview and choose Edit from the drop-down list.

6. In the Identity Plate Editor dialog box, enable the Use a Graphical Identity Plate option.

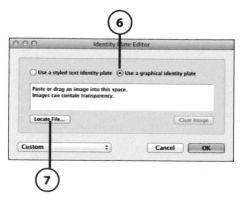

7. Click the Locate File button located under the preview area.

8. In the Locate File dialog box, browse to the file on your system and click Choose. You can also drag and drop, or copy and paste the image into the preview area.

9. Click OK to apply the identity plate as an intro or end screen.

10. If necessary, enable the Override Color option and click the neighboring swatch icon to access the Color Picker and choose a different color for the identity plate text.

11. To adjust the size of the identity plate, drag the Scale slider.

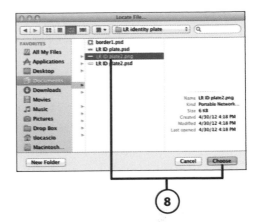

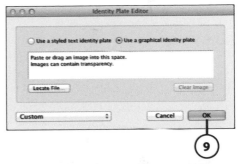

Lightroom applies the screen options.

Adding Soundtrack Music

The Playback panel includes a Soundtrack option that enables you to play background music as you view a slideshow in Lightroom or in an exported video file. To use this feature, you must have music files saved in mp3, m4a, or m4b format accessible on your disk. If you do, then you can choose a single music file to apply as the soundtrack for your slideshow. Note that you cannot include soundtrack music when exporting slideshows in PDF format.

Apply Background Music to a Slideshow

1. In the Slideshow module (with slideshow images already selected in the Filmstrip), choose Window, Panels, Playback to display the Playback panel.

Keyboard Shortcuts
Press Cmd+6 (Mac) or Ctrl+6 (Win) to show or hide the Playback panel quickly.

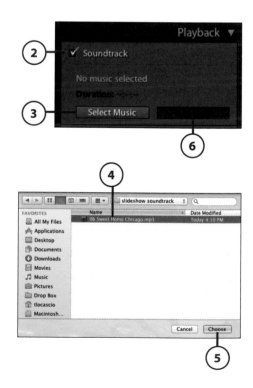

2. Enable the Soundtrack option in the Playback panel.

3. Click the Select Music button in the Playback panel.

4. Select an existing mp3, m4a, or m4b file from your disk.

5. Click Choose.

 Lightroom adds the music file as the soundtrack to your slideshow.

6. Click the Fit to Music button in the Playback panel to automatically calculate the slide duration to fit the length of the soundtrack music.

Previewing and Playing a Slideshow

As you create a slideshow in Lightroom, you can test the chosen display set-
tings by previewing the slideshow in the Content area of the Slide Editor.
After you finalize the settings, you can present the slideshow in full-screen
mode from within the Lightroom application.

Preview a Slideshow ▶

As you choose settings for your slide-
show, you can preview them in the
Slideshow module Content area. You
can also interact with the slideshow
preview by clicking the navigation
buttons in the Toolbar.

1. In the Slideshow module (with
 slideshow images already select-
 ed in the Filmstrip), choose View,
 Show Toolbar.

2. Choose Play, Content, Use
 Selected Photos, or choose
 Selected Photos from the Use
 menu in the Toolbar.

3. Click the Play button in the
 Toolbar, or click the Preview but-
 ton in the lower-right corner of
 the interface.

 Lightroom displays the slideshow
 in the Content area.

Keyboard Shortcuts
Press Option+Return (Mac) or
Alt+Enter (Win) to apply the pre-
view slideshow command quickly.

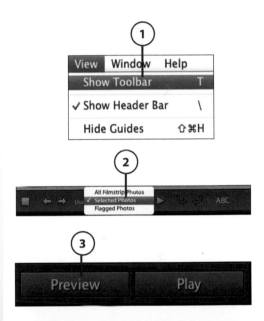

Lightroom displays the slideshow.

Prepare Previews in Advance

When the Prepare Previews in Advance option is enabled in the Playback panel, Lightroom pauses to prepare each preview before displaying the slideshow.

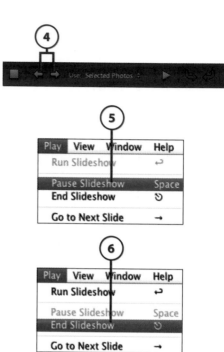

4. Click the left or right arrow buttons in the Toolbar, or the left and right arrow keys on the keyboard, to go to the previous or next slide.

5. To pause the slideshow, choose Play, Pause Slideshow, or press the Spacebar.

6. To stop the slideshow preview, choose Play, End Slideshow.

Keyboard Shortcuts

Press the Escape key to end the slideshow preview.

Play a Slideshow

After all your slideshow settings are entered, you can present the finished slideshow in full-screen mode. Note that you can also display an impromptu slideshow from any Lightroom module by choosing Window, Impromptu Slideshow or by pressing Cmd+Return (Mac) or Ctrl+Enter (Win).

1. In the Slideshow module (with slideshow images already selected in the Filmstrip), choose Play, Content, Use Selected Photos, or choose Selected Photos from the Use menu in the Toolbar.

2. Choose Play, Run Slideshow, or click the Play button in the lower-right corner of the interface.

Lightroom displays the slideshow in full-screen mode.

Keyboard Shortcuts
Press Return (Mac) or Enter (Win) to apply the Run Slideshow command quickly.

3. Click the left or right arrow keys to go to the previous or next slide.

The slideshow in full-screen mode.

Keyboard Shortcuts
To pause the slideshow, press the Spacebar. Press the Spacebar again to resume the slideshow. To stop the slideshow, press the Escape key or click the mouse.

Exporting a Slideshow

In addition to presenting slideshows in Lightroom, you can also export slideshows in mp4 video format, PDF format, or as individual JPEG slides to be used in other applications, such as Microsoft PowerPoint or Apple Keynote. Note that Adobe's free Acrobat Reader application uses fixed transition durations when displaying PDF slideshows and also does not play back soundtrack music. Slideshows exported in mp4 video format are compatible with Adobe Media Player, Apple Quicktime, and Windows Media Player 12.

Export a PDF Slideshow ▶

1. With a slideshow already set up in the Slideshow module, choose Slideshow, Export PDF Slideshow, or click the Export PDF button in the lower-left corner of the module.

Keyboard Shortcuts

Press Cmd+J (Mac) or Ctrl+J (Win) to apply the Export PDF Slideshow command quickly.

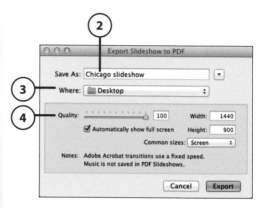

2. In the Export Slideshow to PDF dialog box, enter a name in the Save As field.

3. Choose a disk location to save the PDF slideshow.

4. Determine the quality of the PDF slideshow by adjusting the Quality slider, or by manually entering the value in the field provided.

5. Choose the preferred slideshow dimensions from the Common Sizes drop-down list, or enter specific pixel values in the Width and Height fields provided.

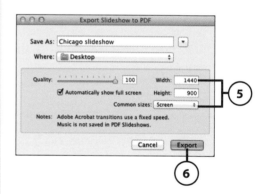

Automatically Show in Full-Screen Mode

If you'd like the slideshow to display in full-screen mode as soon as you open it in Acrobat, then enable the Automatically Show Full Screen option in the Export Slideshow to PDF dialog box.

6. Click Export.

Export a JPEG Slideshow

1. With a slideshow already set up in the Slideshow module, choose Slideshow, Export JPEG Slideshow.

Keyboard Shortcuts

Press Cmd+Shift+J (Mac) or Ctrl+Shift+J (Win) to apply the Export JPEG Slideshow command quickly.

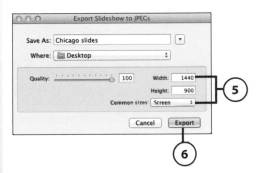

2. In the Export Slideshow to JPEGs dialog box, enter a name in the Save As field.

3. Choose a disk location to save the JPEGs.

4. Determine the quality of the JPEGs by adjusting the Quality slider.

5. Choose the preferred JPEG dimensions from the Common Sizes drop-down list, or enter specific pixel values in the Width and Height fields provided.

6. Click Export.

Export a Video Slideshow

1. With a slideshow already set up in the Slideshow module, choose Slideshow, Export Video Slideshow, or click the Export Video button in the lower-left corner of the module.

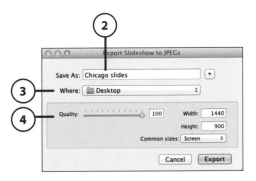

Keyboard Shortcuts

Press Cmd+Option+J (Mac) or Ctrl+Alt+J (Win) to apply the Export Video Slideshow command quickly.

2. In the Export Slideshow to Video dialog box, enter a name in the Save As field.

3. Choose a disk location to save the mp4 video.

4. Determine the quality of the video by choosing a size option from the Video Preset list. Refer to the guidelines displayed below the list for player compatibility.

5. Click Export.

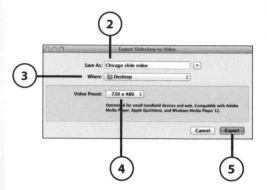

Saving a Slideshow Template

Lightroom enables you to save your favorite slideshow settings as templates. Doing so enables you to reinstate your most commonly used settings with a simple click of a button. You can save templates in the User Templates folder or create new folders within the Template Browser panel. In addition, the Template Browser panel also contains a Lightroom Templates folder that contains all the templates that ship with Lightroom.

Save Slideshow Settings as a Template

1. With a slideshow already set up in the Slideshow module, choose Window, Panels, Template Browser to display the Template Browser panel.

Keyboard Shortcuts

Press Control+Cmd+1 (Mac) or Ctrl+Shift+1 (Win) to show or hide the Template Browser panel quickly.

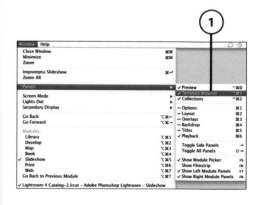

2. Choose Slideshow, New Template, or click the Create New Preset button (the + symbol) in the upper-right corner of the Template Browser panel.

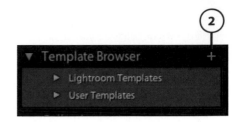

Keyboard Shortcuts

Press Cmd+N (Mac) or Ctrl+N (Win) to apply the New Template command.

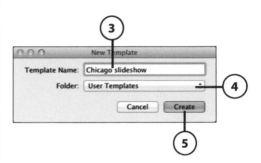

3. In the New Template dialog box, enter a name in the Template Name field.

4. Choose a folder to save the template in from the Folder drop-down list. The default is User Templates.

5. Click Create.

 Lightroom adds the new template to the Template Browser list.

Saving a Slideshow Project

Creating a slideshow for a group of photos can be a very time-consuming process. Although creating slideshow presets can help save setup time, the presets do not recall any photos. By creating a saved slideshow in the Collections panel, you can recall a slideshow with the photos and settings in place.

Create a Saved Slideshow

1. With a slideshow already set up in the Slideshow module, choose Slideshow, Create Saved Slideshow, or click the Create Saved Slideshow button in the upper-right corner of the Content area.

Keyboard Shortcuts

Press Cmd+S (Mac) or Ctrl+S (Win) to apply the Create Saved Print command quickly.

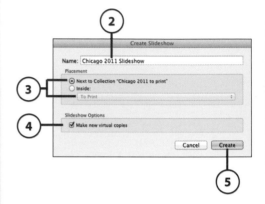

2. In the Create Slideshow dialog box, enter a name for the slide- show in the Name field.

3. Choose to place the saved slide- show in either the Top level of the Collections panel or inside an existing collection set. If you currently have a collection selected in the Collections panel, Lightroom replaces the Top level option with the option to place the saved slideshow next to the selected collection.

4. If you prefer, enable the Make New Virtual Copies option to cre- ate virtual copies of the photos used in the slideshow.

5. Click Create.

Learn to insert
an identity plate.

Learn to create
a saved web gallery.

Learn to save custom gallery
layouts as user templates.

Learn to choose a
web gallery
layout style.

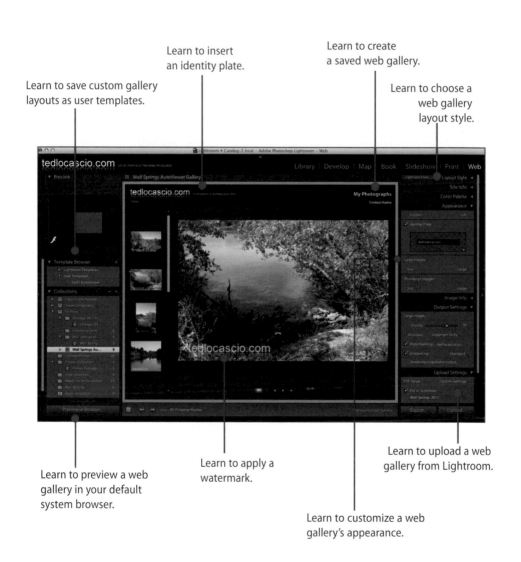

Learn to preview a web
gallery in your default
system browser.

Learn to apply a
watermark.

Learn to upload a web
gallery from Lightroom.

Learn to customize a web
gallery's appearance.

In this chapter, you learn to utilize Lightroom's web gallery options.

→ Choosing a Web Gallery Layout Style
→ Choosing Web & Device Output Settings and Options
→ Previewing a Web Gallery
→ Exporting a Web Gallery
→ Uploading a Web Gallery
→ Saving a Web Gallery Template
→ Saving a Web Gallery Project

Creating Web Galleries

Lightroom's Web module enables you to publish your favorite photo collections as web galleries. Lightroom comes equipped with several website structures (called styles) that you can use to create an online gallery.

In this chapter, you learn how to choose an HTML- or Flash-based gallery style. You also learn how to customize a chosen gallery's appearance and choose specific image and metadata output settings. In addition, this chapter teaches you how to export a Lightroom gallery as a complete website, or upload it to a server directly from the Web module.

Choosing a Web Gallery Layout Style

The Layout Style panel enables you to choose from one of five preset gallery styles that ship with Lightroom. The Lightroom HTML gallery is the most compatible because it uses classic HTML code. The Lightroom Flash and Airtight galleries use Flash code; therefore, the end user must have the latest Flash player installed to view them. You can select the style that you would like to use by clicking its name in the Layout Style panel, or by choosing it from the panel drop-down list when the Layout Style panel is closed.

Choose the Lightroom HTML Gallery

1. From the Library module Grid or the Filmstrip, select the photos to include in the web gallery.

2. Choose Window, Web or click the Web button in the upper-right corner of the interface.

Keyboard Shortcuts
Press Cmd+Option+7 (Mac) or Ctrl+Alt+7 (Win) to enter the Web module quickly.

3. If the Toolbar is not already visible, choose View, Show Toolbar.

Keyboard Shortcuts
Press T to show or hide the Toolbar quickly.

4. Choose Selected Photos from the Use menu in the Toolbar.

5. Choose the Lightroom HTML Gallery from the Layout Style panel list.

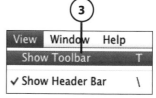

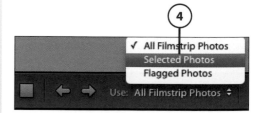

Lightroom displays the selected images in the Content area using the Lightroom HTML Gallery Style.

Lightroom displays the images in the Content area.

Choose the Lightroom Flash Gallery

1. From the Library module Grid or the Filmstrip, select the photos to include in the web gallery.

2. Choose Window, Web or click the Web button in the upper-right corner of the interface.

Keyboard Shortcuts

Press Cmd+Option+7 (Mac) or Ctrl+Alt+7 (Win) to enter the Web module quickly.

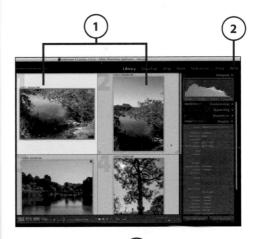

3. If the Toolbar is not already visible, choose View, Show Toolbar.

Keyboard Shortcuts

Press T to show or hide the Toolbar quickly.

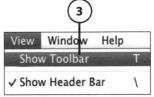

4. Choose Selected Photos from the Use menu in the Toolbar.

5. Choose the Lightroom Flash Gallery from the Layout Style panel list.

Lightroom displays the selected images in the Content area using the Lightroom Flash Gallery Style.

Lightroom displays the images in the Content area.

Choose the Airtight AutoViewer Gallery

1. From the Library module Grid or the Filmstrip, select the photos to include in the web gallery.

2. Click the Web button in the upper-right corner of the interface.

Keyboard Shortcuts
Press Cmd+Option+7 (Mac) or Ctrl+Alt+7 (Win) to enter the Web module quickly.

3. If the Toolbar is not already visible, choose View, Show Toolbar.

Keyboard Shortcuts
Press T to show or hide the Toolbar quickly.

4. Choose Selected Photos from the Use menu in the Toolbar.

5. Choose the Airtight AutoViewer Gallery from the Layout Style panel list.

Lightroom displays the selected images in the Content area using the Airtight AutoViewer Gallery Style.

Lightroom displays the images in the Content area.

Choose the Airtight PostcardViewer Gallery ▶

1. From the Library module Grid or the Filmstrip, select the photos to include in the web gallery.

2. Click the Web button in the upper-right corner of the interface.

Keyboard Shortcuts
Press Cmd+Option+7 (Mac) or Ctrl+Alt+7 (Win) to enter the Web module quickly.

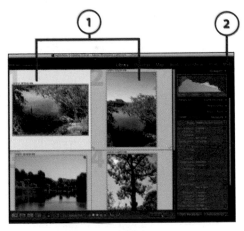

3. If the Toolbar is not already visible, choose View, Show Toolbar.

Keyboard Shortcuts
Press T to show or hide the Toolbar quickly.

4. Choose Selected Photos from the Use menu in the Toolbar.

5. Choose the Airtight Postcard-Viewer Gallery from the Layout Style panel list.

Lightroom displays the selected

images in the Content area using the Airtight PostcardViewer Gallery Style.

Choose the Airtight SimpleViewer Gallery

Lightroom displays the images in the Content area.

1. From the Library module Grid or the Filmstrip, select the photos to include in the web gallery.

2. Click the Web button in the upper-right corner of the interface.

Keyboard Shortcuts
Press Cmd+Option+7 (Mac) or Ctrl+Alt+7 (Win) to enter the Web module quickly.

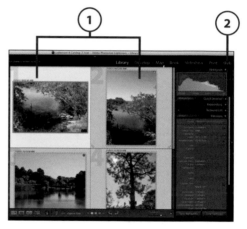

3. If the Toolbar is not already visible, choose View, Show Toolbar.

Keyboard Shortcuts
Press T to show or hide the Toolbar quickly.

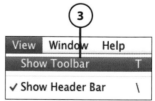

4. Choose Selected Photos from the Use menu in the Toolbar.

5. Choose the Airtight SimpleViewer Gallery from the Layout Style panel list.

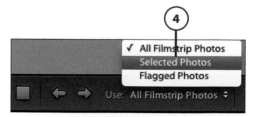

Lightroom displays the selected images in the Content area using the Airtight SimpleViewer Gallery Style.

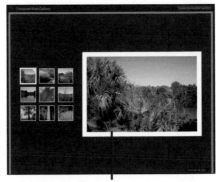

Lightroom displays the images in the Content area.

Choosing Web & Device Output Settings and Options

To create a custom web gallery in Lightroom, you must specify the color and appearance options for the layout style you select. You must also specify the site and image info, as well as the preferred output settings. Lightroom enables you to choose all of these settings from the Color Palette, Appearance, Site Info, Image Info, and Output Settings panels available in the Web module.

Include Site Info

The Site Info panel enables you to include website and contact info in the gallery, as well as additional information about the gallery images. The Site Info panel contains different options, depending on which web gallery style you selected.

1. In the Web module (with or without web gallery images selected in the Filmstrip), choose Window, Panels, Site Info to display the Site Info panel.

Keyboard Shortcuts

Press Cmd+2 (Mac) or Ctrl+2 (Win) to show or hide the Site Info panel quickly.

2. Enter the preferred website and contact information in the Site Info panel fields.

When working in the Lightroom HTML and Flash galleries, the following site info fields are available: Site Title, Collection Title, Collection Description, Contact Info, and Web or Mail Link.

When working in the Lightroom HTML gallery, the Site Info panel also includes an Identity Plate section, plus an additional Web or Mail Link field.

When working with the Airtight galleries, the only field available in the Site Info panel is Site Title.

The Site Info panel in the Lightroom HTML gallery.

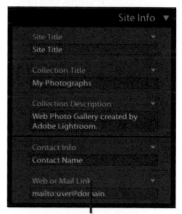

The Site Info panel in the Lightroom Flash gallery.

The Site Info panel in the Airtight galleries.

Apply Color to the Gallery

The Color Palette panel enables you to customize the appearance of the gallery interface. As it is with most of the Web module panels, the Color Palette panel options change depending on which web gallery style you selected.

1. In the Web module (with or without web gallery images selected in the Filmstrip), choose Window, Panels, Color Palette to display the Color Palette panel.

Keyboard Shortcuts

Press Cmd+3 (Mac) or Ctrl+3 (Win) to show or hide the Color Palette panel quickly.

2. To choose a different color for any item listed in the Color Palette panel, click the neighboring color swatch icon and select the color using the Color Picker.

 Lightroom displays the colored gallery items in the Content area.

The Color Palette panel in the Lightroom HTML gallery.

The Color Palette panel in the Lightroom Flash gallery.

The Color Palette panel in the Airtight galleries.

Choose Lightroom HTML Gallery Appearance Attributes

You can apply additional edits to a chosen gallery interface by enabling the various options available in the Appearance panel. As it is with most of the panels in the Web module, the Appearance panel options change depending on which web gallery style you selected.

1. In the Web module, with web gallery images already selected in the Filmstrip and displayed in the Lightroom HTML gallery style, choose Window, Panels, Appearance to display the Appearance panel.

Keyboard Shortcuts

Press Cmd+4 (Mac) or Ctrl+4 (Win) to show or hide the Appearance panel quickly.

2. In the Common Settings portion of the Appearance panel, enable the Add Drop Shadow to Photos option to apply a drop shadow to every gallery image.

3. To include section borders in the grid, enable the Section Border option in the Common Settings portion of the Appearance panel.

4. To choose a different color for the section borders of the grid, click the neighboring color swatch icon and select the color using the Color Picker.

5. To set the grid dimensions for the gallery, click anywhere in the grid that is located in the Grid Pages section of the Appearance panel.

6. To display cell numbers in the grid, enable the Show Cell Numbers option.

7. To include photo borders in the grid, enable the Photo Borders option.

8. To choose a different color for the photo borders, click the neighboring color swatch icon and select the color using the Color Picker.

9. In the Content area, click a thumbnail in the image grid. Doing so displays the image by itself on an image page.

10. In the Image Pages portion of the Appearance panel, adjust the Size slider to determine the display size for the image pages, or enter the value manually in the field provided.

11. To include photo borders in the image pages, enable the Photo Borders option in the Image Pages portion of the Appearance panel.

Image Pages Warning

When viewing the photo gllery index page, a warning icon may appear in the upper-right corner of the Image Pages section of the Appearance panel. This lets you know that changes made to image page settings are not currently visible in the index grid.

12. To choose a different color for the image page photo borders, click the neighboring color swatch icon and select the color using the Color Picker.

13. In the Image Pages portion of the Appearance panel, adjust the Width slider to determine the pixel width for the Image Page photo borders, or enter the value manually in the field provided.

Choose Lightroom Flash Gallery Appearance Attributes

1. In the Web module, with web gallery images already selected in the Filmstrip and displayed in the Lightroom Flash gallery style, choose Window, Panels, Appearance to display the Appearance panel.

Keyboard Shortcuts

Press Cmd+4 (Mac) or Ctrl+4 (Win) to show or hide the Appearance panel quickly.

2. At the top of the Appearance panel, choose a layout option from the Layout drop-down list. Options include Scrolling, Paginated, Left, and Slideshow Only.

3. To include an identity plate at the top of the Flash gallery, enable the Identity Plate option in the Appearance panel.

4. In the Large Images portion of the Appearance panel, choose a size option from the Size drop-down list.

5. In the Thumbnail Images portion of the Appearance panel, choose a size option from the Size drop-down list.

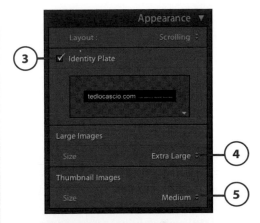

The Lightroom Flash gallery with chosen appearance attributes.

Choose Airtight AutoViewer Gallery Appearance Attributes

1. In the Web module, with web gallery images already selected in the Filmstrip and displayed in the Airtight AutoViewer style, choose Window, Panels, Appearance to display the Appearance panel.

Keyboard Shortcuts

Press Cmd+4 (Mac) or Ctrl+4 (Win) to show or hide the Appearance panel quickly.

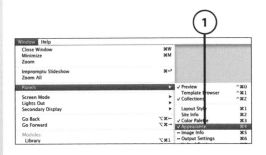

2. In the Stage Options portion of the Appearance panel, adjust the Photo Borders slider to determine the pixel width for the photo borders, or enter the value manually in the field provided.

3. In the Stage Options portion of the Appearance panel, adjust the Padding slider to determine the amount of space to place between gallery images, or enter the value manually in the field provided.

4. In the Stage Options portion of the Appearance panel, adjust the Slide Duration slider to determine the amount of time each image is displayed when playing the gallery slideshow, or enter the value manually in the field provided.

The Airtight AutoViewer gallery with chosen appearance attributes.

Choose Airtight PostcardViewer Gallery Appearance Attributes

1. In the Web module, with web gallery images already selected in the Filmstrip and displayed in the Airtight PostcardViewer style, choose Window, Panels, Appearance to display the Appearance panel.

Keyboard Shortcuts

Press Cmd+4 (Mac) or Ctrl+4 (Win) to show or hide the Appearance panel quickly.

2. In the Postcards portion of the Appearance panel, adjust the Columns slider to determine the number of columns to include in the postcard gallery, or enter the value manually in the field provided.

3. In the Postcards portion of the Appearance panel, adjust the Photo Borders slider to determine the pixel width for the photo borders, or enter the value manually in the field provided.

4. In the Postcards portion of the Appearance panel, adjust the Padding slider to determine the amount of space to place between gallery images, or enter the value manually in the field provided.

The Airtight PostcardViewer gallery with chosen appearance attributes.

5. In the Zoom Factors portion of the Appearance panel, adjust the Distant slider to determine the size of the postcard images in their zoomed-out state, or enter the value manually in the field provided.

6. In the Zoom Factors portion of the Appearance panel, adjust the Near slider to determine the size of the postcard images in their zoomed-in state, or enter the value manually in the field provided.

Choose Airtight SimpleViewer Gallery Appearance Attributes

1. In the Web module, with web gallery images already selected in the Filmstrip and displayed in the Airtight SimpleViewer style, choose Window, Panels, Appearance to display the Appearance panel.

Keyboard Shortcuts
Press Cmd+4 (Mac) or Ctrl+4 (Win) to show or hide the Appearance panel quickly.

2. In the Stage Options portion of the Appearance panel, choose a layout option from the Position drop-down list. Options include Top, Bottom, Left, and Right.

3. In the Stage Options portion of the Appearance panel, adjust the Rows slider to determine the number of rows to include in the gallery, or enter the value manually in the field provided.

4. In the Stage Options portion of the Appearance panel, adjust the Columns slider to determine the number of columns to include in the gallery, or enter the value manually in the field provided.

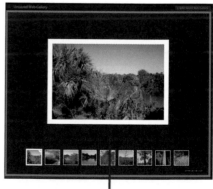

The Airtight SimpleViewer gallery with chosen appearance attributes.

Include Image Info

The Image Info panel enables you to include image info above and below the photo in the main image views of the gallery. Note that in the Airtight galleries, you can only include info below the image.

1. In the Web module, with web gallery images already selected in the Filmstrip and displayed in one of the gallery styles, choose Window, Panels, Image Info to display the Image Info panel.

Keyboard Shortcuts

Press Cmd+5 (Mac) or Ctrl+5 (Win) to show or hide the Image Info panel quickly.

2. In the Labels portion of the Image Info panel, enable the Title option (Lightroom HTML and Flash galleries only).

3. Choose an image info preset option from the Title drop-down list, or to create a custom setting, choose Edit. In the Text Template Editor dialog box, use the drop-down lists to choose the items that you'd like to include. Click the neighboring Insert buttons to add the text items.

4. If you've chosen to apply a custom setting, click the Done button in the bottom-right corner of the Text Template Editor dialog box.

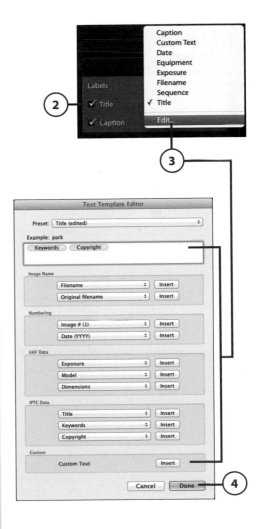

Lightroom displays the title info above the large image in the Content area.

5. In the Labels portion of the Image Info panel, enable the Caption option.

6. Choose an image info preset option from the Caption drop-down list.

Lightroom displays the caption info below the large image in the Content area.

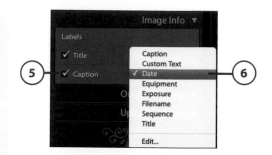

Lightroom displays the image info in the Lightroom HTML gallery.

Choose Lightroom HTML and Flash Gallery Output Settings

The Output Settings panel enables you to specify the image and meta-data output settings for your web gallery. As it is with most of the Web module panels, the options in the Output Settings panel change depending on which web gallery style you currently have selected.

1. With a Lightroom HTML or Flash gallery already set up in the Web module, choose Window, Panels, Output Settings to display the Output Settings panel.

Keyboard Shortcuts
Press Cmd+6 (Mac) or Ctrl+6 (Win) to show or hide the Output Settings panel quickly.

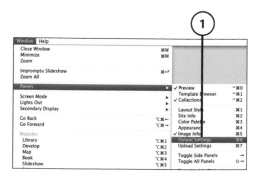

2. In the Large Images portion of the Output Settings panel, adjust the Quality slider to determine the display quality of the large gallery images, or enter the value manually in the field provided.

3. If you'd like to output specific image metadata, choose a metadata preset from the Metadata drop-down list, or else choose All.

4. Enable the Watermarking option to display a watermarking preset over the image.

5. Choose a watermarking preset from the Watermarking drop-down list.

6. Enable the Sharpening option in the Output Settings panel.

7. Choose the sharpening quality from the Sharpening drop-down list. Options include Low, Standard, and High.

Lightroom applies the output settings.

Choose Airtight SimpleViewer Output Settings

1. With an Airtight SimpleViewer gallery already set up in the Web module, choose Window, Panels, Output Settings to display the Output Settings panel.

2. In the Large Images portion of the Output Settings panel, adjust the Size slider to determine the display size for the large gallery images, or enter the value manually in the field provided.

3. Adjust the Quality slider to determine the display quality of the large gallery images, or enter the value manually in the field provided.

4. Adjust the Photo Borders slider to determine the pixel width for the large image photo borders, or enter the value manually in the field provided.

5. Adjust the Padding slider to determine the amount of space to place between the large image and the edges of the screen, or enter the value manually in the field provided.

6. Enable the Allow Right-Click to Open Photos option to allow the end user to access the Open command from the contextual menu.

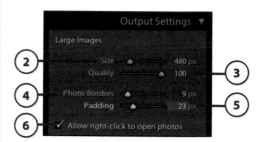

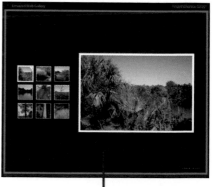

Lightroom applies the output settings.

Choose Airtight AutoViewer and PostcardViewer Output Settings

1. With an Airtight AutoViewer or PostcardViewer gallery already set up in the Web module, choose Window, Panels, Output Settings to display the Output Settings panel.

2. In the Large Images portion of the Output Settings panel, adjust the Size slider to determine the display size for the large gallery images, or enter the value manually in the field provided.

3. Adjust the Quality slider to determine the display quality of the large gallery images, or enter the value manually in the field provided.

4. Enable the Watermarking option to display a watermarking preset over the image.

5. Choose a watermarking preset from the Watermarking drop-down list.

6. Enable the Sharpening option in the Output Settings panel.

7. Choose the sharpening quality from the Sharpening drop-down list. Options include Low, Standard, and High.

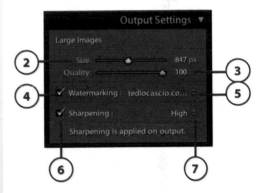

Lightroom applies the output settings.

Previewing a Web Gallery

As you choose settings for your web gallery, you can preview them in your default system web browser, such as Apple Safari, Mozilla Firefox, Google Chrome, or Microsoft Internet Explorer. To do so, choose Web, Preview in Browser, or click the Preview in Browser button, located in the lower-left corner of the interface.

Preview a Web Gallery in the Default Browser

1. With a web gallery already set up in the Web module, choose Web, Preview in Browser to display the gallery in your operating system's default browser. You can also click the Preview in Browser button, located in the lower-left corner of the interface.

Keyboard Shortcuts
Press Cmd+Option+P (Mac) or Ctrl+Alt+P (Win) to apply the Preview in Browser command quickly.

Lightroom generates a temporary export of the gallery and previews the result in your default browser application.

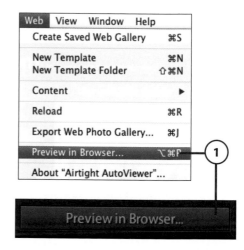

Lightroom generates a temporary export of the site.

Lightroom displays the gallery in your default browser.

Exporting a Web Gallery

After you finish applying all your web gallery settings, you can export the gallery as a complete website. Doing so allows you to view the website in other browsers besides the system default. You can also manually upload the exported site to a server using a separate FTP program, such as Fetch (Mac OS X) or SmartFTP (Windows XP/Vista/7).

Export a Gallery as a Website

1. With a web gallery already set up in the Web module, choose Web, Export Web Photo Gallery to save a complete version of the website to a folder on your computer. You can also click the Export button, located In the lower-right corner of the interface.

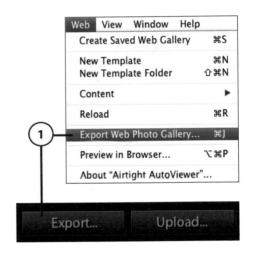

Keyboard Shortcuts
Press Cmd+J (Mac) or Ctrl+J (Win) to apply the Export Web Photo Gallery command quickly.

2. In the Save Web Gallery dialog box, enter a name in the Save As field.

3. Choose a system location to save the website.

4. Click Save.

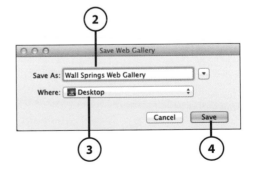

Uploading a Web Gallery

Lightroom also enables you to upload a web gallery directly from the Web module. To do so, you must choose a preexisting FTP preset option from the FTP Server drop-down list, or enter custom settings in the Configure FTP File Transfer dialog box. You can save custom settings as an FTP preset by choosing Save Current Settings as New Preset from the Preset drop-down list.

Upload a Web Gallery from Lightroom

1. With a web gallery already set up in the Web module, choose Window, Panels, Upload Settings to display the Upload Settings panel.

Keyboard Shortcuts
Press Cmd+7 (Mac) or Ctrl+7 (Win) to display the Upload Settings panel quickly.

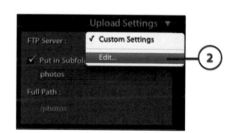

2. Choose an FTP server preset option from the FTP server drop-down list, or choose Edit to create a custom setting.

3. In the Configure FTP File Transfer dialog box, enter the server URL in the Server field.

4. Enter the username in the Username field.

5. Enter the password in the Password field.

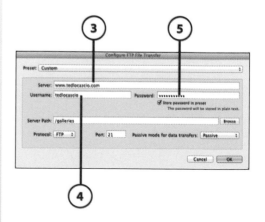

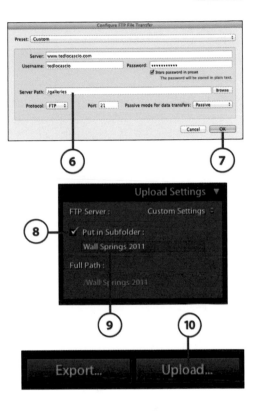

6. Enter the directory path in the Server Path field, or click Browse and select a folder from the pop-up dialog box.

7. Click OK.

8. Enable the Put in Subfolder option in the Output Settings panel.

9. Enter a unique subfolder name in the Output Settings panel.

10. Click the Upload button located in the lower-right corner of the interface.

Saving a Web Gallery Template

Lightroom enables you to save your favorite gallery settings as templates. Doing so enables you to reinstate your most commonly used settings with a simple click of a button. You can save templates in the User Templates folder or create new folders within the Template Browser panel. In addition, the Template Browser panel also contains a Lightroom Templates folder that contains all the templates that ship with Lightroom.

Save Web Gallery Settings as Templates

1. With a web gallery already set up in the Web module, choose Window, Panels, Template Browser to display the Template Browser panel.

Keyboard Shortcuts

Press Control+Cmd+1 (Mac) or Ctrl+Shift+1 (Win) to show or hide the Template Browser panel quickly.

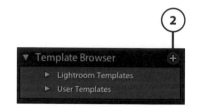

2. Choose Web, New Template, or click the Create New Preset button (the + symbol) in the upper-right corner of the Template Browser panel.

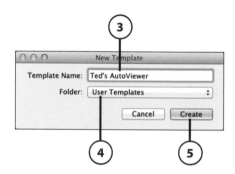

Keyboard Shortcuts

Press Cmd+N (Mac) or Ctrl+N (Win) to apply the New Template command.

3. In the New Template dialog box, enter a name in the Template Name field.

4. Choose a folder to save the template in from the Folder drop-down list (the default is User Templates).

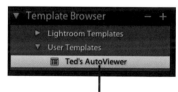

Lightroom adds the template.

5. Click Create.

Lightroom adds the new template to the Template Browser list.

Saving a Web Gallery Project

Creating a web gallery can be a very time-consuming process. Although creating gallery presets can help save setup time, the presets do not recall any photos. By creating a saved gallery in the Collections panel, you can recall a gallery with the photos and settings in place.

Create a Saved Web Gallery

1. With a web gallery already set up in the Web module, choose Web, Create Saved Web Gallery, or click the Create Saved Web Gallery button in the upper-right corner of the Content area.

Keyboard Shortcuts

Press Cmd+S (Mac) or Ctrl+S (Win) to apply the Create Saved Web Gallery command quickly.

2. In the Create Web Gallery dialog box, enter a name for the web gallery in the Name field.

3. Choose to place the saved slide-show in either the Top level of the Collections panel or inside an existing collection set. If you currently have a collection selected in the Collections panel, Lightroom replaces the Top level option with the option to place the saved web gallery next to the selected collection.

4. If you prefer, enable the Make New Virtual Copies option to create virtual copies of the photos used in the web gallery.

5. Click Create.

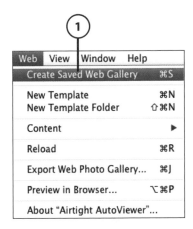

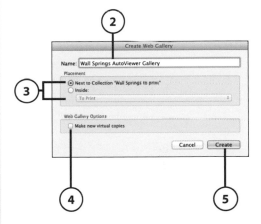

Index

C

FREE
Online Edition

My Adobe® Photoshop Lightroom® 4

Ted LoCascio